The

PRESIDENT'S

THERAPIST

and the
secret intervention
to treat the alcoholism
of GEORGE W. BUSH

a novel by

JOHN WAREHAM

THE PRESIDENT'S THERAPIST

Welcome Rain Publishers / New York

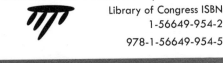

Library of Congress ISBN
1-56649-954-2
978-1-56649-954-5

CAVEAT

This is a work of the imagination. Some characters are based on real people in the public eye, and fragments of their sentences may occasionally have been drawn from real conversations within the public domain, but all other characters are fictional. Most of the settings also exist, but what happens in such places—or anywhere in these pages—is entirely fictional.

DEDICATION

To the achievers who so generously invited
me into their lives, shared their travails and
triumphs, and taught me so much about the
art, science and craft of leadership.

"If you want to test
a man's character
give him power."
—Abraham Lincoln

The

PRESIDENT'S

THERAPIST

and the secret
intervention to
treat the alcoholism
of GEORGE W. BUSH

STATEMENT OF MARK ALTER

—and supplemental documentation—

17 May 2007

YES, I WAS THE PRESIDENT'S THERAPIST. Yes, George W. Bush himself. Yes, I counseled him in the White House. It all happened, believe me. You need to know *all* that happened, and *exactly* what happened? Well, if that's what it's going to take—and upon your promise as a professional colleague that whatever I disclose will be held in absolute confidence—then okay, I'll tell you. I have an eye for detail and I'm a trained listener—and everything is vivid in my memory—so I'm sure we'll have no trouble understanding each other. Let me start at the beginning.

ORIGINS & INTENTIONS

MAYBE I BECAME MORE INSIGHTFUL AND empathetic after my son died. For sure, a string of professional successes followed. I had foreseen and prepared myself for his tragic departure, but I'd still not gotten over Grace's slaying. To lose a beautiful and loving wife so suddenly is to be shaken to the core. But perhaps the intensity of my losses tapped into a hidden well of strength. Maybe my newfound effectiveness sprang from my words as they lowered my son's drug-ravaged body into the ground. "Oh, give me the power," I whispered, "to truly listen, and to help others listen."

Well, most of us view life through a cloudy prism of self-serving beliefs. Numbed by emotional pain we traipse through life like zombies, and maybe I'd been more detached than most. Armed with the insight of the dream that came to me the night of Ethan's funeral, however, my ability to help others, if not always myself, took an inspiring turn.

I mostly work with corporate executives. They call me a coach but if I can penetrate their gung-ho, take-charge masks, I'm usually most helpful as a therapist. Alas, however, unconscious inner demons compel too many strivers to sabotage their own successes, and alerting them to the wellsprings of their self-defeating behaviors is seldom easy.

But, like I said, everything changed after Ethan's funeral. That night I dreamed of a godlike professor standing in front of a blackboard. He pointed to the board and two huge words appeared in golden script: CONSTRUCTIVE CONFUSION. I awoke with no idea what the dream was saying. Moments later, however, in front of my shaving mirror, I had an Ah-ha moment. My son's obsession, which as a youth I briefly shared, was to earn his living as a poet. When he failed, I tried to

comfort him by pointing to the unrealism of the goal. Now, however, my dream was telling me that Ethan died because, time and again, I had been rational to the point of rigidity, and insisted that he be cerebral, too. The dream's meaning was that *clarity springs from confusion.* I should have listened to my son more closely, and shone a soft light on all sides of our differences. We might both have become bewildered, but *that* was the path to understanding. and the route to sobriety. As tears welled in my eyes, I vowed to honor Ethan's memory by applying the principle of constructive confusion. That way his better angels—his charm, bright spirit, and the sense of curiosity that propelled his rebellion—would live on in my work. CONSTRUCTIVE CONFUSION! The idea was so big that the razor shook in my hand. To enlighten, I must *perplex.* But how, exactly? Yes! The professor and the script upon the blackboard! I would engage my clients in a series of puzzling discussions. Constructive Confusion! Would it really work? Would the process be fast or slow? And where might it lead? The answer, as you know, is that I enjoyed such dramatic success treating Jack Quick, that I got a call for help from the White House.

It would probably help you to understand precisely how and why a corporate titan like Jack Quick came to sing my praises so publicly, so let me briefly tell you what went down.

TUES., 04/03/07—QUICK STYLE ADJUSTMENT,

JACK QUICK'S CHARISMATIC PERSONA MASKED underlying anger, and the emotional barricades he threw up seemed insurmountable. We had drifted into pretending that he was a genius with the divine right to make his own rules. My role, however, was to help him with corporate team

building. So far, however, his temper and voracious sexual appetites torpedoed most of my attempts to create a respectful professional *esprit de corp*. His problems were well known but his team members wanted to survive, so denial was the norm. The week after my son's funeral, however, things changed.

I gathered his executive team together for a two-day team-building program. Fifteen of us, neatly clad in "business casual," gathered around a large oval table in a folksy boardroom in a woodsy retreat fifty miles out of Manhattan.

I welcomed everyone, then passed out a discussion paper and asked, "How to we feel about this idea?" Then I read the opening paragraph aloud:

> *"The greatest kind of leadership is Servant Leadership. It begins with the natural feeling that one wants to serve others above all else. Then conscious choice brings one to aspire to lead…The difference shows in the care and concern of the servant-first leader to ensure the emotional and spiritual growth of his followers."*

There was momentary silence, then a pretty blonde marketing vice president spoke up, "That's Jack! He's always takes care of everyone. "

"Is that right, Jack," I asked, "are you a servant to everyone?"

"Ask the team, not me," he responded with an aw-shucks smile.

They murmured approvingly.

I continued the reading:

> *"Unlike control and command styles, servant leadership emphasizes collaboration, trust, empathy, the ethical use of power and consensus decision-making."*

The team became apprehensive and confused. They all knew—and knew that I knew—that Jack was a command and

control tyrant. 'Please don't rock the boat,' implored their downcast eyes.

Jack jumped into the silence. "I speak for the team in saying that we're all in favor of full participation," he said. Again, the team rustled appreciatively. "But you've gotta be joking about that consensus crap."

"Why is that?" I asked.

"Because a leader has to *lead*."

"Are you saying that the only way to lead is by proclamation?"

"I'm saying that it's okay to listen, but a leader has to decide."

"What if everyone disagrees with him?"

"Then he has to go with his gut."

"Is there no truth to the adage, 'all of us are smarter than any one of us'?"

"What I'm saying, Doc, is that if things go wrong, my ass is on the line—so I'm entitled to make the judgment calls."

"So every leader is entitled to be a dictator?"

Jack was peeved and momentarily stuck for a response. Sensing his unease, a well intentioned enabler slipped into the silence. "We're especially fortunate to have a charismatic leader like Jack. Sure, we all know that he runs a tight ship, but that's for our own good, and since Jack has the judgment of a genius he *always* makes the right decision—and I'd say we always do agree with him."

"And that's *always* inspiring to the team," chimed in another courtier.

I turned my focus on the first speaker. "Trouble is, Jack champions team leadership, but only if he can make all the decisions—and only a schizophrenic or a cynical sycophant

can seriously agree with both positions, so I hope you're not trying to suggest that Jack is a hypocrite too?"

I cast a stern eye over the group as an uneasy silence descended. Then I broke into a wide grin. "Well, no more than anyone else, right, Jack? I mean one way or another we're all a little hypocritical." The team was horrified. They expected Jack to erupt. "Maybe that's why, as we've all just seen, everyone in this room is so keen to agree with everything you say, right, Jack?" He eyed me silently for a couple of moments. "I mean, honestly, Jack, how much open communication are we all seeing in this room right now?"

He took a deep breath and cast a long look over his long-suffering team. Then he smiled broadly. Had he, in that snapshot of their almost comic need to please him, also sighted his own failings?

"Well, you're right, of course, Doc," he said, softly. "Hypocrisy's the norm."

"And might you agree that by the time a person becomes a leader, hypocrisy is so deeply ingrained that he winds up lying to everybody—perhaps even himself?"

"I would."

"And does that duplicity come at a price?"

"Everything has a price."

"But would you agree that the ultimate cost is emotional?"

"I would."

"That such a leader feels rotten?"

"Some leaders do, I guess."

"So such a leader would need to find a way to shore himself up?"

"It follows."

"So some turn to booze and tranquillizers, some find comfort in limousines and private jets, some prefer power and

intimidation, and others seek to sate their underlying hungers with, uh, *affection?*"

By the expression on his face, I could tell that Jack had not only processed my words, he was also coming to the realization that the group was wise to his addictions.

I turned to the group. "So what advice should we share with such leaders?" I tossed in a smile, "Don't answer! It's just query to put you in the mood for tomorrow. Just be sure- to read up on our next set of discussion papers."

The chief information officer raised his hand. "Those papers are confusing."

As the meeting was dispersing, Jack pulled me aside. "You told them I was a hypocrite."

"Just joshing, Jack, nobody's perfect. And the spotlight was on *their* hypocrisy, surely."

"I've always told them I walk the talk."

"And do you?"

"I'm a square shooter in business."

"In business—so what else is there?"

"I work hard and I play hard. My private life is my affair."

"Right, it's a free world and it's your life, so who cares what the team thinks?"

"Are you saying …"

It didn't matter that he gagged on the sentence, it was easy to guess what was on his mind. But did he truly want me to lead him down that route?

"You don't need to know what I think."

"I don't?"

"No. You need to discover what you think."

"I know what I think."

"Ah, but Jack, if you truly know, then why do you ask?" No answer came, so I continued, "Tell you what, I packed you some light reading. So skip the partying tonight and look over this stuff instead"—I handed him an envelope with some readings I'd prepared ahead of time—"Then let's meet for an hour in my suite at six A.M. tomorrow morning."

He arrived promptly at six, wearing black slacks, a gray silk shirt, no tie, Gucci loafers, and a heavy splash of Brut.

"Jack, thanks for coming." I grabbed his outstretched hand and steered him to one of those bland modern easy chairs that hotels seem to specialize in, then seated myself opposite him.

"Well, thank you, Doc." He'd always looked young for his years, but this morning the lines in his face were deep.

"You slept well, I hope?"

"Sure, just great."

"Really? I can never totally relax in hotel beds."

He didn't speak right away. "Well, to be honest, Doc, I lay awake mulling over this weird collection of stuff you gave me to read," he said as he opened an envelope and tossed the contents onto the coffee table.

"That's good, and what did you make of the opening quiz?" He hesitated, so I picked up the top sheet and read the first paragraph aloud—

> On a warm summer day you are meandering through the countryside. You're come to a fence that surrounds a field of mouth-watering strawberries. You've not eaten all morning and you're hungry. You're alone and the fence is the only impediment between you and a complimentary snack. *What is the height of the fence?*

"So, Jack, what's the height of the fence?" I gently asked.

"Fences don't exist for leaders. A leader's job is to see beyond and go beyond."

"So there was no fence?"

"For others maybe, not for me." He paused and I waited. "Well, since you're pressing me for an answer I would say that however high that fence happened to be, it disappeared when I looked at it." He grinned and so did I.

"And what about the next question—"

> You slip into the field and consume the tempting fruit. *How many berries do you eat?*

He grinned again. "Till I'm no longer hungry—and I have a big appetite, so there might not be a lot of strawberries left when I'm through."

"And what about the next question—"

> Suddenly the grower whose berries you've eaten descends from a hill. He's peeved and yells at you. *What do you say to by way of justification?*

"I tell him that luscious strawberries deserve better protection. Then I negotiate a deal and pay for what I've eaten."

"You'll pay him off?"

"He'll be happy with the deal."

"Well, so we hope. And finally—"

> On the way back home, you contemplate your adventure. *How did the berries taste? And how do you feel about your escapade?*

"The berries were okay, but not so great as the farmer imagined."

"And how do you feel, looking back?"

"I'm too busy for regrets."

"Hey, Jack, that's the most interesting thing you've said."

"What?"

"'I'm too busy for regrets.' Are you implying that you suffered at least a little guilt for eating those berries?"

He was slow to answer. "Maybe... But who's worrying about a few berries? And, anyway, I paid the farmer. There's going to be a point to all this, right?"

"Sure. The point of the strawberry quiz, Jack, is what your responses reveal about you. On an unconscious plane, those succulent forbidden strawberries symbolize sexual temptation. The height we assign to the fence reveals how easily we might engage in promiscuous sex."

Jack leaned back in his chair and took a deep breath. "I said there was *no fence*—not for me."

"You said the fence disappeared when a leader like you looked at it. What do you think that really means?"

"Does it mean that women are attracted to me?"

"Maybe. Might it also mean that it's a simple matter for a leader to tupple his subordinates."

"Like shooting fish in a barrel?"

"And gorging himself on as many as possible—"

"But I negotiate a deal that leaves everybody happy."

"But is everybody truly happy?" He was slow to answer, so I continued. "Remember, at the end of the whole scenario you were left with feelings of guilt and regret, so perhaps someone got hurt too." We sat silently for thirty seconds before I continued. "Let's talk about the second reading from the *Journal of the Conference Board*"—

Transactional Analysis & Office Adultery

Napoleon observed that adultery is "a mere transaction upon a sofa." So, too, modern psychologists agree that an office affair has little to do with love and everything to do with setting up a contract wherein each party exchanges something of value—usually power—in return for sexual favors. Thus the core problem of an office affair is that it shifts the balance of power within the office structure. The boss who topples an attractive underling is overthrown.

The office affair is ultimately less about copulation than emasculation. During the act itself, one party may be on top and the other below. When the partners rise and shuffle off to go about their business, however, the roles will likely be in the process of reversal: the strong will have been weakened, the weak made stronger. The subordinate effectively "one-ups" the superior and the underling who formerly deferred to the boss may now feel less inclined.

The extent to which the power structure changes is proportionate to the degree of secrecy sought by the parties, which seldom remains static. The party with the most to lose has the most pressing need for stealth. That person is usually the boss, who now becomes exposed, rightly or wrongly, to charges of sexual harassment. If this party is also conducting a clandestine extramarital affair, the need for secrecy is elevated and power over the subordinate sapped. And as the ante is upped, the relationship curdles. Hoping to keep the transaction quiescent, the party most in need of cover typically effects some sort of payoff. The truth is inevitably revealed, however, thereby unraveling the dalliance. Usually the weaker party enjoys a burst of satisfaction in communicating the fact of the affair to an aide or confidante. Bear in mind, too, that coworkers are usually highly sensitive to the presence of a supposedly clandestine office affair: colleagues divine a change in the office chemistry; they sense subtle and often poisonous shifts in moods, attitudes and behaviors; they feel demeaned or diminished by the patently below-the-belt political alliances; the survival antennae move to alert and they analyze the situation with cooler, clearer heads. The actual parties to the affair, on the other hand, are typically thinking with their genitalia; their brains are disengaged, they randomly signal the affair at almost every turn, sometimes by seeming too intimate, or often, paradoxically, by seeming too remote.

"You want me to connect this back to the strawberry quiz?"

"You think there might be a connection?"

"I get it, Doc, I get it. Yesterday I'd have denied it. Today—well, today is new—I mean I can't look away. I can't make excuses."

"You can't"—I dropped the words very softly—"be a hypocrite?"

"Is that the bottom line?"

"For what it might be worth, my take is that clandestine sex is mostly an addiction that reveals a deep, destructive craving. Trust is shattered and intimacy with the very people we committed to love becomes impossible. And down deep, we hate ourselves for lying. One outcome is that secret relationships wreck families and careers—and poison organizations. It's not so much the sex as the secrecy that does the damage. It's not whom we lie with, it's whom we lie to."

He fell silent. I watched him closely. He blinked and looked away.

At this point, or even earlier, you might have expected someone like Jack to take offense and perhaps storm out of the room. But so long as I melt their initial defences, pique their curiosity, and lead them empathetically—all of which became easier for me to achieve following my son's funeral— such narcissists are intrigued to explore their inner lives, and become increasingly engaged.

We must have stood stock-still for nearly a minute before he turned his eyes back to me.

"I've been an idiot, Doc."

I ever so slowly shook my head. "Maybe you've just been sleepwalking."

"Sleepwalking?" He mulled over the idea before breaking into a wistful grin. "Yeah," he said, "I've been *sleepwalking*."

"And now you're waking, Jack—and I think we're out of time."

He glanced at his Rolex. "The time went fast. Something's happened. I feel light-headed—different—like I've just returned from a long vacation. What's going on?"

"You've opened a window, Jack. From this point forward you'll be seeing the world in a new light"—I paused and held his gaze—"and your insights will be reflected in your actions."

I can also understand that you might doubt the power of such apparently simple discussions to change the mind of a person like Jack Quick. As I'm sure you know, however, most overachievers are driven by feelings of unworthiness that they hope accomplishment and acclaim will ease. But success merely makes them feel like phonies—and they can't figure out why, so the cycle continues. My hunch is that Jack agreed to sponsor and participate in the program because his anxieties were bubbling, and he somehow sensed that I might be able to help. Bear in mind, too, that an artful team building meeting is like group therapy, and that a "Trojan Horse" agenda and an apt discussion paper can deliver hidden issues into the forum. In this case, the cloud of constructive confusion gradually forced Jack's intuitions to pierce the mist and catch sight of his own foibles.

Ultimately, in the crucial moment of departure, I also seized the chance to slip a potentially mesmerizing suggestion into his brain; *from this point forward you'll be seeing the world in a new light, and your insights will be reflected in your actions.*

Whether or not that prophesy would self-fulfill remained to be seen.

The following Sunday I pored over a front page article in the Business Section of *The New York Times*:

QUICK CHANGE

Hi-Tech Chief Discovers Light at the End of His Tunnel Vision

At Friday's annual general meeting of Omega Systems, chief executive Jack Quick claimed to have undergone a psychological metamorphosis that led him to discard the imperious style of which he was formerly proud. "I am truly seeing the world in a whole new light," he said to the assembled shareholders. He claimed his transmogrification had produced "a new business paradigm, a fresh vision, and an inclusive, embracing leadership style." Sensing a mere public relations makeover, many shareholders were skeptical. Private discussions with Omega senior executives confirmed the sincerity of the conversion.

One confidential source advised that the change was effected during a senior team-building program customized by leadership psychologist, Dr. Mark Alter. "Alter proved to be a psychological sorcerer," said the source: "Everyone confessed to miraculous conversions similar to Jack's."

Mr. Quick advised that Dr. Alter was "the best in the business" and had been "enormously helpful." Alter noted that his professional relationship with Quick and Omega prevented him from discussing the matter beyond noting that, "No person remains what he was upon recognizing himself." He continued, "Organizational values move from the top down." Presumably he was indicating that he had somehow managed to arrest the attention of the mercurial Mr. Quick for enough time to bring the Quickian blind spots into focus and thereby effected a change that permeated the entire Omega culture. Skeptics remain doubtful, but following the release of the new corporate vision and the downsizing of staff, Omega shares have recorded a dramatic rise.

As I set *The Times* back on my desk, sunlight from the south window hit Grace's silver-framed photo. I picked it up and became as captivated as ever by her sparkling eyes and vibrant smile. I had aged but she had not. She'd have taken pride in that article. She always said that my successes were never properly acknowledged. The work is reward enough, I used to reply. She would just smile and say, "Maybe."

I was lost in my thoughts when the unlisted cell phone number I reserved for intimate clients vibrated over my heart, drawing me into an extraordinary orbit.

SUN., 04/29/07—CONVERSATION

"ARE YOU THE DOCTOR ALTER MENTIONED in *The New York Times*?"

The voice was cool and detached, overly so, I thought..

"The Omega piece? Yes. How did you get this number?"

"And you're a leadership psychologist? That's your profession?"

"You can Google me; my qualifications are listed."

"You did your doctorate at Columbia. And you've written widely, including several pieces for the *Harvard Business Review*."

"How can I help you?"

"I didn't see a client roster published anywhere."

"I deal with top leaders. I never publish names. What do you need to know?"

"You say your specialty is helping leaders. I'm wondering who, exactly."

I was becoming peeved. "You don't say what you want— or even identify yourself—yet you want me to disclose the names of my clients?"

"Sorry to seem, uh, cryptic" He paused and I got the feeling that a third party might be listening. "Look, if you're

truly used to dealing with powerful leaders then this call could be important. We have a confidential project and you might be the perfect person to handle it."

"*We*—who's *we*?"

"I could tell you whom I represent and you'd be very impressed. But first we need to speak privately."

"Come to my office, then."

"Your office is a few blocks from the Waldorf Hotel. Meet me there in the lobby at seven. A.M. tomorrow."

I was intrigued. "How will I know you?"

"You won't need to. Just be on time."

The caller seemed haughty and condescending but confidentiality is important to top leaders, so I dismissed my misgivings. That night, however, I slept badly and had a troubling dream.

> *Ethan and I were perched in the cockpit of a rocket about to journey into outer space. He was fit and well and smiling, clearly delighted to be included in the same adventure. I felt a special warmth for him as the engines burst to life and propelled us into the stratosphere. We set the controls to circle the earth and lay gazing out the window. The colors of our planet changed as day turned to night. I was struck by how small the earth appeared and ruminated upon the triviality of so many human complaints. After three orbits I felt we should return home, and pressed the luminous green Return to Earth button. Instead, of changing course, however, the rocket exploded, leaving Ethan drifting weightlessly toward the moon, and me plummeting back to earth. As the gap between us widened he produced a spray can of white paint and scrawled one of his favorite verses into the deep blue sky:*
>
> > *A poet's avocation*
> > *must be art*
> > *and not salvation.*

MON., 04/30/07—MEETING, MANHATTAN

THE WALDORF IS FAVORED BY WORLD LEADERS for good reason. An entourage can bail out of a limousine, swing into a hidden side door opening, and navigate directly through a secure labyrinthine underground to a high-speed nonstop elevator, which will whisk the retinue to a secure suite.

Despite its many makeovers, the subdued Waldorf lobby has always seemed to me a maze of dingy corridors, so I was not surprised, in this shadowy setting, that my introduction began with a tap on my shoulder.

"Doctor Alter."

It was a statement not a question. More to the point, the voice was female. I turned. She was thirty or maybe less, and dressed in a black pantsuit that accentuated her slim frame; her not-so-high-heeled shoes brought her to my height, 5' 10".

"I'm Cathy Vale." Her smile was warm. It was the sincerity in her cobalt eyes, however, that caught my attention.

"And you're looking for me?"

"My colleague arranged for us to meet." She was wearing a minimum of makeup and her complexion was sallow. "We have a suite, so we can talk privately. Let me lead the way."

We entered the elevator. Despite her professional air, she seemed a touch vulnerable. The doors swished shut, then reopened directly into a small suite. In the center of the room, a square chrome-and-glass coffee table was surrounded by four chairs. A desk, a credenza, and a swivel chair were off to one side. The curtains were drawn; the only light came from two lamps, one beside the table and one on the desk. A swarthy man wearing a three-buttoned gray suit and tightly laced black Florsheim wingtips stepped out of the shadows and dropped a manila file onto the coffee table.

"Thanks for coming, Doctor." He smiled, but his eyes remained cold. He indicated that I was to sit, and then as Cathy Vale fiddled in the background with an I-Phone, he slipped into a facing chair. "First, we need to decide whether you'll be a good fit for this assignment, so we need you to help us gauge the chemistry." He opened the manila envelope, peered at a couple of pages, returned them, and closed it again. "Your wife was shot to death." He paused. "How do you feel about that?"

I was startled. "That was several years ago. It happened when a restaurant robbery went bad. Her death was more or less accidental."

"She was collateral damage?"

"Grace was my *wife*—"

"I didn't mean to seem insensitive."

"I'm sure. Fortunately the city is safer these days."

"Thanks to the law-and-order mayor?"

"He deserves a lot of the credit."

"So you're in favor of strict punishment?"

"I approve of just penalties."

"Do you think your wife's killer got what he deserved?"

"He was a kid. He needed a blend of jail time and rehab. He's still serving time for manslaughter, but he recently became eligible for parole. I just pray that he comes out a better person than he went in. As for the loss of my wife, well, I'll never get over that."

"And your son? Are you over his death, too?"

"Oh, Christ—he's barely cold in the ground. What do you want from me?"

"He was a junkie?"

"He was troubled. He needed help beyond the power of any parent."

"It takes a village?"

"Yes, mentors outside a family—perfect strangers can be the best of all."

"You're also on the board of a drug rehabilitation clinic?"

"Yes—I wrote a book on that subject."

"You said alcoholism can be cured."

"I said it can be treated."

"How?"

"Treatments vary. If the cause is innately genetic, the ultimate cure has to be acceptance and abstinence."

"That's what you recommend?"

"Not necessarily. If the problem is psychological, then understanding and moderation can also work."

"*Understanding*—that's a cure?"

"When addicts truly understand the origins their predicaments, they can become capable of breaking free. At the very least, understanding can sugarcoat the otherwise bitter pill of abstinence."

"Does that apply to leaders, too?"

"Power can be as addictive as alcohol or sex. Given the pressure of any leader's role, it's not surprising that so many get high on a cocktail of all three."

"And you can help them get off?"

"Only if they listen. I've had some successes."

"One last question, Doctor. Where do you fit on the political spectrum?"

"I'm a pragmatist. Whatever works is fine with me."

My interrogator sprang to his feet. "Okay, Doctor. You believe in tough love. You're a savvy realist, not a starry-eyed bleeding heart." He glanced back at Cathy Vale. "We could even call him a compassionate conservative." They smiled. "So email Andy. Tell him we need clearance to brief the

doctor—but nothing else. Anything more will be Andy's decision. "

I had no idea what he was talking about.

We sat in silence as Cathy fiddled with the I-Phone.

"If we get clearance, many lives will depend on your professional skill," he said, turning his attention back to me.

"He's okayed the project"—Cathy Vale's cool voice was laced with adrenaline—"we can take it to the next level."

"Countless lives will turn upon your expertise, actually. This project could prove to be the jewel in your psychoanalytic crown." He smiled, amused at his metaphor. "But confidentiality must be inviolate."

"Lives are always in danger when a leader needs help, so I'm used to absolute confidentiality." I stared into his steely blue eyes. "That's why I've not bothered to ask you to disclose your name."

"You don't need to know it. Our research team said you weren't a quack or a charlatan. I just needed to confirm that you matched your profile and that you have the right values."

"What a relief to finally discover that I have the right values."

"Be careful how you dispense your sarcasm."

"Irony's not always sarcasm."

"I'm trying to help. Leaders can be very sensitive. Even failing to select the proper honorific can cause offense. I hope you can get your mind around the idea that any form of mockery could result in the kind of trouble you might never recover from. Do you understand?"

"Sure, your superiors place a premium on deference, just like just about every insecure leader I ever met . For what it might be worth, however, part of my success has been my ability to get beyond such defenses. But, sure"—I smiled—

"I'll take extra care. For which, by the way, will I be recompensed?"

"If you're the Pied Piper they say, we're hoping you can play the right tune and complete this assignment swiftly—as you did with Jack Quick." He tossed me an envelope. "So here's an upfront retainer. It's an all-cash premium to get started. As of now—and starting right now—we'll need you for a few days. If you succeed, there'll also be a bonus. A life-altering payoff. There's a credit card in there, too. Put your expenses—air travel, hotels, meals, whatever—on that." He glanced at his watch. "I have to go. Agent Vale will escort you to the Washington Shuttle and on to the next level."

Perhaps the limo ride back to my apartment went so quickly because I was facing Cathy. Nothing besides a gold college ring graced her fingers. I decided she was single. Perhaps she was one of those ambitious, intelligent women who frighten alpha males, and for whom passive creatures hold minimal interest.

"You won't need a suit," she said, eyeing the elegant prewar building that had been both home and office to me for so many years. "Jacket and gray slacks with business shirt and tie is the uniform they favor." Despite the professional air, she was warm and empathetic. "Anything else you need we can pick up in the hotel boutique."

I had planned a quiet week, a kind of mini-sabbatical, so it was easy for me to commit to this exhilarating assignment, which I also hoped would distract me from the inevitable waves of grief I continued to suffer, following my son's loss.

I'm so used to packing for semiformal weekends that getting my things together takes mere minutes. I use the

overnighter that Grace gave me. It holds everything and even has a pouch for my computer and trusty mini-printer.

As I opened my shirt drawer, I stopped to admire Grace's photo. She was smiling as winsomely as ever, and glancing back over her shoulder at me. Perhaps she was doing so now. I grabbed the picture. "Oh, Grace," I whispered, "what am I getting myself into?" She didn't answer. Well, maybe she did. Maybe that smile was saying, *Trust your judgment Mark—if you feel right about it, just do it.* But Grace was my true-believer, of course. I set the photo back on the dresser, my feelings decidedly mixed.

Cathy and I waited in a quiet corner of the VIP lounge. She peered over the top of a copy of *The Times* until the last of the bustling mix of executives and bureaucrats had boarded, then she folded the paper. "Time to go," she said. The doors were closing as we boarded. A respectful flight attendant directed us to the front row in the first-class section.

The in-flight coffee was freshly ground, the gold-rimmed cups real china. "So tell me about the next level," I asked.

" 'How poor they are that have no patience.' "

"You know you're quoting one of the great villains?"

She paused a moment. "Well, yes—Iago, right?"

"Right. I'm most fond of the next line actually."

" 'What wound did ever heal but by degrees?' "

"It's a popular quote in my profession. People mostly change slowly, but lightning can strike." She was beginning to relax. "So you studied literature, Agent Vale?"

She paused. "Call me Cathy, but only when we're alone. I did three majors: literature, politics, and psychology. Then a law degree."

"So you're an overachiever."

"I want to make a difference."

"You want to change the world?"

"Cynicism is the last refuge of the idealist, Doctor Alter."

"Call me Mark."

She smiled. "You earned the honorific, so I think I'll continue to call you Doctor. But, yes, I really do hope to help change things." She paused, wanting to say something but thinking better of it.

If only I'd shown such foresight.

04/30/07., P.M. —JEFFERSON HOTEL, WASHINGTON

THE LIMO DROPPED US AT THE JEFFERSON, where Cathy ushered me into an elevator that opened directly into a high-ceilinged suite. A faux oil portrait of an exceedingly handsome Thomas Jefferson hung over a marble mantel. I barely had time to admire the picture, however, before sensing, off to my right, the flesh and blood presence of an equally imposing, silver thatched man in a custom, navy blue suit. He was standing in front of a huge window, golden light streaming in from behind him. I caught a glimpse of the Washington Monument in the distance. He seemed almost to be floating on that edifice, actually. I don't know why—perhaps I was undergoing an exhilarating peak experience—but the whole scene was invested with a kind of mystical significance. It reminded me of that Salvador Dali painting of Christ pinned to a giant floating cross, and registered in my mind as one of those luminous never to be forgotten moments.

"Permit me to introduce Doctor Alter." Cathy's tone was deferential.

He stepped forward and looked me over. Then, satisfied he could trust me—how he reached that conclusion I have no

idea—reached out to shake my hand. "You come highly recommended, Doctor Alter." He smiled. "Call me Andy," he said, warmly. He nodded to Cathy, who slipped quietly from the room. Waiting until the door clicked shut behind her, he motioned me to sit in one of the reproduction Georgian chairs. He remained standing. "We have a problem, Doctor." He strode back to the window. "We need to be able to rely upon your professionalism—and, most crucially, your confidentiality."

"I subscribe to a formal code of ethics. It precludes my discussing a client problem."

"Of course. I just need to emphasize, however"—he strolled back into my space and stood over me—"that if word of this or any conversation ever gets out, well, that would be an unhappy day for"—he stared directly into my eyes— "everyone." If it was a threat, the tone at least was soft. Perhaps he was merely indicating the need for me to exercise extreme discretion. Or perhaps he was offering me a chance to back out of the project. Looking back, I should have done so.

"I have never betrayed a confidence."

"So we understand each other. He seated himself opposite me. "Here's the problem"—he paused to gather his thoughts—"like so many outstanding leaders, the president has always been his own man. He was, in fact, as a young man, something of a rebel. And, like so many young people from that era, he was sometimes a little wild. Sometimes he, uh, drank more than he should. His political opponents have often tried to exploit his youthful exuberances. It gets them nowhere, of course, for as I'm sure you know, he made a mature decision—which he calls a sacred promise—to give up alcohol."

I could see where this was going.

"Such promises can become impossible to keep."

He paused. "So it seems, Doctor."

"He's fallen off the wagon?"

"Kind of. Well, yes. It's not a problem. I mean it's not serious. Not yet. It's just that the stakes are incredibly high."

"How serious is it?"

"Serious enough to be taken seriously."

"Who knows about it?"

"Some people suspect, but the only ones who truly know are his wife, the vice-president, his key strategist, and me."

"What about the agents who brought me here?"

"Their only job was to find a discreet professional therapist. Agent Vale recommended you, so I guess she has an inkling of the core issue. Our other agents merely checked you out."

"So what do you want from me?"

"We need a cure."

"This latest lapse is only one of many?" He didn't respond. "And they're becoming more frequent?"

"Maybe."

"Relapse is the norm for recovering addicts. And as a world leader, he's under more stress than most alcoholics. Also, his political problems seem to be worsening by the day, so I'm assuming the temptation to drink is pretty constant."

"He struggles with it, yes."

"Is he getting professional counseling?"

"That's a delicate issue. It's no secret that he's a born again Christian. But he's not a man for introspection. He and Billy Graham talk one on one. The reverend has counseled him at length, and he also gets, uh, spiritual reinforcement from other pastors."

"But you think he needs something more?"

He took a deep breath. "Agent Vale says you specialize in counseling leaders, and that you can make a dramatic difference in double-quick time. Do I have that right?"

"I can't promise, but, yes, it's possible. How much time do we have?"

"Today is Monday. If you start seeing him tomorrow morning, could you change him by Wednesday?"

I couldn't believe my ears.

"*Wednesday*?"

"Well, uh, by Wednesday night actually."

I studied his face. Yes, he was serious.

"That is a *very* tall order."

"Are you saying it can't be done?"

"Not too long ago I'd have probably lectured you on the impossibility of working within such a time frame. Nowadays I see the wisdom in a remark of Frederich Nietzche—"

"The power crazed German philosopher who urged his followers to become supermen?"

"Sometimes it takes a crazy man to deliver a contrarian flash of insight."

"Such as?"

"He said, 'a thought, a line, even a word, can shatter and transform us.'"

"Sounds too good to be true."

"The trick is to prepare the mind before attempting to deliver the sundering words. So if you could help me get a process into play, and if the stars align in our favor, then I might just be able to deliver the concept possessing the power to fracture the president's mindset. And if that happens, then what you call a cure might just be possible."

Andy rose and stepped back to the window, gazed for a moment in the direction of the Washington Monument, then turned back to me.

"We need him sober long enough to end this terrible war."

"You do realize that you're effectively asking me to reconstruct his personality—and giving me less than three days to do it?"

"You're a leadership psychologist. We just want you to get his head clear and counsel him concerning his goals. That is what you *do*, right?"

Fools can ask questions that wise men cannot answer. But he wasn't a fool. And, sure, that is what I try to do. He just didn't understand the complexity of this particular task. So maybe nobody else did, either.

"Is this what everybody wants?" He didn't answer, so I followed up, "And, just how confidential is this assignment?"

"Not everybody wants to end the war. And, to be blunt, not everybody wants to recruit a shrink to mess with the president's thinking. I can't say exactly who does and who doesn't, so for the moment the only people you can trust are me and Agent Vale."

I sucked a lungful of air. "I understand what you want"— I glanced at my watch—"and I'll give it my best shot."

His professional mask slipped for one moment, and he pumped both fists.

"I can maybe speed the process," I continued, "by researching existing biographical material."

"We're ahead of you, Doctor." He strode to the door and cracked it open. "Hey, Cathy, we need you." She stepped back into the room. "Did you pull together that biodata?" he asked.

"Sure—I finished it late last night." She handed me a heavy manila envelope.

I weighed it in my hand. "Why do government documents routinely arrive in dull beige shrouds?"

"Because they're impenetrable"—she smiled enigmatically—"but what's inside this one might help you unlock a code or two."

"Thanks. I'll look it over and come up with some discussion readings."

"*Discussion readings*?" Andy was fretful. "They'd best be brief."

"They'll be pithy and profound. Can we get them to him before the first meeting?"

"Sure. Pithy? Well, if they're packaged right, he prides himself on his ability to juggle big ideas." He seemed momentarily doubtful, but then smiled. "So let's boogie, Doctor. Make this suite your home for the next few days. What sort of access will you need?"

"Several ninety-minute sessions at crucial times over a couple of days might work. Maybe I could see him tomorrow, as early as six A.M. or so. Then again in the afternoon. Then maybe for a third session before he turns in for the night."

"I'll level with you, Doctor. I'm chief of staff—gatekeeper, if you will—but the best I can hope for right now is to swing two sessions tomorrow; one early morning and one in the evening. "

"Fine. If I pitch it right, he'll want at least another couple of sessions on Wednesday."

"You seem very sure of yourself. Why do you think he'd rather talk to you than, say, a head of state?"

"Because I'll catch his interest. And because you'll arrange for only B-listers to be on his schedule."

"And do you have any suggestions as to what I might say to persuade him to see you at all?"

"Yes. Tell him I have specific research-based insights on how a leader under pressure can regain popularity and win elections in a time of war."

"He'll jump at that."

"I'll set a précis on paper for him to read in prior to our meeting. You can deliver it in one of my envelopes."

"You have personalized envelopes for precisely this purpose?"

"Plain white with my name discreetly engraved in the upper left corner; the medium is often the message so I like to get off to a professional start. Just deliver the envelope. If he doesn't want to see me, he can back out."

"When will you have the envelope ready?"

"Give me a couple of hours. Everything I need is in my laptop, and I'll drop a hard copy from my mini-printer. You'll just need to get it to him for the first session."

"Agent Vale will deliver it to me." He glanced at his watch. "He's in town for the next few days. His wife dashed off to the ranch."

"She's unhappy?"

"The pressure puts a real strain on the marriage."

"He was drinking today?"

"Not as far as I know. Not for a week or so, I think. But he can be moody. I arranged dinner for him with one of his spiritual advisors. There'll be no alcohol served and he likes to turn in early, so with any luck he won't be imbibing tonight. He's an early riser, so a six o'clock meeting is possible, in which case you'll catch him with a clear head."

"Great. I'll need to look over Agent Vale's material and pick out a couple of ideas to catch our leader's attention."

RAW INTELLIGENCE PAPERS

WAS THOMAS JEFFERSON REALLY AS HANDSOME as the portrait above the marble mantel made him seem? Were the eyes so piercing, was the jaw so square, the nose so noble, the silver mane so flowing? Probably not. And let's be honest, he kept slaves and fathered a child by at least one of them, too. No, I harbor no illusions concerning the secret frailties of the imperious paladins who seek to scale the greasy public pole; leaders' weaknesses are typically as monumental as their strengths. Perhaps I should have been daunted by my own audacity. Perhaps I should have been afraid and fretful that I had so casually agreed to attempt transform the dipsomaniac leader of the free world within some forty-eight hours. Instead, however, I became lost in thought as I sought to create a blueprint to effect that metamorphosis.

When I looked up next, dusk was giving way to darkness, and the tall window was reflecting, from the opposite wall, the ghostly image of Jefferson's portrait. The ambience in the beautifully proportioned room was mystical, almost like that of being in church. I took ice and tonic water from the mini-bar and poured it into a tall glass, then slipped into the chair at the Georgian desk, an antique so elegant that it could have been an altar. I took a sip, then set the misting crystal on a monogrammed Jefferson coaster and opened Cathy's manila file. First there was a note written with a blue felt-tip pen on a five-by-three white card:

> *The bio on "W" is in the public record and pretty reliable as far as it goes. The bio on his father is the official White House version. I picked up all the other material from sundry sources. To the best of my knowledge, it is all accurate.*

Her neat, upward sloping handwriting bespoke much confidence, perhaps even passion. Using my red ink biro to single out clues to a pattern, I underlined highlights from the official White House handout on the president's father:

BUSH I

- <u>Ran unsuccessfully for the Senate twice</u>. Lost his 1980 campaign for the Republican nomination for President but was chosen as a running mate by Ronald Reagan.

- Won the nomination and the presidency eight years later, and brought to the White House a dedication to traditional American values and a determination to direct them toward making the United States "<u>a kinder and gentler nation</u>." In his Inaugural Address he pledged in "a moment rich with promise" to use American strength as "a force for good."

- His <u>greatest test</u> came when Iraqi President <u>Saddam Hussein</u> invaded Kuwait, then threatened to move into Saudi Arabia. Vowing to free Kuwait, Bush rallied the United Nations, the U. S. people, and Congress and sent 425,000 American troops. They were joined by 118,000 troops from allied nations. After weeks of air and missile bombardment, the 100-hour land battle dubbed Desert Storm routed Iraq's million-man army.

- Despite unprecedented popularity from this military and diplomatic triumph, Bush was unable to withstand discontent at home from a faltering economy, rising violence in inner cities, and continuing high deficit spending. In 1992 he <u>lost his bid for reelection</u> to Democrat William Clinton.

I wondered whether that drive to build a "kinder, gentler nation" suggested the kind of "nice guy" personality that wins appointments but loses elections. Understandably, perhaps, there was no mention of his decision to leave Saddam in power. Hoping to compare their records, I scanned the unvarnished Wikipedia bio of the son:

BUSH II

Born in New Haven, Connecticut, on July 6, 1946, Bush II was the <u>first child</u> of George H. W. Bush and Barbara Bush. Bush was raised in Midland and Houston, Texas, with his four siblings, Jeb, Neil, Marvin, and Dorothy. Another <u>younger sister, Robin, died in 1953 at the age of three from leukemia.</u>

Texas Gubernatorial and Governorship

In his candidacy for the 1994 Texas gubernatorial election, Bush II faced incumbent Governor Ann Richards, a popular Democrat who was considered the favorite. The Bush II campaign was criticized for allegedly using <u>controversial methods to disparage Richards</u>. Bush II's <u>popularity grew,</u> however, and he won with 52 percent against Richards's 47 percent.

Unlike his father, he was a come-from-behind winner.

As governor, he <u>executed a record 152 prisoners</u>.

And, unlike his father, he seemed pitiless in his use of power.

He proclaimed June 10 to be <u>Jesus Day</u> in Texas, a day when he "urged all Texans to answer the call to serve those in need."

He seemed anxious to win salvation in the next world, so perhaps his religious convictions were genuine.

In 1998, he won reelection in a landslide <u>victory</u> with nearly 69 percent of the vote.

He had clearly tapped into a rich vein in Texas. But could he do it again as a United States president?

U.S. Presidency
2000 Candidacy and Presidency

• During the election cycle, he labeled himself a "compassionate conservative" and promised to "restore

honor and dignity to the White House," a reference to the scandals of his predecessor. In the televised Republican presidential debate on December 13, 1999, Bush II cited Jesus Christ as the major influence in his life, "because he changed my heart."

• He won the 2000 General Elections in a heated victory, but the <u>outcome was tied up</u> in courts for a month until the <u>U.S. Supreme Court stepped in</u>. Bush II received 271 electoral votes to Gore's 266, but lost the popular vote by more than half a million votes, making Bush II the <u>first president elected without at least a plurality of the popular vote since Benjamin Harrison in 1888.</u>

A come-from-behind candidate who then demonstrated, doubtless with the help of his father and cronies, an ability to do whatever it took to win the tightest of all possible elections.

As president, Bush II commanded broad support in the Republican Party and did not encounter a primary challenge. He outlined an agenda that included a <u>strong commitment to the wars in Iraq and Afghanistan</u>, a renewal of the USA <u>PATRIOT Act,</u> decisions to make earlier <u>tax cuts permanent</u>, to cut the budget deficit in half, to promote education, as well as reform in tort law, to reform Social Security, and to create an ownership society.

And, once again, ruthless in pursuit of his (imagined?) enemies.

2004 Candidacy and Presidency

• In the 2004 elections the Bush II campaign <u>portrayed Bush's opponent, decorated war hero Massachusetts Senator John Kerry,</u> as an <u>indecisive</u> individual who lacked the vision necessary for success in the war on terrorism.

• A political group of American Swift Boat veterans and former prisoners of war of the Vietnam War formed during the campaign—some say with strong support from the Bush campaign—to challenge the legitimacy of Kerry's combat medals and to assert that Kerry was "<u>unfit to serve</u>" as

president based upon his alleged "willful distortion of the conduct" of American servicemen during that war. After the election, the group was credited as an example of a successful political smear campaign.

• Bush II carried 31 of 50 states for a total of 286 Electoral College votes. He also won an outright majority of the popular vote, the first president to do so since his father in 1988.

• Bush II began his 2004 presidency with approval ratings near 50%, which rose to 80-90% during the four months following the September 11, 2001 attacks on the World Trade Center.

It seemed a similar pattern to his term as governor of Texas.

• His approval ratings have since steadily dropped as he received heavy criticism for his handling of the Iraq War, his response to Hurricane Katrina, his mixed positions on LGBT rights, and his response to the Abu Ghraib torture and prisoner abuse, his stand on NSA warrantless surveillance, and his stand on the Guantanamo Bay Detention Camp controversies.

• In 2006, a majority of respondents in 18 of 21 countries surveyed around the world were found to hold an unfavorable opinion of Bush II. A March 2007 survey of Arab opinion conducted by Zogby International and the University of Maryland found that George W. Bush was the most disliked leader in the Arab world. In a *Newsweek* poll of June 21, 2007, Bush II received an approval rating of 26%, second only to Richard Nixon's record low seven months before he resigned from office.

• Calls for the impeachment of Bush II have been made by various groups and individuals, with their reasons usually centering on the NSA warrantless surveillance controversy, the Bush II administration's justification for the war in Iraq, and the violations of the Geneva Conventions.

So, that was the formal public domain material. It was, for sure, a richer vein than I'd anticipated. I skipped ahead and scanned the more intimate fruits of Cathy's research. It was, as you can imagine, even more revealing. There was much to ruminate upon. Handled tactfully, however, I had already distilled enough information to get the recovering wayward son talking. I switched on my laptop, compiled three sets of readings for the first three sessions, then watched the mini-printer spit out the documents. As I finished, there came a knock on my door. I opened it and caught a faint whiff of perfume. It was Agent Vale, Cathy, now in a modest black dress—and with refreshed lipstick, too. She stepped inside, still looking every inch the professional.

"You have the president's homework, Doctor?"

"Sure," I said. "Here it is, hot from the printer." I gathered the first set of readings, folded them neatly, slipped it into one of my envelopes and passed it to her outstretched hand.

Our fingers touched. Her skin was supple. As I looked away, I caught her softly lit profile in the gold-framed mirror.

She strolled to the fake fireplace and propped herself against the gray marble mantel and lowered her voice. "This is an important assignment, Doctor—you know that, right?"

"I do, of course. What I don't know is why there's such incredible urgency to complete it by Wednesday night."

"Maybe you'll find out later." She obviously knew more than she was saying. "Right now, what I can't quite figure out is why you put so much faith in his ability to read a few pieces of paper."

"They're the innards of a missile."

"A booby trap?"

"More like a grenade, actually."

She smiled. "You worry me, Doctor." She folded the flap into the envelope. "This'll get to him within the hour. Andy scheduled your first session for six A.M. You'll have exactly sixty minutes. He also worked some magic to get you another hour tomorrow night at eight o'clock. He turns in soon after nine, so—"

"The seeds of big ideas will flourish overnight."

"They'll germinate and start reaching for the sky—like those magic beans in Jack and the Beanstalk?"

"Right—the sky and the ogre who lived there—that's quite a parable."

"You're welcome," she said, handing me a card. It bore a ten-digit number, nothing more. "It's my cell phone number. You can reach me on it any time." She strode to the door, then turned back into the room. "I'll bring a coffee and bagel and pick you up here at five-thirty."

I waited till she left, then pulled out my wallet and flipped it open to Grace's photo. I put this particular picture there the day of her funeral. I'd taken it, just like the other one, so I wasn't in the frame, yet whenever I studied it I sensed myself behind the camera. Right now, however, it seemed as if our places had switched. Grace wasn't in the picture of my daily life, yet her spirit seemed palpable. Oh, sure, I know, yes of course I do, that Grace's presence existed only in my head and heart. But the feeling was comforting, just the same.

I turned in right away, but sleep was slow in coming. I thought about other cocky chieftains I'd tried to help. One would have to be obsessed to want their kind of responsibility. Then, of course, the pomp and pageantry of their positions, not to mention the power and incessant fawning of self-serving supplicants, would cloud anyone's judgment and eventually separate just about any mere mortal from reality.

One way or another we're all neurotic. So the real question is whether we have our complexes or whether they have us. And, even if those demons have seized control, might it be unwise—depressing and dangerous, even—to cast them out? What about the idea behind that line from the poet Rilke; "If my devils leave, I fear my angels will take flight, too." So far, my tea leaves had suggested that the current leader of the free world was imprisoned by that same fear. And, anyway, even if his demons were successfully exorcized, might some other devil rush back in where angels feared to tread? But my job was merely to meet the Wednesday evening deadline, so this was not the time to fret about the future. I finally drifted to sleep, but suffered another disturbing dream:

> *I found myself sitting in a wheelchair at Ethan's open graveside. The overhead sun glistened off his deep mahogany coffin. It shimmered so brightly that the lid seemed almost to be moving. Indeed it was moving. Fingers from within the coffin were clutching both sides of the top. Then Ethan arose from the coffin and stood before me wearing a khaki army-issue windbreaker emblazoned with the presidential seal. He was grinning and carrying a revolver in one hand and a stopwatch in the other. I knew the expression on his face and studied his pupils closely. They were pinpoint sharp. He was high on heroin. He pushed the face of the stopwatch toward me and depressed the button with his thumb. Then, as the seconds began to tick down, he raised the gun to his head, and whispered a rhythmic recitation:*

> > *Gonna go now, Dad, gonna ride,*
> > *gonna glide back quick*
> > *to the other side*

> *I reached out to stop him, but both my arms had been amputated at the elbow. I cried out for help but no sound came. He cocked the revolver and prepared to squeeze the trigger—*

TUES., 05/01/07., 5:33 A.M. — LIMOUSINE

THE DASHBOARD CLOCK PUT THE TIME AT exactly 5:33 A.M., and Cathy, sitting opposite me, was strangely silent as the limo coasted smoothly down the broad avenues. As I finished the bagel, she spoke up. "Listen, Doctor"—she glanced back over her head through the thick pane of Perspex to the driver; she must have decided that he was lost in his own soundless bubble and could hear nothing—"I'm the person who read about what you did with Jack Quick. I'm the person who checked you out before going out on a long, long limb to recommend you to the one decent man capable of enlisting you for this assignment. Getting anyone to even consider this project has been a battle. And bringing you into this has taken every political skill I ever learned. So I think you owe me something."

"And that is?"

"You became cynical when I said I wanted to make a difference. But I do. And, now, right now, you and I have a once in a lifetime chance to change the world. Look, I know it was all meant to be confidential, but I thought it would be helpful for me to read the material you intend to discuss with the president, so I hope you don't mind that I did." She took a deep breath. "You don't really intend to talk him through that stuff, do you? Your job, remember, is to make a difference."

"My charter, as I recall, is to help him stay on the wagon."

"Oh, for goodness sake, Doctor, you know as well as I that drinking's a symptom, not a problem. But even if it were, how in the name of all that's right and decent do you hope to achieve anything—anything!—with those crazy discussion papers? I'm even more worried than I was before. I'm scared you're going to screw up this whole assignment. From what I

read, you don't even seem to be trying to get him to address the alcohol issue. But even if by some miracle you do, it'll come at the cost of reinforcing his darker angels—then one or two devils in this administration will be confirmed in the belief that they're entitled to continue to flout the Constitution along with the Geneva Conventions—and only God knows what else."

"I thought you were a loyal aide."

"I am, but my first loyalty is to the Constitution."

"And you don't trust me, either?"

"You worry me."

"Don't fret. The truth's like the sun. We can't stare directly into it. Leading a person to the light takes subtlety."

We were now at the White House checkpoint. The guard recognized Cathy, and she returned his smile as she showed him an official-looking badge. "This is Doctor Alter," she said, indicating me and she waving a piece of paper. "Here's his security clearance."

The guard studied it briefly, punched a keyboard, glanced at an LCD screen, then back to me. "Into the lion's den, eh?"

The limo pulled up to the heavy timber-and-glass paneled entrance, and we stepped out. An attendant cracked the door. Cathy flashed our credentials again and glanced back at me. "I'll wait in the car," she said as she stepped close and held my gaze with her azure eyes. "Go to it, Doc," she murmured, "Change the world."

Were there really supernatural forces in the universe capable of sending a messenger to help a struggling United States president? Given his born-again beliefs, this particular chief might answer yes. I was not so certain.

Looking back, I was right to be worried.

My mistake, however, was not being nervous enough.

05/01/07, A.M. — OVAL OFFICE SESSION.

"Well, an esteemed, honest-to-god, Doctor of Leadership—Wow!" He surged from his private study door into the Oval Office with as much warmth as that cast by the sunlight from the four eighteen-foot, floor-to-ceiling windows. A navy suit jacket was draped across his arm and his crisp white shirt perfectly hugged his sturdy back and shoulders.

I'd been ushered into the Oval only a minute earlier, and he was exactly on time, which, despite the sardonic greeting, I took as a good omen. The oval rug on the polished walnut floor was soft beneath my feet. Shafts of gold, woven into the fabric, radiated outward like sunbeams from the circle of stars that surrounded the eagle on the vivid presidential seal, nicely offset toward the presidential desk, behind which the windows framed a dewy lawn.

He dropped his jacket onto a sofa arm, then shook my hand and draped his left arm around my shoulders. The discussion papers I'd prepared dangled from his stumpy fingers. "I've always wanted to meet a doctor of leadership." Removing his arm from my shoulders, he tilted his close-cropped pelt of patrician gray hair backward and looked me over. "Should I call you Doc?" He grinned and flexed his thick shoulders. "Or maybe you'd prefer to be called the, uh, Alter-Nator—I mean you're here to share some erri-oooh-dite ideas, I'm told." He grinned broadly as he mockingly drawled the word *erudite*. "Big ideas that might just alter my thinking, right? I mean that's the reason you sent me all this homework, right?" He tossed the papers onto the mahogany coffee table and indicated that I was to sit on one of the two elegant beige wool sofas that faced each other across a mahogany coffee table. "Have a seat," he said, plonking himself down. "Make yourself at home, Alternator, 'cause I'm gonna do the same."

He rested the heels of his black ostrich-skin cowboy boots beside the silver coffee tray and cluster of sweet-smelling pink roses that graced the mahogany coffee table. "Can I offer you a coffee?" I nodded yes, and he smiled. "Gets you going in the morning, right—you take it black?" He poured two cups. "I like a little cream myself, sugar too."

We raised the cups and he smiled across his steaming brew, then sucked a manly gulp. "A *leadership guru*"—he winked—"heady stuff, right." He leaned forward. "Well, I agreed to see you because I'm highly experienced in picking the brains of high class advisors and, as you'll see, I'm great at getting to the heart of things and spotting big ideas. But first, let me share one little insight of my own, Doc." His eyes were set too close, but a superior cosmetic surgeon had surely tinkered with other aspects of his face. His nose was chiseled and the modest creases in his countenance conveyed the enviable patrician quality that denotes success. He smiled— or was it a smirk? "You can't learn to be leader by reading books. Well, not me, anyway. I'm a decider and a doer. And the kinds of things that come in most books are worth about as much as—what'd that guy say?—a pitcher of cold spit."

He grabbed the readings from the coffee table, and gave them a cursory glance. "I agreed to see you because I liked your philosophy. This is a *fine* set of big ideas. You're hardnosed and practical." He set his feet on the floor and leaned toward me. "But, not to be disrespectful, you just don't seem to have written anything I hadn't already figured out—and put into practice, too." He tossed the readings back onto the coffee table. "So I'm not totally sure where all this is going. I mean you might be a nice guy, but I have a hunch that your, uh, alternating, might just turn out to be, uh"—he grinned, knowing what he was about to say, I think—"supereffluent."

I gathered up the discussion papers. "One core skill of a great leader, which I'm told you possess in abundance, Mister President, is the knack of listening to and sizing up people. From what you've just said, I gather that you also process your information intuitively, which is also the mark of a great leader." I had his attention. "But if you'd indulge me, just to be sure we're singing from the same hymn book, I'd like to read that first leadership recommendation in its entirety."

He grinned. "I doubt it'll alter my thinking, Mr. Alternator, but give it your best shot." He settled back in his chair as I proceeded to read:

> *On winning elections.* In making political promotions never weigh or ponder the rights of different people. Serve your own ends unflinchingly. Never attempt to objectively examine truth, especially insofar as it favors competitors. Address promotions and advertising exclusively to the general public. Do it skillfully so as to convince everyone that your facts are real, your processes necessary, your goals correct. Aim for the emotions and adjust the intellectual level to the most limited intelligence.

He chortled. "You'd better not let "Turd-Blossom" find out you've been peeking into his playbook, Mister Alternator."

Turd Blossom—what a scathing nickname for Karl Rove, the close personal advisor whom Time magazine dubbed 'Bush's Brain'.

"But let me tell you something you mightn't know. I've never feared losing and I never ran a race I thought I wouldn't win. An election tests your will. You discover whether you're a fighter prepared to do whatever it takes to prevail."

I pressed on:

> In promoting perseverance in a war, you must influence the entire nation. Minimize intellectual content and maximize the focus on the emotions of the public at large.

> Don't make your promotions many-sided or logical. The
> receptivity of the public is limited, their intelligence is small,
> and their memories are weak. So limit the message to a
> very few points, create memorable slogans and harp on
> until the last member of the public gets the message.

He jumped to his feet. "You got *that* right, Mister
Alternator. And that's *exactly* the kind of argument we're using
in Iraq. He clenched both fists as if about to engage in a fight,
but then struck an oratorical pose and delivered a line as if to
an imaginary audience: "We gotta fight 'em over there, or they'll
chase us home and we'll have to fight them here." He glanced
at me and grinned. "People love that line." He dropped back
onto the sofa.

Then, as if I were an important television interviewer,
he leaned forward to command my attention. "*That's* why we
can't cut and run, Doc. Defeat in Iraq will embolden the enemy.
It'll give them more opportunity to plan an attack on us—and
to train. Radicals will topple moderate governments. *That's* why
the war in Iraq is vital to victory in the war on terror." He
struck a buddy tone. "But one of the hardest parts of my job
is to help the American people see the connection. They got
to realize that this is the ideological struggle of the twenty-
first century. Look, my biggest fear is that somebody will slip
into this country and kill Americans again. And no one can
say exactly how they'll do it." He paused. "Well, you're the
smart one, Doc. Maybe you can figure it out."

I pressed on:

> If you sacrifice simplicity and try to be many-sided, the
> effect will dribble away. Stick to the one-dimensional. Most
> crucially, confine your message to a few points and repeat
> them over and over. The public is slow to move and it
> always takes time to gain attention. But the way to do it is
> to repeat the simplest ideas thousands of times. Steady,

consistent emphasis leads to results that are almost beyond our understanding.

He sprang to his feet again. "And that's exactly the scenario that's gonna play out, Doc. Harry Truman cracked defeat in the jaws of victory, and I will, too." He began to pace the floor.

"You may well be right, Mister President. So let's give a little more thought to the question of tough enemies and tough tactics."

When nations fight for existence—when the question of destiny, "to be or not to be," cries out for a solution—then all considerations of humanitarianism or aesthetics crumble into nothingness. In war, the most aggressive fighting technique is the most humane. But when people approach these questions with bleeding hearts, only one answer is possible: where the destiny and existence of a people are at stake, the only admirable methods are those that safeguard freedom. If they effect a quicker victory, the cruelest methods are in fact the most humane—

He glared at me, excitedly. "Yes, Doc, yes! People need to understand that we gotta be, uh, robust. We're hunting down terrorists, for God's sake! And we're bringing them to justice. So tough love's the only way to go." He raised his fist as if in a gesture of brotherhood. "Dick and Rummy see it. Turd Blossom knows it. Condi gets it. Why can't everybody?" He paused defiantly, then dropped his voice. "Because they're not leaders, that's why."

"Would you mind if I asked a question, Mister President?" He nodded. "When did you first realize you were a leader?"

He gazed pensively upward. I followed his eyes to the embossed white-plaster eagle in the center of the ceiling. "If you're searching for an exact moment when I became a leader, well, I don't know." He dropped his eyes back to mine. "Look,

I don't even know how you learn leadership. I can tell you—that, I, uh, that you either know how to do it or you don't—and that it was always in my heart. But I do know a leader's got to think big. And I know how you learn to *decide* things. It happens when you make up your mind—and *stick* to it."

"So you're never torn by doubt?"

"Never! And I'll tell you why—I ran for president for the same reason I'm fighting this war in Iraq—because I have *principles*. I stand by them now and I always will. I share the same moral position as this man." He strode to the portrait of Abraham Lincoln. "I'm fighting the same fight he fought." He addressed Lincoln's impassive face. "He believed in God. He also believed that God created all men equal. Equality! It goes hand in hand with democracy." He turned and spoke directly to me. "And that's what *I'm* fighting for."

"So I guess you never worry that maybe the price—in terms of blood and treasure—might be too high?"

"Never. It's nothing compared to the prospect of the enemy winning and taking us back into the Dark Ages. Sure, the world looks at me and wants to know whether I've got the resolution to spend whatever it takes to see this through. Well, I know it's vital to succeed. And that I do have the resolution. Look, I won't lie to you, being president is tough. This is a trying period we're in now. Iraq is always on my mind and I struggle with the question of casualties—I get the reports. But—it's *war*. Don't get me wrong. It's a commander-in-chief's duty to visit the wounded and share the pain of decisions that didn't go right. It's hard to see the injuries, loss of limbs and head wounds, and all of that. It's not always, uh, congenial, and sometimes there are disagreements. But most of the parents look at their president—me—and say, 'My son did what he wanted.'" He pointed both index fingers to his chest.

"I take comfort in that. I go to them as a healer, yet, you know, it's a curious thing, *I'm* the one who gets healed."

"Some politicians say that the wounded they meet tell them, 'Get out now.' Well, they never say that to me. Oh, a couple of wives might have said, 'It's not worth it, so bring them home now.' And, sure, others say, 'Get them home as soon as you can, Mister President'—but then they add, 'My kid volunteered and is proud of what we're doing.' So I keep my spirits up. Exercise helps and so does prayer. And I'm sustained by the discipline of the faithful experience."

"Sounds inspiring, Mister President."

"Well, thanks, Doc. And remember this: when you're putting a kid in harm's way, he'd better know you're acting on principle. If he thinks you're making a decision based on polls, you're letting him down and creating conditions for doubt. You can't give a kid a gun and have him second-guess your motives. He's gotta believe you're doing what's right—and that you're gonna support him all the way to victory."

He slipped back onto the sofa. "So now we're gonna talk about interrogations?" I nodded and brought the discussion paper into focus. "Well, I gotta say this idea struck me as a biggie, too. Just a pity Tony Blair's not here to share it."

Again, I read aloud:

METHODS OF EXAMINATION
*New Enhanced Interrogation Regulations
for Extreme Cases. Effective 12 June 1942.*

Sir Henry Miller, Chief of Her Majesty's Secret Service

Enhanced interrogation may only be applied if, on the strength of the preliminary interrogation, it has been ascertained that the prisoner can give information about important facts, connections, or plans hostile to the country or the legal system, but does not want to reveal his

knowledge, and the latter cannot be obtained by way of inquiries. Under this circumstance, the enhanced interrogation may be applied only against extremists, terrorists, saboteurs, insurgents, sociopaths, or non-cooperating aliens.

"Right, Doc! And that's the reason we need Guantanamo. We put those sadistic fuckers there—pardon my French—precisely because we're the good guys. We'll put the terrorists through a military tribunal so they get the justice they've denied other people." He jumped back to his feet and began to pace the room. "And that's why we need the tools to interrogate them. See we're *not* interrogating right now, and that's a big mistake.

"The problem is that CIA officials feel like the rules are so vague that they can't interrogate without being tried as war criminals. And that's irresponsible. So we're working with Congress to make sure it's possible to do our job going forward. Not torture—we'd never do that. We got to stay within the law, but we need to legalize smart things like enhanced interrogation. The terrorists got information and we've gotta be able to get it." He had halted on the embroidered American eagle within the presidential seal. He stood on the Eagle's eye, patted his groin, jutted his head into my face, and held my gaze earnestly. "So do we cower in the face of terror—or do we lead?" He winked. "*You* know the answer, right Doc?" Again he settled back into his sofa. "So share a little more of your wisdom with me, Doc." I pressed on:

Enhanced interrogation may not be applied in order to induce confessions about a prisoner's own criminal acts. Nor may this means be applied toward persons who have been temporarily delivered by justice for the purpose of further investigation. Exceptions may require my personal

permission. The enhancement can consist of the following, among other things, according to circumstances: simplest rations (bread and water), hard bed, dark cell, deprivation of sleep, and exhaustion exercises. It is also permissible to resort to blows with a stick, but in the case of more than 20 blows, a doctor must be present.

"No wonder they knighted that crafty bastard. Those slippery Brits have been way, way ahead of us for years. Aristocrats like him are total sophisticates. See, when push comes to shove, the smart move is to define what needs to be done as enhanced interrogation. Then it's all legal." He propped one heel back on the coffee table. "The dirty little secret as far as this kind of interrogation goes is that it's only recently that we've begun to catch up with other countries. But look, Doc, this thing ain't over."

He dropped the boot back onto the floor, then rose and strode toward the antique credenza along the east wall. He picked up a small bronze bust of his father. It glowed as he turned it in his hands. Then he set it back and pointed to the gold-framed oil canvas above it. "That painting was inspired by a hymn, 'A Charge to Keep I Have.' It's about serving the Almighty. It speaks to me personally. I love it. See, it's a horseman charging up a cliff. He's a determined horseman and it's a punishing trail. The man's on a mission, see. There are at least two people behind him, maybe even a thousand. He's a leader who wants to serve something greater than himself"—he stepped back, turned around, and held out both hands, palms upward, toward me—"and so do I. So we're gonna go on fighting in Iraq, okay? And we're gonna win. We're gonnna do it because that's *my* charge to keep. I can't let polls tell me what to think. You have to *believe*. And that you

can't fake. And I truly do believe. I am convinced in my soul—no, I *know*—that we will succeed."

I absorbed the passion of his words, wondering if this might be a good moment to challenge him. "But might there be value, at this point," I spoke very softly, "in examining that belief?" He stopped dead. Perhaps no one had ever suggested that he separate belief from knowledge. "I say that, Mister President, because sometimes honest convictions can be more dangerous enemies of truth than lies."

He stared at me, somewhat in surprise, startled, even. "I don't have the luxury of second-guessing myself, Doc." He glanced over his shoulder then back at me. "Part of being a leader is knowing that *people watch you all the time*. The enemy is watching me—and the troops are watching me—and the people are watching me. So, what do you think would happen if"—he struck a groveling pose—"I wandered around with my head down and my tail between my legs, and got up and said, 'Well, maybe it's not worth it'?" He straightened himself and puffed out his chest. "No! People read your body language, so I never let them get even the slightest whiff of defeat when I walk outside. I march into that hall"—he raised and pumped a fist—"and I *inspire* those commanders." He paused, relaxed, and opened his palms, Jesus-like. "So, about this homework of yours, Doc," he said, "how'm I doing?"

The question took me by surprise. "I'd say we're on track, Mister President," I replied. "I knew you'd be on top of the leadership material, of course—but what did you make of the poems?"

He eased himself back onto the couch. "Well, in my job, nuance is a luxury. I need the plain and simple facts. And I need them fast. So my gut reaction was that this stuff is a perfect example of"—he shot me a semi-smirk—"the kinds

of mindless, ivory-tower mind-games you intellectuals love to play."

"And you might well be right, Mister President." He seemed relieved by this admission. "But if you don't mind humoring me, and since both poems are real short, let's consider them for a minute or so." He seemed intrigued and nodded, so I pressed ahead. "The first one is by the American writer, Stephen Crane. He was only twenty-eight when he died, seriously underestimated by many critics. Nowadays, however, everybody knows he was a brilliant man ahead of his time. So listen carefully now."

He took my cue, and leaned back and closed his eyes.

> *The wayfarer,*
> *Perceiving the pathway to truth,*
> *Was struck with astonishment.*
> *It was thickly grown with weeds.*
> *"Ha," he said,*
> *"I see that no one has passed here*
> *In a long time."*

"I get that part, Doc. You're suggesting *I'm* the wayfarer, right? You're saying I'm the one who's astonished how people's minds are full of weeds. I mean, isn't it all about what I just said about me having to connect the dots so that the American people can cotton to the connection between Iraq and terrorism?"

"That's one way of seeing it, Mister President, but what about these last four lines?

> *Later he saw that each weed*
> *Was a singular knife.*
> *"Well," he mumbled at last,*
> *Doubtless there are other roads."*

"Maybe he meant, uh, maybe … Well … I dunno. You got me, Doc—what *did* he mean?"

"It's a poem open to several interpretations—"

He jumped in triumphantly, "So *you* don't know for sure, either, do you?"

I ignored the putdown and softened my voice. "Do you think he might be saying that sometimes what we most need to know is hidden by a pathway of dangerous weeds—"

"So we give up and try to find some other way?"

"Exactly." I smiled approvingly. "Perhaps we run away from the unpalatable truth that we need to explore. It's an all too human failing."

"You're not trying to say that *I* hide from the truth?" I chose not to answer, and he ran on agitatedly, "Listen, I'm just about the only guy in America who's actually *facing* the truth—and it's hurting me *plenty*!"

Again I let him simmer. But it was time for me to come clean.

"I have a confession to make, Mister President."

"A confession"—he blinked twice, cocked his head sideways, then broke into a grin—"never heard of a doctor who wanted to make a confession, not in the Oval, anyway. So this'll be historic, Mister Alternator. Fire away."

I rose to my feet and looked down at him. "I'm not the author of the first of those readings"—I paused for several seconds to let that sink in—"and Sir Henry Miller isn't the name of the man who wrote the second one, either."

He leaned back, then propped his heels up on the coffee table again. "You don't say—"his eyes narrowed—"so you set out to *trick* me?"

"I just wanted to catch your attention."

"Well, you got it." He glanced at his watch. "And time's running short."

"Here's my confession, Mister President: I never wrote one word of the leadership material you ascribed to me—I merely copied it—from Adolf Hitler's autobiography, *Mein Kampf.*" He stared at me blankly. I had no idea what he might be thinking, but I pressed on anyway. "And the monster who created that directive on so-called enhanced interrogation was actually Hitler's Gestapo Chief, Heinrich Muller."

He eyed me quizzically. When the reply came his voice was perfectly even. "So are *you* actually trying to compare *me* to Adolf Hitler?" He paused. "And are you really comparing anyone in my administration to a Gestapo chief?"

His whole demeanor told me that he had truly listened. And attempted to process the information. And, clearly, was confused.

"I would never say that, Mister President."

He gazed vacantly over my shoulder. "I read the newspapers. I know that some people say that our policies are wrong." His voice had dropped to a near whisper. "They even say that I personally condone torture. But I have a good heart." He gazed directly into my eyes. "You can see that, right, Doc?" I nodded empathetically. "Of course you can, but a leader has to lead. Good and decent people—people just like me and you—sometimes have to do things that seem bad—cruel even, maybe. You're a shrink, so you know just from talking to me that I'm not a sadist." He paused. "I mean, there's absolutely no reason for me to do anything except the right and decent thing for everyone." It was a question as much as a statement.

"And yet, Mister President, mere moments ago you warmly approved of the methods of Hitler and his Gestapo thugs—even though your head now tells you—and your heart

agrees—that these people were rotten to the core and sadistic beyond belief. So I'm wondering, how do you reconcile all that?"

His face reddened and he sprang to his feet. "Because we're in a new world." He was in my face. "In case you hadn't noticed everything changed on 9/11. Nobody in history—not Hitler, not anybody—ever had to deal with crazy Muslim extremists. And they're out there running around with dirty bombs. Dirty-fucking-bombs—you know what that means right? Well, let me tell, you, it means that to protect this country we got to be right one hundred percent of the time, and they only got to be right once." He recovered his composure and dropped his voice. "*That's* why we need enhanced interrogation—right?"

He ended that final sentence with a question. And he didn't seem quite so certain of the answer, either. Something had changed.

"You make a really strong point, Mister President, and the best possible argument for torture."

"We *don't* torture, everything's within the law"—he glanced at the floor—"and I got a good heart."

"The Justice Department says that torture stops short of organ failure—so I guess you're right. But, I'm kind of wondering … whether you think … that Jesus would favor waterboarding—"

"I can't talk about techniques—"

"And what kinds of 'stress positions' you think he might advocate—"

"Look—it's all within the law! And these are *bad guys*. As protector of the people, I have no choice." He dropped back onto the couch. "You think I've got some other secret reason?"

There was a touch of sarcasm in his voice. And yet, and yet—was he also begging for a response?

"Maybe this is one of those weeds that turns to a knife, Mister President. Maybe you'd rather go searching for some other nonexistent pathway to truth." He blanched. "Or maybe, you'd like to explore the idea that sometimes the heart has reasons that the conscious mind knows nothing of."

He clasped his hands together, raised them to his chin and closed his eyes. I had reached him. I was certain of it.

"So what about that last poem?" he asked softly.

"It's by an Indian mystic, by the name of Tagore. He called it 'The Little Self.'" I picked it up and began to read:

> *I came out alone on my way to my tryst.*
> *But who is this beside me in the dark?*
> *I move aside to avoid his presence*
> *but I escape him not.*
> *He makes the dust rise from the earth*
> *with his swagger;*
> *He adds his loud voice to every word I utter.*
> *He is my own little self, my lord,*
> *he knows no shame;*
> *But I am ashamed to come to thy door*
> *in his company.*

He sat quietly, his eyes still closed, for maybe a minute. Then he looked directly at me. "Who's this little self, Doc?"

I paused. "That's quite a question, don't you think? Again, it's just a poem, so we can interpret it any way we want. But let me give it a shot. Maybe the poet hates the shameless voice of his own self-certainty. Maybe he hates it because he knows that all that swagger and loudness and certainty are utterly false. Maybe somewhere deep inside himself he knows that

he's lying—but he's afraid to admit doubt. So he's trapped in a mental and emotional prison.

The response, when it came, was soft and considered, "Can he break free?"

"Will Rogers said it best, Mister President: 'It ain't the things we know that gets us into trouble, it's the things we know that just ain't so.' The beliefs we need to break free from are all too often those we most cherish. Only when we realize—and accept—that a belief is false can we get it out of the brain. Until then our false beliefs distort our experience and block the way to real knowledge. Sure, a leader has to seem confident. But an overblown sense of certainty actually undermines his authority. Real confidence springs from self-awareness and realism. When it substitutes for doubt, certainty blocks the capacity to think. The good news is that this makes it a whole lot easier to act. The bad news is that it gets us into trouble—and keeps us stuck there."

A faint siren sounded out on Pennsylvania Avenue. For the moment anyway my work was done. "We're meeting again tonight, Mister President."

"It's on my agenda, I guess," he said. Then he grabbed the jacket of his suit from the couch and slipped it on over his pumped shoulders.

I extracted the white envelope containing the second set of readings from my pocket. "Here's another little batch of big ideas to jumpstart our discussion—maybe you can find fifteen minutes in your day to look them over." Studying the envelope for a moment, he took it and turned it over as if weighing the contents. Had I truly reached him? The time was ripe for a parting suggestion. "You're clearly a great listener and a leader who responds rapidly to big ideas, Mister President, so the intuitions you've unleashed will doubtless

quicken through the day. Then, if I'm any judge at all, when we meet tonight you'll be seeing things more clearly than ever before."

He paused, then slipped the envelope into his breast pocket. As we turned and moved toward the north door, he again took my hand and draped his left arm over my shoulder. This time, however, the embrace seemed natural. "Well, Doc," he said softly, "you really are an intriguing guy with big ideas to share. So, sure, see you tonight."

The words were hardly out of his mouth when the door burst open and cigar-tainted breath invaded the space. I recognized the surly face atop the short, rotund body. Yes, indeed, that pugnacious figure adjusting frameless glasses and looking me over carefully was the vice-president. "Sorry—didn't realize you had a guest," he said, abruptly turning to the president, "and we need you right away."

"This is Mark Alter, Dick," said the president: "*Doctor* Mark Alter, actually. He likes to be called the Alternator. That's because he has some, uh, big ideas on leadership that we might be able to tap into."

The vice-president simultaneously smiled and bristled. "Doctor"—the prefix gave him pause—"a doctor with big ideas, eh? Well, nice to meet you."

"The president flatters me," I said, reaching for the interloper's hand. He let me touch it, then abruptly pulled it back. Turning his back, he shepherded the president away. Perhaps sensing his apparent impoliteness, he glanced back, "Catch you again some time, Doctor Alter."

SUPPLEMENTAL INTELLIGENCE

CATCH ME AGAIN? THE REMARK SEEMED ALMOST a threat. But, why waste even one minute on such a hostile ideologue? Time was running out. What little there was left of it was passing too quickly. The limo swept us along the broad Washington avenues. Perhaps my life was drifting, too. The tragedy of old age is that we are young. On the bright side, age can bequeath wisdom—but the legacy is bitter sweet. We come to realize, altogether too late, what it was to be young. I used to be young—fit, strong, alert, and ambitious. Whatever happened to all of that? But not *all* was lost. Not yet, anyway. Not for a little while yet. Ah, youth—it would be an ideal state if only it came a little later in life. Catch me again some time? No, I was in the September of my life. Monday was gone, Tuesday was going, and Wednesday was imminent. I had to make the most of every moment.

"So how did it go?"

The voice that broke into my thoughts belonged to Cathy. She was sitting opposite me, elbows resting on the attaché case across her knees. Her palms were upturned and a wan smile flickered in her lips as she waited for an answer. She seemed so young. *How did it go?* From the look on her face and the tone of the question, I gathered that she'd somehow become aware of the full scope of the project. Just the same, some professional caution was in order.

"Better than I could've hoped. Unless I'm mistaken, his imagination has been stretched and his mindset shaken—and with any luck the process might quicken. But I'll know more after tonight's meeting, then even more again when the dawn comes up tomorrow."

"Come on"—there was less formality between us now and she was eyeing me sweetly—"I got you the gig, and we're both on the same mission. You must have some impressions. What did you make of him?"

"Well, he clearly believes he's on a divine mission."

"He told you that?"

"Not in so many words. But even his selection of paintings was indicative of his beliefs."

"'A Charge to Keep'—he told you it was inspired by the Almighty?"

"You seem skeptical—"

"Yeah. There's a history to that painting that he knows nothing about. He believes it depicts the circuit-riders who spread Methodism across the Alleghenies in the nineteenth century—"

"That's why he identifies with the galloping cowboy?"

"Yeah—he thinks the guy is some kind of Protestant missionary."

"And he's not?

"No, he's got it all wrong—title, message, meaning—everything. In fact, the artist executed the painting to illustrate a Western short story, 'The Slipper Tongue'. It was published in *The Saturday Evening Post* in 1916. It's the tale of a smooth-talking horse thief who gets caught, and then escapes a lynch mob in the Sand Hills of Nebraska. He's a con-man hell-bent on dodging the law." She grinned. "In the magazine, the illustration is captioned, 'Had His Start Been Fifteen Minutes Longer He'd Not Have Been Caught.'"

"So the inspiring, proselytizing Methodist is in fact a horse thief fleeing a lynch mob—and the president doesn't know?"

"He should. The painting's history is no secret, and he had it hanging proudly in the Texas governor's mansion for many years."

"The Tolstoy Syndrome!"

"What's that?"

"Most people, Tolstoy said, can't accept even the most obvious truth if it runs counter to conclusions they've reached and shared with colleagues and woven into the fabric of their lives. The syndrome is a real problem for insecure leaders. They hunker down in their deluded versions of reality, shut down all inquiry and dismiss conflicting intelligence. It's the hallmark of the tragic leader. In W's case, he's hitched his presidential persona to a man he believes is a mythic, heroic figure—"

"So now he can't deal with the idea that the horseman might be a wily criminal one step ahead of the law?"

"Right, he wouldn't want to hear about that. The analogy of the horse thief might be altogether too apt for him to bear. He's an insecure guy on the verge of a breakdown, Cathy."

"How do you know?"

"Because he puts so much energy into proving he's tough. A truly secure person wouldn't sacrifice credibility by so incessantly insisting that he never wavers, never spends a sleepless night, and harbors no regrets. Whereas you and I both know that he's sipping his courage from a bottle."

"Can you help him?"

"I might have put a process in play. On a conscious level, he must be confused by the similarities between his policies and those of Adolf Hitler. If so, his unconscious might begin to contemplate a different legacy."

"So that was the meeting?"

"Not quite. I also got to meet the vice-president. He barged in just as I was about to leave."

"He's a dangerous character. We had to go around him to get you in there. Be careful."

"The rumor is that he's the real chief. Any truth in that?"

"It might be a huge fallacy, actually. Sure, he seems smoother and smarter, but he also does what he's told. He's your ultimate fawning sidekick."

"A card-carrying Iago?"

"A member of the club, anyway. A Kiss Up, Kick Down creature. His orders come from the Commander In Chief, but after that he runs unchecked. It's a problem because he has a nasty sadistic streak."

"The kind of person who turns shotguns on birds for sport?"

"He put real energy and creativity into setting up the secret prisons and the torture program. I never could figure why the chief went along with any of that." She paused. "It was a turning point for me"—she took a deep breath—"and several others, too." As she leaned forward, she dropped her voice. "Let me level with you. We have a plan and we need your help to make it work."

"Who is we?"

"Might be better for everyone if you don't know—not yet, anyway." She opened her attaché case, extracted an unsealed, unmarked crimson envelope, and passed it to me. "The envelope is red for a reason. It's a potentially incendiary document, so guard it with your life. There's an executive summary on the top page and two copies of everything else. One is yours, and one for you to share with the president."

I opened the envelope and unfolded several crisp white pages, and was immediately struck by the title, *The POTUS*

Reversal Plan. I was intrigued, too, that none of the pages bore any signature or identification. The whole thing was a quick read and Cathy watched in silence as I absorbed it. So! *That* was the plan. Audacious indeed—and I was to be in the middle of it. I took a deep breath. This was more than I'd bargained for. I should have backed out right then. Instead, I merely tucked the papers back into the envelope and slipped it into my right breast pocket.

"It seems very, uh, professional."

"As it should be. 'The best and brightest' put it together." A flash of sun lit up her modest smile. "I helped." She paused. "Do you think you might be able to persuade him to go along?"

"That will depend."

"On what?"

"On whether I can get him to understand why he feels compelled to behave like a Nazi in a cowboy suit."

"Compelled?"

"We're puppets of our pasts until we cut the strings."

"Do you have magic scissors to make that happen?"

"I'll be sharing some sharp ideas close to my heart." I was telling her more than she realized. Inside my left breast pocket lay my copy of the second set of potentially mind-blowing ideas that in the parting moment of our meeting fate had permitted me to deliver into the hands of the leader of the free world. I gazed out the limousine window, and she fell silent.

"I'll pick you up again tonight," she said, waving as the tinted glass began to rise. I watched the limousine pull away. She hadn't called me Mark, but she hadn't called me Doctor, either. Perhaps the age gap was closing.

I went straight to my room where my satchel was on the middle of the desk where I'd left it. Or was it? Hadn't I nudged

it off to the right, so as to spread out Cathy's papers? Or maybe I'd been bitten by the notorious Washington paranoia bug, I told myself. That would surely be very unsurprising given that Cathy had just raised the stakes and the burden of my mission. So much, much more would now be riding on my ability to communicate underlying patterns. No wonder, then, that I felt a surge of adrenaline as I grabbed the satchel, extracted the manila envelope containing Cathy's more confidential nuggets of intelligence, spread those papers on the Georgian desk, and studied them more closely, this time underlining the items that seemed especially significant:

FATHER

• <u>Son of former U.S. Senator</u> Prescott Bush. Attended Phillips Academy in Andover, Massachusetts. Was <u>president of his senior class</u> and secretary of the student council, president of the community fund-raising group, a member of the editorial board of the school newspaper, <u>captain of both the varsity baseball and soccer teams</u>. Also apparently elected a member of A.U.V., or "Auctoritas, Unitas, Veritas" (Latin for "Authority, Unity, Truth"), an exclusive fraternity.

• Joined the U.S. Navy on his 18th birthday. Commissioned as the <u>youngest ever aviator</u> three days before his 19th birthday. Piloting a fighter plane that attacked the Japanese installations, he was hit and set aflame but completed the attack, then bailed out. Spent four hours in the ocean before being rescued. In all <u>flew 58 combat missions</u> and received the <u>Distinguished Flying Cross</u>, three Air Medals, and the Presidential Unit Citation (which was awarded aboard the aircraft carrier, San Jacinto).

• Entered Yale University in 1945. <u>Captained the Yale baseball team</u> and was selected to join the powerful, secret "Skull and Bones" society. Graduated Phi Beta Kappa with a bachelors degree in economics.

Above and beyond all his advantages as the son of a senator, George Senior was clearly gifted with a good heart, a fine intellect, athletic ability, and a winning persona.

MOTHER

• Daughter of the president of McCall Corporation. Raised in Rye, New York. Attended Ashley Hall, an exclusive girls boarding school. <u>Dropped out</u> of all-girls Smith College after two years.

• An overweight, plain girl who <u>"always raised her hand to play the part of a boy when the boys and girls paired up in dancing partners to avoid being the last girl chosen—or being rejected altogether."</u>

• Handled virtually all parenting. Her public persona is jovial, but is reputed to be <u>cold, controlling and sarcastic</u> in private. Apparently <u>spanked</u> her children readily, as her own mother—<u>whose funeral she did not attend</u>—had apparently done to her.

How intriguing for a girl so cold and plain to attract a beau as warm and handsome as George Senior. But of course she was his social equal. They met as teenagers and married when he was barely twenty. Perhaps she compensated for her homeliness by making herself sexually available at every turn. And, maybe, he at that time, though highly sexed—which might explain the sublimation to athleticism—was nonetheless apprehensive of rejection by pretty women. But given her cold, sarcastic nature, how could such a relationship last?

FATHER'S MISTRESS

Jennifer Fitzgerald, a British-born retired U.S. diplomat had a <u>long-term affair</u> with Bush Senior from the time he was United States ambassador to China, which continued while he was Vice President and then President. She <u>served under Bush "in a variety of positions"</u> (to quote the

Washington Post) for much of this time. Her influence on Bush in turn reportedly led to <u>staff friction</u>. She has never spoken about the affair and Bush has denied it, but only on one occasion. The affair was <u>well known to the press.</u> There have also apparently been at least <u>six other paramours</u>.

Ah yes! George Senior outgrew his teenage shyness—and as he rose politically, attractive women probably threw themselves at him, too. Just the same, such necessarily clandestine liaisons must have put a strain on family life.

EARLY YEARS

• The <u>eldest </u>of six children, born 6 July 1946, while his father was still at Yale.

• Assigned at Andover to write about the <u>most important event in his life</u>, he selected the <u>death of his sister</u>, Robin.* Robin was diagnosed with leukemia, which set into motion a series of extended East Coast trips by parents and child in the ultimately fruitless pursuit of treatment. W was <u>never informed of the reason</u> for their sudden absences. Unaware that his sister was ill, he was simply told not to play with her. She died in New York in October 1953, and her parents <u>spent the next day golfing in Rye</u>. They attended a hospital memorial service the following day and then flew back to Texas. W <u>learned of his sister's illness only after she had died</u>, when his parents returned to Texas where the family remained while the child's body was buried in a <u>Connecticut</u> family plot. There was <u>no funeral</u>.

And, yes, again! There's always one moment in childhood when the door opens and lets the future in.

• <u>As a child, captured frogs, stuffed them with firecrackers, threw them into the air, and blew them up</u>, (says childhood pal, Terry Throckmorton).

* Was given a zero for the essay, and the comment, "disgraceful".

• <u>Took cocaine at Camp David</u> during his father's presidency. Purchased and used cocaine while at Yale. Heavy alcohol use at the exclusive Andover High School.

• At Andover, played stickball—baseball but with a broomstick and a tennis ball and funny hats—and <u>anointed himself the "high commissioner of stickball."</u> Alcohol was forbidden on or off campus, but as "high commissioner" he beat the system by designing and distributing <u>fake IDs</u> in the form of an "official stickball membership card" that seemed to carry the imprimatur of Andover.

• Moved on to Yale at 18 at the height of the Vietnam War. Classmates remember him as a "<u>hard-drinking good-time guy</u>" and "a jock sniffer" who "loved to raise hell".

And there it was, the solution to the teenage problem of how to simultaneously rebel and conform: defy authority and win the plaudits of peers.

MIDDLE YEARS

• In the spring of 1972, after graduating from Yale and while serving part-time in the Texas Air National Guard, embarked on what he would later describe as his "nomadic years". <u>Bush Senior got him a job</u> with a Republican campaign in a Senate race in Alabama. Fellow campaign workers remember that he tended to show up for work "around noon," prop his cowboy boots on a desk, and start bragging about how much he had drunk the night before. Also he often <u>retreated to the bathroom to take marijuana or cocaine</u>.

• Spending Christmas in Washington with his parents, he went out drinking, drove home, smashing into several dustbins, and then apparently swaggered into the house where he was confronted by his sober, unsmiling father. "<u>You want to go mano a mano right here?</u>" George junior challenged.

• <u>Senior arranged for Junior to perform</u> community service
with a mentoring program for inner-city youth started by
Houston Oilers footballers. Worked for seven months
starting in January 1973 at a warehouse in a tough district
where kids up to 17 years of age were offered sports, crafts,
field trips, free snacks, rap sessions, tutoring for those who
had been expelled, and big-name mentors from the athletic,
entertainment, business, and political worlds. Was
apparently very <u>successful</u> in this role. " <u>Everybody loved
him... had a way with people.</u>"

• Was accepted at <u>Harvard </u>Business School at the height
of Watergate. Attended classes in cowboy boots and a
<u>leather flight jacket</u>. Sat in the back of the class, chewing
tobacco and spitting it into a dirty paper cup. Was
characterized as <u>"one red-assed Texan who made sure he
was in your Yankee face and up your New England nose."</u>

• After graduation <u>moved back to Midland</u>, his boyhood
home town in Texas, to become an oilman. Lived above a
garage in an apartment that was piled high with dirty
clothes that his friends' wives periodically washed. Most
of his nights were spent in bars, drinking with buddies in
the oil business.

So, poor W careens into his thirties, comfortable with kids of
lower status, a competitor with high-performing peers, an
unabated hater of authority, and an ongoing victim of drugs
and alcohol. How long would he have to wait before a rescuer
showed up?

• In July 1977, soon after his 31st birthday, friends
introduced him to his <u>polar opposite, Laura Welch</u>. W
and Laura attended and enjoyed heavy pot-smoking parties
in Tortola. They married within three months at the First
United Methodist Church in Midland. Laura, the only
child of a Midland builder, is remembered by some former
students at Southern Methodist University in Dallas for
not being as conservative as most. She had smoked

marijuana and backpacked through Europe after graduation. A Democrat, she had also supported the antiwar candidate, Senator Eugene McCarthy, for the presidency in 1968.

• After a hard struggle to conceive and a fragile pregnancy with twins, Laura pulled back from hell-raising—but he apparently "charged on, leaving her behind." The couple kept their distance from the Bush family for several years in the 1980s, staying in Midland and even skipping the big surprise party that George Sr — by then vice-president of the United States — threw for his wife on their 41st wedding anniversary. "It was a long way," Barbara said later, "and too expensive." In fact, family members confirmed that she had stopped speaking to her son, whose drunken outbursts had become a source of unending embarrassment to his wife and parents.

So, at that the time, though perhaps a caring liberal—if not an actual bleeding heart—Laura had too similar a personality to W's to become his rescuer. The rotten relationship with the mother also bears thinking about.

BUSINESS DEALINGS

Arabusta. W founded a Texas oil company, Arabusta, with $20,000 of his own money and $4.7 million from 50 investors (mainly family friends). The company foundered in the early 1980s (when his father was U.S. vice president) and the investors lost 80% of their money. A small oil firm, Spectrum 7, owned by two Reagan/Bush Sr. supporters, bought Arabusta in September 1984. They appointed W president of Spectrum and gave him 13.6% of the parent company stock. Spectrum crashed two years later, losing $400,000 in its last 6 months of operation. Harken Energy Corporation then bought part of the failing Spectrum operation and W received a parcel of their stock at 40% below face value. He was made a board member and received a consulting fee of some $100,000 well into

the 1990s, and personal loans at preferential rates. (The company's 1989 and 1990 SEC filings said it forgave $341,000 in loans to unspecified executives.)

An amazing series of failures from a young man with a Harvard MBA. The father's influence may have him rescued him at every turn.

Texas Rangers. W was loaned $600,000 by the supporters of his father (who also bailed out his failing oil company), to purchase a stake in Texas Rangers baseball team which they also owned. W subsequently sold his shares for $14 million—while Texas governor to a Texas millionaire with many businesses regulated by W's administration.

Did that Texas millionaire freely offer a bribe, or did W—or his father—squeeze him for a payoff?

Desert Storm Deal. W sold 60% of his stock in Harken Oil in June, 1990. That was brilliant timing; in August, Iraq invaded Kuwait and Harken's stock dropped 25%. Soon after, a big quarterly loss caused it to drop further. These are pretty clear-cut indications of illegal insider trading. The SEC, controlled at the time by President George Bush Sr., investigated but chose not to press charges.

Brilliant timing indeed! And, again, the thumb of the father on the scales.

CONVERSION / TRANSITION

• At age 40 became a born-again Christian and gave up tobacco, alcohol, and drugs. In his memoir, he credited his family's good friend, the Reverend Billy Graham, with planting "a mustard seed in my soul". But in fact, he "came to Jesus" in a coffee house conversion with flamboyant evangelist, Arthur Blessitt, who was known among born-agains as the man who had wheeled a 96-lb cross of Jesus into 60 countries on six continents, winning a place in the *Guinness Book of Records*.

• <u>Became rigidly disciplined.</u> Rose and retired early. <u>Prayed daily</u> from his One-Year Bible, which was divided into 365 readings, each from the New Testament, the Old Testament, Psalms, and Proverbs. Exercised at least one hour, sometimes two hours, a day. Started and ended meetings exactly on time. The routine became the core of his developing political career, first as governor of Texas and then as president.

• <u>Continued, however, to curse.</u> Responded to a friend who accused him of taking the Lord's name in vain, "That's bullshit, total bullshit." Apparently "made no effort to curb his trash mouth" talking to reporters, congressmen, or heads of state.

• Refused to read memos longer than two pages. Thrived on making quick decisions and <u>rarely looked back</u>.

• As governor, <u>supported increased penalties</u> for possession and signed legislation mandating jail time for people caught with less than a single gram of cocaine.

• <u>Sent more inmates to the death chamber than any governor in American history.</u>

The classic conversion from drugs to religion. In this case, however, the underlying aggression and ongoing hypocrisy is especially interesting.

• After eight years of Clinton, the assessment of GOP professionals was that the American public wanted "a hero, an <u>unblemished and untarnished guy</u>, in the White House." It was decided to align Junior with his personal declarations on morality, and his newly crafted public image, which was in fact, the longstanding Bush family image. Junior was promoted as "the anti-Clinton: <u>fresh</u> and <u>clean</u>, <u>religious</u> and therefore acceptable to evangelicals, and <u>faithful</u> to his wife, a significant plus since the majority of voters are women).

- In the second 2003 presidential debates, television cameras detected a <u>strange square object on the president's back, cloaked by his jacket</u>. Some observers believed the object to be a communications device that permitted him to receive "live" input from offstage prompters. Others, noting that his father has suffered and been treated for a heart murmur, say the object was a small, portable, external defibrillator to monitor and automatically correct <u>atrial fibrillation</u>, which can manifest under extreme pressure (or be brought on by binge drinking).

So, there it was. Several patterns seemed apparent. Given the religious bent that reinforced his self-certainty, I would need to arrest his attention long enough for him to comprehend his predicament. My mind raced to the deceptively bland white envelope that providence had permitted me to slip into his hand. Might the contents create a magic mirror within which the president might discover his own reflection? I extracted my copy of the document from my breast pocket and glanced over it again:

Mark Alter Ph.D.
600 Park Avenue
New York, New York, 10010
P (212) 555-9501 / markalter@nyc.rr.com

Confidential Memo to President George W. Bush

Discussion Material for Our 2nd Meeting

An honor and a pleasure to work with you, Mr. President. I'm thinking it will help if I provide a kind of executive summary of some of these next ideas. I might just need your indulgence in this first piece, however, as it involves an imaginary journey and four questions. Just look it over so we may jumpstart our discussions later.

Climbing the Mountain

• You have set off to climb a mountain in search of a fabulously rare stone. *What is your impression as you stand at the foot of the mountain and look up at it?*

• After a hard search, you still haven't found the stone, and now the sun has set and the moon has risen. *What will you do next?*

• You finally discover the stone you were seeking. *What kind of stone is it? Describe its size, weight, and value.*

• Now it is time to come down from the mountain and return home. *What parting words do you have for the mountain, and what is its reply?*

Here's something with a little more to chew on—a summary of the forces that go into shaping our lives, by my late colleague, Dr. James McCracken. I'll be interested to hear what you make of it.

THE PSYCHIC CONTRACT

The key to spotting winners and losers is to appreciate that most children embrace the values of their parents, and before getting out of their teens strike what I call a psychic contract, whereby success in life is tacitly defined as marginally outperforming their parents in terms of income or status.

Parental expectations are crucial. Nothing has a greater effect on a child than the unrealized ambitions of the parents. Parental expectations generally crystallize into a *prime parental injunction*— an oft-repeated instruction delivered from the parent to the child that becomes a vital guiding force in the selection of lifestyle and goals. The process of fixing the contract is mostly unconscious, which explains why most people dedicate their lives to fulfilling the psychic contract, even as they argue that they are doing no such thing.

On a conscious plane, the psychic contract manifests into a *culminating event* or crucial later-life measurable milestone that signals ultimate success or failure. The specific culminating event varies from person to person. Such milestones might include appointment to a particular role, chief executive, professor, lead violinist, senior partner, whatever. For others, the culminating event might include founding a business, accumulating a million dollars, getting a child into a fine college, paying off a mortgage, having a book published, and so on. With this framework in mind, we can postulate three types of person:

• *Winners.* A winner, in terms of the psychic contract, is someone who makes good on his promise. He sets a goal, commits himself to it, and ultimately achieves it. His covenant or dream may be to run a sub four-minute mile, or write a great novel, or become a professor at Harvard, or direct a great corporation. If he achieves his goal, he is a winner.

• *Losers.* If, in the pursuit of those particular goals, a person finishes barely breaking a five-minute mile, getting published by a vanity house, becoming a corporate trainer, or managing a hamburger franchise, then he clearly is a loser.

• *At Leasters.* If that person runs the mile in 4 minutes 10 seconds, is appointed associate professor at Yale, becomes a vice-president, or writes a thriller, he could well be described as an at-leaster—not a loser, but not a winner either.

It might be helpful for us to compare Dr. McCracken's viewpoint with the following pithy perspective of the increasingly controversial Sigmund Freud:

From the time of puberty onward the individual must devote himself to the great task of freeing

himself from parents; and only after this detachment is accomplished does he cease to be under their control and capable of making his own unique contribution to the world. For a son, the task consists in releasing the libidinous desires for his mother, and in freeing himself from the domination of his father. This task is laid down for every man but seldom carried through ideally. For some, psychological detachment from the parents is never accomplished; the son remains all his life in subjection to the father.

I know you're a man of action not given to apparently frivolous introspection, so I might finally need your indulgence on another couple of unusual poems. At first glance, they might seem irrelevant, but in fact they can be a unique way for gifted intuitive leaders like yourself to tap the full power of your inner wisdom. Most tough-minded leaders find the first poem, *Snakebite*, by contemporary poet Max Phillips airy-fairy and confusing. But don't worry. Just look it over, and maybe ask yourself one question, "Does the snake's victim ever realize what happened?"

A lash of brightness catches you off guard
in childhood. It completes you. You change size
in dreams of smelly water, catch your eyes
impersonating something bright and hard
as sun and moon wear hot grooves in the sky
and you lurch toward conclusion. Here your strange
illumined limbs betray you. You must change
unrestingly now. You, swollen and sly,
must welcome turmoil as a central friend
who plies her fangs of difference through your heart.
And now you're anyone's to take apart.
And now you're anyone's to find and mend.
You will not understand, but will endure,
snakebit, and never dreaming of a cure.

This next poem is the classic, "*La Belle Dame Sans Merci*," or "The Beautiful Lady Without Mercy," by John Keats, a brilliant poet who died young. The narrator meets a pitiful "knight-at-arms" on a forlorn hill at the onset of winter, and asks him what went wrong. The knight explains that he was seduced and abandoned by The Beautiful Lady Without Mercy, and that when it was all over he had a premonition. Here are the opening verses where the poet asks what's wrong:

> *O what can ail thee, Knight at arms,*
> *Alone and palely loitering?*
> *The sedge has withered from the Lake*
> *And no birds sing!*
> *O what can ail thee, Knight at arms,*
> *So haggard, and so wobegone?*
> *The squirrel's granary is full*
> *And the harvest's done.*
>
> *I see a lily on thy brow*
> *With anguish moist and fever dew,*
> *And on thy cheeks a fading rose*
> *Fast withereth too.*

And this is the first part of the knight's answer:

> *"I met a Lady in the Meads,*
> *Full beautiful, a faery's child,*
> *Her hair was long, her foot was light*
> *And her eyes were wild.*
>
> *"I made a Garland for her head,*
> *And bracelets too, and fragrant Zone;*
> *She looked at me as she did love*
> *And made sweet moan.*
>
> *"I set her on my pacing steed*
> *And nothing else saw all day long,*
> *For sidelong would she bend and sing*
> *A faery's song*

> "She found me roots of relish sweet,
> And honey wild, and manna dew,
> And sure in language strange she said
> 'I love thee true.'
>
> "She took me to her elfin grot
> And there she wept and sighed full sore,
> And there I shut her wild, wild eyes
> With kisses four."

And here, finally, is the premonition and final answer:

> "And there she lulled me to sleep,
> And there I dreamed, Ah woe betide!
> The latest dream I ever dreamt
> On the cold hill side.
>
> "I saw pale Kings, and Princes too,
> Pale warriors, death-pale were they all;
> They cried, 'La belle dame sans merci
> Thee hath in thrall.'
>
> I saw their starved lips in the gloam
> With horrid warning gaped wide
> And I awoke, and found me here
> On the cold hill's side.
>
> "And this is why I sojourn here
> Alone and palely loitering;
> Though the sedge is withered from the Lake
> And no birds sing."

Again, different people interpret this poem in different ways, so 'correct' interpretations are hard to come by. As a world leader, however, your powerful intuitions as to the identity of the Beautiful Lady will be of special interest, so I'm very much looking forward to tonight's meeting.

—Mark

Was I wasting precious time? Would he take any of this seriously? Given his well-known lack of curiosity, the answer to that latter question would have to be a resounding no. On the other hand, our first meeting went well and I caught his

attention. He got beyond his initial defensiveness and actually listened and seemed intrigued by the prospect of juggling new ideas. So, with luck, our next meeting could begin where the last left off. Better yet, he might have responded positively to my parting shot. If so, his unconscious could be mulling my memo, and well on the way to discovering some liberating answers and insights. Time would tell.

The phone burst into life and I grabbed it.

"Hey, Mark—he *liked* you!" It was Cathy. "He wants you to come early and have dinner."

"Where?"

"Deep in the inner sanctum, his private dining room."

"Dinner with the patient?"

"It won't be much, maybe just a hamburger. What's important is that he's the one asking for extra time. Something you said must have gotten to him."

"Maybe he's just lonely."

"They want you there at a quarter to seven. I'm on my way to pick you up. Meet me downstairs in ten minutes."

In a minute there are moments for decisions and revisions that a minute may reverse. I plucked yet another reading, "The Curious Case of the Grinning Man", from my satchel. It was a longer piece, so I'd made two copies, one for him and one for me. I opened my copy, spread it before me, and pored over it. Might it be altogether too confusing? *Do I dare disturb the universe?* Yes—and no. And maybe. I folded both copies into a separate white envelope, and tucked the Grinning Man into my left breast pocket. If I chose to release him, there'd be no going back.

Life can indeed take dramatic turns. She called me Mark.

05/01/07—EVENING WHITE HOUSE SESSIONS

"THERE'S A SLIGHT CHANGE TO THE SCHEDULE, Doctor Alter." Andy's voice was calm, but his furrowed brow conveyed concern as he grabbed and pumped my hand. "The vice-president heard that you made a big impression this morning, so I explained that you're a leadership psychologist with special insight on how we might sell the enhanced interrogation program to the generals. Now he wants to meet with you again—this time in his office." He shepherded me through a cluster of thickly carpeted, pastel corridors, then halted and dropped his voice to a whisper, "He knows nothing of our earlier conversations—and shouldn't." I nodded. We arrived at a solid, black paneled door. He knocked and waited a moment before turning the golden knob and pressing me into the room.

The vice-president was ensconced behind a commodious mahogany desk at the far end of the narrow, boxy room. A musty odor overpowered even the vase of the daffodils on the foreground coffee table. A baronial map of Iraq hung on the wall behind him. Beneath it stood an oversize credenza thick with family photos. He made no effort to stand, but beckoned me to sit in the armless upright guest chair opposite his desk. As he leaned across the desk and offered me his hand, I caught the whiff of thick cologne. His grip was firm but moist. "The president has been delayed and I had a moment to spare"—his tone was cordial but businesslike—"so I thought it might be helpful for us to chat."

"An honor to meet you, Mister Vice-President."

"You made such a big impression on the chief"—his desk light was shining in his glasses and the six-pronged

chandelier was refracting from his pate—"that I'm wondering if you'd care to share a little of that wisdom with me."

"That's, uh, possible, I guess. How much time do we have?"

"Right now? Ten minutes or so."

"I'd need more time to lay out the underlying intellectual framework." He frowned. "The short answer, however, as I'm sure you well know, is that getting such a model into place is the key to winning people over, including military commanders."

"Of course. I gather you've been doing this, uh, leadership consulting of yours for quite awhile."

I nodded yes.

"So you do realize, I imagine, that for practical purposes all the touchy-feely leadership theories so favored by intellectuals became obsolete on 9/11."

"Some people say so."

"Some people?" He peered over his glasses. "But not the people charged with the responsibility for protecting us all in this era of unprecedented peril."

"Exactly so, Mister Vice-President."

Mollified by my response, he glanced at the paper on his desk. "I see you also teach prison inmates."

"It's a two-way street, and I learn as much as I teach."

"And that you came to that calling on account of your son's tragic addiction—which caused his recent death."

Who had told him this?

"Into each life . . ."

"Must have been especially tragic for a psychologist not to be able to save his own son."

"Yes and no. I took it to heart at the time, but I also knew that parents can seldom save their children from addiction—or anything for that matter."

"You may well be right." He leaned back in his chair. "How do you like living in New York—Sin City, as it is called?"

"I like it a lot."

"Seems you have a good life there, Park Avenue apartment, country getaway, nice car—all the good things."

"I'm very lucky."

"I guess you must be. It's a high-tax city—and state." Taxes? He'd moved the conversation to my taxes. "Not to mention Federal taxes, of course." Was this a veiled warning? Was he threatening a tax audit? "Well, as I'm sure you know, Doctor Alter, discretion is vital. This new 9/11 world is treacherous. There are enemies within our midst, especially in New York. That United Nations headquarters is a den of thieves and a portal for terrorists. If they discover you're advising the president they'll look for ways to, uh, influence you." After punching a button on his desk, he rose. I heard the door behind me open. "Well, I know you'll be circumspect"—he cocked his head and shot me a crooked look—"but do be vigilant."

Andy led me back down the carpeted corridors. "How'd it go, Doctor Alter?" His voice was businesslike, but he shook his head slowly and the look on his face indicated that people might be listening. He was telling me to choose my words with care.

"It was extremely enlightening—and certainly helped me better understand the president," I replied.

"Glad you enjoyed the meeting. Now, just to confirm, if all goes well in this meeting, you're tentatively scheduled for a six A.M. session tomorrow."

Tomorrow. Tomorrow would be Wednesday. Macbeth's haunting lines rushed to mind. *Tomorrow and tomorrow and tomorrow, creeps in this petty pace from day to day.* This petty pace, indeed. *And all our yesterdays have lighted fools the way to dusty death.* Dusty death. The gun and the stopwatch. Urgency!—*that* was the message of the dream, surely. But a bar of gold cannot buy an inch of time. Nothing mattered. Whatever would happen would happen. I resolved to let the process play out.

We stopped in front of another black door. Again Andy knocked, waited, opened the door—then gently closed it behind me.

"Hey, Doc, delighted you could make it." The president rose from a delicate round dining table set for two. A low arrangement of roses sat in the center, scenting the air and highlighting the inlaid antique golden wood in which was reflected the soft light of the five-armed chandelier. His earlier blend of defensiveness and domination was gone. He greeted me with the warmest of handshakes and a smile directed into my eyes as if I were an old friend. "Take a chair—there, the one with the view of the garden." He seated himself opposite me, commanding a view of door I'd just entered, plus one to his left and one to his right. The fear of being stabbed in the back runs deep, I guess. He was dressed in a hand-tailored blue suit. His white shirt and blue tie shimmered bronze in the tungsten light, and an enameled Old Glory adorned his left lapel. I couldn't quite figure out whether the integrity of the presentation was enhanced or marred by the cowboy boots.

"I like to eat light at the end of the day, Doc. So I got us each a couple of Tacos—you like Mexican, right?"

"A happy choice, Mister President."

"So let's get to it," he said, snatching the chicken Taco from his monogrammed plate.

I followed his lead and we munched for a moment in silence. I glanced over his shoulder and caught sight of myself in an ornate mirror. To the left of the mirror was an eight-paned floor-to-ceiling window. To the right was a French door opening to a garden.

He poured ice water from a crystal pitcher into two stemmed glasses.

"To your good health, Doc." We touched glasses and then he gulped the contents, swirled them in his mouth and swallowed hard before setting the glass back on the table. "I've been considering our conversation, taking it seriously, you understand." He plucked another Taco from his plate and almost inhaled it. Then he pressed his napkin to his lips and leaned toward me. "I never waste time with shallow opinions."

He rose, turned, and reflexively studied himself in the mirror. Then, catching my eye, he spoke to my reflection, "Your ideas set me to thinking. I'll confess it plain, you got me confused. Now that's good and bad both. See, what I respect most is people who tell it like it is. Like I do. I call it like I see it. Everybody knows that." He whirled around to stare into my eyes. "But you, you go piddling down both legs. I'd normally kick someone who does that straight out the door"—he broke into a grin—"but I liked the high-concept stuff we discussed. And then this second batch you dropped into my hand"—he plucked the latest reading from his breast pocket—"caught my attention, too." He tossed the papers onto the dining table, plopped back into his chair, and poured himself another glass of water. "So what does it all mean, Doc?"

"Perhaps whatever we make of it, Mister President." He seemed truly interested, so I decided to press ahead. "Let's think about that first question—"

"The one about climbing the mountain?"

"Exactly. What's your impression as you stand at the foot of that peak and look up?

He smiled broadly. "It's as big and as challenging a mountain as anyone can imagine. It'll take a world-class climber to get to the top."

"So you accept the challenge and climb to the top, but after a hard search you don't find the stone, and the sun has fallen—what'll you do next?"

He tapped the table with the heel of his fist. "I never quit. I'll up the ante. I'll get help and work through the night till I find it."

"Great—so what does it look like, and what's it worth?"

He clenched his fists. "It's rare, awesome, and priceless. And it shines like the lone Texas star. It looks so good that when I get back home I'll mount it in the middle of in my belt buckle." He grinned. "It'll look so good that Rum-Stud will want to snatch if off me!"

Rum-*Stud*—what a Freudian nickname for one's Secretary of Defense. Given Donald Rumsfeld's septuagenarian status he was also a father-surrogate, surely, and if so, at this stage of the deteriorating war, the epithet intentionally mocked his impotence.

"So now it's time to head home. What parting words do you have for the mountain?"

"I say, 'See, Mister High and Mighty Mountain, you didn't believe I could do it, but I did'"—he pointed both index fingers at me as if they were six-shooters—"'and everyone's gonna know it'!"

"And does the mountain reply?"

"Yeah, it says, 'You've been lucky so far, but getting down's tougher than getting up and nobody ever beats me.'"

"Sounds like a peevish precipice."

"It sure as hell misunderestimated me." He shot me a half smile. "So what's the tricky moral, Mister Alternator?"

"It'll take a moment to figure that out, so first, let's jump to a really big idea, the psychic contract."

"Yeah, well, I read it and thought about it. And I'm gonna surprise you. I'm not a fan for second-guessing myself. Mostly this kind of psychoanalyzing is what I call 'paralysis by analysis'—he grinned—"but soon after you left, I grabbed a half hour to read this stuff. And, I gotta say, you got a nice, neat model there. It set my mind to racing. Yesterday I'd have argued the point. Today, right this minute, I'm not so sure. And since you're pressing me, I'd have to say that I was raised in a home where politics was everything. Jeb and I both got infected with the political bug, so if there was what you call a psychic contract, it was to get into public service and become a winner."

"But you went into business, first."

"Yeah, well"—he grinned, somewhat sheepishly—"so did my dad. So I suppose you'd say I was following in his footsteps …"

"And…"

"Yeah, yeah—I wanted to be a fighter pilot, too. But I just couldn't deal with all the sitting around. Anyway, one way or another I wound up in politics."

"And became what—a winner or a loser?"

His face reddened. "I'm the President of the United Sates of America, Mister Alternator. I'm the guy in charge. Tough choices come to my desk and *I'm* the decider. I'm the leader of the free world, for Chrissakes. Slice it any way you want, and let the knockers say whatever they will"—he brought the fire in his voice under control—"but I'm a winner in any language."

"And if you had to single out a so-called culminating event?"

"Yeah, I thought about that, too. Something you do that proves you outpaced the opposition and made good on the contract. Well, people say I coasted into power on the family name. But my dad got elected only once. I did it *twice*. And the person who got me reelected was *me*. And I felt good about that. But I've done a whole lot more, too." He snatched up the readings from the table and sprang to his feet. "Here, let me show you something." He threw open the door to his right, then strode through another, and waved his hand over a tiny, almost tomb-sized space of maybe a hundred square feet. A petite chandelier hung from the incongruously high eighteen-foot ceiling. "Welcome to the inner sanctum, Doc."

So this was the president's private study. Two beige lounge chairs, with one matching footstool between them faced the center of room. Narrow floor-to-ceiling windows overlooked a garden. A modest antique roll-top desk sat in a corner with a swivel chair in front of it. A bookcase with a flatscreen television and a smattering of family photos were to the right of the desk.

He tossed our readings onto the farthest chair, then removed his jacket, and hung it from the corner of a shelf. He stepped to the desk and opened a drawer. Then, ever so reverentially, he extracted and presented for my inspection, in his upturned pink palm, a glistening revolver. It was a serious instrument of death and gave off that faint scent of oil and cordite that so excites the brain.

"Saddam's revolver." After rolling it into his other hand, he hastily—it seemed to me—slipped it back in the drawer. "Not too many people ever get to see that." Sitting in one easy chair, he nodded for me to take the other. Then he swept

the readings to the footstool and sunk back into his chair. "My dad made a big mistake, so I had to go back and finish Saddam off for him. So maybe, uh, maybe when we plucked that filthy dictator from his spider hole, maybe that was a culminating event for me, too?"

"Perhaps so—how do you think Doctor Freud might answer that?"

"The dirty doctor?" He laughed. "Well, that's what some people call him, right?" He gathered the readings from the footstool and passed them to me. "Why don't you just refresh my memory."

"Sure, let's start with this nugget—"

> From the time of puberty onward the individual must devote himself to the great task of freeing himself from parents; and only after this detachment is accomplished does he cease to be under their control and capable of making his own unique contribution to the world. For a son the task consists in freeing himself from the domination of the father—

"Yeah, well, I've done that. You got to remember, my dad was raised in the snotty-nosed East, and I was raised in real-world Texas. So, compared to him I'm more like Ronald Reagan, a big ideas leader unafraid to take on a big challenge. Listen, my dad made a big mistake not finishing things off in Iraq—it was a no-brainer, his approval rating was in the nineties for Chrissakes. Well, I'll tell you this, nobody's ever accused me of having a problem with the vision thing—and nobody's ever called me a wimp."

"Nobody ever has, I'm sure. But what about the earlier half of that Freudian equation where he says that freedom begins with '*releasing the libidinous desires for his mother.*'"

"I guess that's exactly why they called him the dirty doctor. But if he knew my mom he'd sure scrap that part of his theory."

"How so?"

"Libidinous desires? Listen"—he glanced over his shoulder—"she was a cold, sarcastic woman. No way in hell did she ever stoke my desires. Not unless you get off on a little S and M. She was a tough taskmaster. We called her the enforcer. If we got into fights, she'd bust us up and slap us around." He paused, reflectively. "Well, to be fair, she never had time for the lovey-dovey stuff. My dad was never around, always on the road."

"So you had to get by on your own."

"I had a knack for making friends—and organizing games."

"What kinds of games?"

"Oh, when we were kids we did all sorts of things. Stickball was big."

"And as a Texan kid I guess you played with guns?"

"Not really—unless you count BB guns. We had BB guns. We'd go behind the barn for target practice. I got pretty good at that."

"How good?"

"Well, listen, we were kids, right? After a big storm, thousands of frogs would come out and we'd shoot at 'em."

"How did the frogs react?"

"They weren't happy"—he grinned—"even less so when we stuffed them with firecrackers, tossed them in the air, and blew them away." He shrugged his shoulders awkwardly. "We were just kids. I'll tell you the truth, it all seemed natural. It was like nothing, actually. I certainly didn't think about it—not until recently, anyway, when one of my so-called boyhood

buddies leaked the story to the press. I don't even know why I'm bothering to repeat it. Like I said, we were just kids."

"Maybe you needed to share it."

He paused. "Yeah, well, maybe." He brightened. "My mom suffered from frostbite of the fingers, you know."

"Frostbite?"

"Freezer burn, actually"—he grinned broadly—"she never cooked—every meal was a frozen dinner. That might be why I developed my partiality for Mexican takeout." His eyes sparkled. "Tacos and enchiladas, beef and beans—not to mention the wash-down with lemon and Corona—or maybe Dos Equis. Hey! Those were things you could actually taste!"

"Anything else you remember about your childhood?"

He paused reflectively, and his smile faded. "Well, my sister died young—I remember that—of leukemia. She was three; I was six."

"That must have been tough."

"Not really. I never heard about any of it till much later."

"She just disappeared?"

"So it seemed." He paused again. "My parents loved that girl. I did, too. I wrote a high-school essay about her passing, but my teacher hated it. Gave me a zero, but I got over it. Whole thing made me tougher."

I turned back to the reading:

> For some, psychological detachment from the parents is never accomplished; the son remains all his life in subjection to the father.

"Yeah, well, *he's* the one in subjection now. I sent him off on a peace mission. If not for that he'd be chasing a golf ball or twiddling his thumbs, so what's the moral, Doc?"

"You'd be the better judge of that, Mister President. Can I just beg your indulgence one last time—"

"You want to talk about those crazy poems?"

"Great ideas often come in puzzling packages. What did you make of 'Snakebite'?"

"I gave up on it, actually."

"That might be a good sign. Sometimes the mind reflexively rejects the very words the heart most needs to hear."

"Well, I didn't give up on it *completely*. It's about a kid getting bitten by a snake—and not realizing what happened, right?"

"Hey, you did read it. And you got it, too. Yes, the poet is saying that childhood is dangerous territory. You think you're safe but—*a lash of brightness catches you off guard*—that lash would be the strike of the snake."

"So the kid gets poisoned?"

"And worse—*altered*. The child gets harmed, loses innocence, and is forced into becoming someone other than his true self. What the venom does is this:

> *It completes you. You change size*
> *in dreams of smelly water, catch your eyes*
> *impersonating something bright and hard*
> *as sun and moon wear hot grooves in the sky*
> *and you lurch towards conclusion.*

So the snake has effectively destroyed that kid's childhood and forced him into a threatening world where—

> *your strange illumined limbs betray you*

and now—

> *You, swollen and sly, must welcome turmoil as a central friend,*
> *who plies her fangs of difference through your heart.*"

"So the kid's hurt and anxious—and not really a kid anymore?"

"Yes, but not just *anxious*, in a state of *turmoil*, feeling like an outsider, unable to think clearly and dangerously vulnerable to deceitful strangers—

> *And now you're anyone's to break apart,*
> *And now you're anyone's to bind and bend."*

"I like the way you read it, Doc. But it's not a happy song. Trouble is"—he smiled considerately—"I'm not too sure how you're gonna make it relevant to the problems facing the leader of the free world"—his smile widens into a grin—"that being me, by the way."

"The answer might lie in the last two lines:

> *You will not understand, but will endure,*
> *Snakebit, and never dreaming of a cure.*

He repeated the words pensively, "'*You will not understand, but will endure*'"—then he rose, stepped to the bookcase and gazed at a silver-framed, black-and-white headshot of his parents—"'*Snakebit and never dreaming of a cure,*'" he whispered.

After easing back into his chair, he softly asked, "So what is it you think I don't understand, Doc?"

"Would you mind if we talked about this final poem first?"

"The Beautiful Lady who seduced and abandoned the innocent knight?"

"That's the one. Do you have any suggestions as to her identity?"

"You gotta give me a clue."

"Okay. For openers she lulled him to sleep with roots of relish sweet, and honey wild, and manna dew. And, then— and this is the most cynical in the poem—*in language strange she said, 'I love thee true.'*"

"So they both got high and she became his lover?"

"He was *her* lover, actually. *She* was a liar and a killer. Sure she *said* she loved him. But all the time she knew that she was annihilating him for her own orgasmic delight."

"How do you get all that? I mean, how do you know?"

"Because in his drug-induced nightmare her former victims, *death pale kings, princes and warriors* say so—"*'La belle dame sans merci, thee hath in thrall.'*"

"And that's how he winds up all hung over on the side of a hill?"

"Worse. It's only at the end of his life, when he's fallen from grace and can't recover, that he begins to realize what happened."

"So the Beautiful Lady without mercy is drugs—right?"

I shrugged and he took a deep breath.

"I see why you wanted me to read it, Doc. We both know I used to have a drug problem. I wouldn't be president today if I'd kept on drinking. But I quit when I was forty—not the end of my life as it's turned out. Billy Graham planted a mustard seed in my soul, and I kicked that ruthless and not-so-beautiful lady out the door. My whole life changed. I got motivated, got the discipline to make my dreams come true, and learned to trust God—who returned the favor by giving me the job of overthrowing an evil dictator and winning the war on terror. Like I said this morning, we're in the middle of a clash of civilizations. So it's freedom or slavery. The terrorists want to kill us because we love freedom. It's good versus evil, the good guys against the bad guys, but God wants us to win"—he said confidently—"and I'm making it happen."

My turn to stretch, so I rose. The family photos in the bookcase suggested some answers to his question, What is it that you think I need to understand? But how many of the secrets that he was hiding from himself should I reveal to

him? Maybe I should wait until morning. By that time his own unconscious might have prepared him for the trauma of the truth. But then again maybe tomorrow would never come. I slipped back into my chair.

"Let me tell you a story about a young boy. Let's call him George. He was a regular kid, but his father was a distracted giant determined to change the world—just like his own giant father had done before him. Now, George's mother, who was something of an ogre herself, wanted to help change the world, too. But she was bossy and demanding and the giant wanted to do things his own way. So he set out into the world alone, leaving her at home—often for weeks and months on end—to bring up George. Soon, just about the only thing the giant and the ogre had in common was George, and they grew to care for him, more than for each other. It was easy because he was a sunny, playful kid with a great heart.

Then when George was just three years old, his mother produced a sister. Now, you'd think that George would have been glad to have a playmate, and the parents would have been content to live happily ever after, but that's not what happened. George's father got so busy paying the bills and changing the world that he rarely came home. This maddened George's mother, so that whenever she looked at George or his sister she became resentful. *If I can't control my giant husband,* she thought to herself, *at least I can control his children.* So she bossed them around, said nasty hurtful things, and spanked them.

Now, George was a very bright boy and figured out that things began to go sour on the day his mother brought home his new sister. Secretly, he wished that the little girl had never been born. Indeed, whenever his mother got angry, George wished his sister was dead. And then one day she did become seriously sick. The giant and his wife took the sister to a hospital

in a faraway land, but she died there and never returned. As you might imagine, when he found out George felt incredibly guilty. He'd wished her dead and now that she was, he felt he was to blame.

And what made it worse was that neither the giant nor the mother ever discussed the little sister's passing. It was as if the sister and her death had never happened. The only difference was that the giant and the mother decided to have lots more children to make up for the sister. And now the giant stayed away from home just about all the time. And now the mother became more frustrated than ever. And George felt guiltier than ever, too. And his guilt made him anxious— and then frustrated—and then angry."

"Snakebite," he whispered.

"Right—"

"And he never knew?"

"All he could see was an angry woman with a cold voice and freezer-burn fingers. He never understood the damage she was doing to him or the source of her rage. He never realized—nobody did—the harm he was causing himself because of the shame he felt about the death of his sister. And then, of course, there was the additional problem of the giant father—and to get a handle on that, I'd like to take you back to that mountain we looked at earlier."

"I got mountains to climb, believe me."

"We all have. The mountain symbolizes father-son relationships. The height of the mountain and difficulty of the climb reveal how difficult we think it will be to fulfill the psychic contract. The stone we're searching for is the prize of making good on the psychic contract and winning our own self-esteem. What we say to Old Man Mountain as we depart is what we'd like to say to the old man himself. And the

mountain's reply gives a hint as to the ongoing relationship. So what did we learn?"

"That the mountain was, uh, high and mighty?"

"And an awesome challenge for anybody, perhaps?"

"That the payoff would be . . . peachy."

"A jewel in the crown, perhaps—a precious stone in the belt, something ambitious men would covet."

"And that the mountain would put up a helluva fight?"

"As I recall you insisted that it would never be beaten."

"Yeah—you might get to the top, but you could never get back home."

"Apparently not, so let me ask a question: is it possible that down deep you have the feeling that your father trashed your ability to climb that mountain?"

"Why would he do that?"

"Maybe he planted doubts in your mind because he didn't—and still doesn't—want you to succeed."

"Yeah, well"—he pursed his lips and frowned reflectively—"Dick has suggested as much from time to time. Rumstud, too. I cut those conversations short but maybe the idea hung around. And maybe, since this conversation is off the record . . . "

"Of course."

"Then maybe … maybe …"

"Maybe you've been going through a little more than people realize—more maybe, than even you quite you realize."

"Yeah, maybe." He paused. "Look, you seem like a savvy guy, Doc, so maybe I really could use someone like you to bounce these kinds of ideas off."

"We all need a good listener."

"Yeah, so maybe it's good for you and me to play around with this stuff."

"Maybe fate wants us to do just that."

He stared at me for several seconds, then softened his gaze.

"Yeah, okay then. So why, really, given all that he's done to help me, would my own father want me to fail?"

"Well, since *you* were the one who suggested that the mountain couldn't be beaten, let me ask why you might think your father might want you to lose."

"Because he's a competitive guy?"

"I guess—and perhaps because he wants to remain king of the hill."

"But, I beat him fair and square."

"Yet your own unconscious seems to be saying that you've failed to climb back down the mountain and find your way home?"

"Is it possible to find my way home?"

"Maybe not if the Beautiful Lady has anything to do with it."

"She's a non-issue. She was my drinking problem, and she's long gone."

"The Beautiful Lady comes in many forms. Sure, we mostly recognize her when she takes the form of drugs or alcohol, but in this incarnation she takes the form of a seducer, easing the emotional wounds of troubled young men but setting them on the path to hell. She can also enter the spirit of innocent people as pure malice, and compel, for example, an emotionally damaged boy to mercilessly destroy God's harmless creatures. She may even assume the form of political power, intoxicating well-intentioned leaders and seducing them into heedless acts of war that lead to cruelty and torture."

Speechless, he raised his hands as if to push me away.

"Let's be clear, Mister President, you *do* have a great heart. You *are* a decent and loving person. You *have* been the very best person you could possibly be in every stage of your life. Trouble is, you got bitten by the snake. You've also been fighting to fulfill a poisoned psychic contract."

"Poisoned?"

"It was no-win, right from the start. On one level it said, 'Follow my example and become a giant,' but on a deeper level, the message was, 'If you try you'll fail, and you'll never have a home to go to.'"

"So I turned to the Beautiful Lady?"

"There are two ways to even the score with your parents. You can become a big success and *show them*—or you can give them the finger and show them *up*. Maybe in the beginning, you enlisted the Beautiful Lady to ease your pain and did your damndest to show them up. Maybe, since your father captained the baseball team, you mocked him by getting high and anointing yourself High Commissioner of Stickball.

"Maybe the family name got you into Yale, but that wasn't what you wanted, so you stayed high and became a party animal. A regular student would have had to shape up or ship out, but not the son of the powerful giant. So maybe Yale chose to turn a blind eye to the problematic grades of a rebellious son and graduate him anyway. And maybe from his above-the-clouds vantage point the giant congratulated himself on *his* success in making that happen. The giant became a decorated fighter pilot, but maybe he didn't want to be outshone. So maybe he subtly and perversely pulled strings to help his son dodge that war by enrolling him in the Air Reserve. Maybe that stymied kid gave the old man the finger by going AWOL with the Beautiful Lady and then dropping out. And

maybe here again the giant came to the rescue—or so he made it seem. So maybe the giant was always an enabler.

"Maybe that's why the son resented the legacy scholarship that got him into Harvard. Maybe that's why he spat tobacco juice in the faces of those snotty-nosed Northeasterners. Yet again, however, the family name prevailed and graduation followed. The son felt impotent and worthless, of course, but the Beautiful Lady remained his constant comforter. He went into business, and the giant's friends saw to it that he made a lot of money. Even as the money came in over the transom, he felt manipulated and cheated." I paused. "Is any of this making sense to you, George?"

To go on calling him Mister President would have been to sell him short. I wanted him to see that I respected him for who *he* was, warts and all. If he noticed the switch, he chose to ignore it.

"I'll tell you the truth, Doc. I *like* what you're saying"—he smiled—"so maybe I'm more screwed up than you know."

"Quite the opposite. I'm not revealing anything you don't already know. Look, your own unconscious has been grappling with these issues for a long, long time. One part of your mind wants to keep it hidden from you, but another part has been making sense of it all in the hope of breaking free."

He drew a deep, deep breath, "Yeah, right. I got it. You've brought it into focus. I had a rotten childhood and screwed up. I've said it before, when I was young and foolish, I was young and foolish. But I just never knew why. Now I see that I got snakebit and turned to the Beautiful Lady. I appreciate all that, I really do." He leaned back in his chair and clasped his hands behind his head before continuing, "But what *you're* not getting—and what you're not giving me credit for—is that I saw the light, and I repented, and I was born again. You can

doubt it if you like, but I really was. Then I got called to politics, and I heard that call, and I responded," he said as he sprang to his feet. "And then I showed *everybody*.

"People *liked* me. They *believed* in me. I got a *following*. My competitors tried to spread the word that I was dumb. Well, you know what"—he pointed both index fingers at me—"I was so dumb that I went head to head with the best and brightest minds those fuckers could find and I beat them all." After sitting in his desk chair, he paused to take it all in again. "And not just yokels like that witchy Texas governor. Sure, I whipped her ass and became one of America's most popular governors, but then I beat Vietnam War heroes and two of the smartest, snootiest, and most successful Ivy League alums ever. They were *sure* they would win. They were *meant* to win. The press said they *would* win, but I beat them all! So, however you cut it, Mister Alternator"—he slowed his speech—"I have shown myself to be a leader. So how do we explain all my success?"

He appeared so vulnerable that I was uncertain whether we should keep going.

"Several things happened when George got bitten by that snake. He experienced a sense of rejection, isolation, loneliness—and anger. On one level, he coped with these feeling by becoming oblivious to pain, his own and that of those around him. He could vent his anger on hapless frogs without even noticing his own cruelty. Just as arsenic can cure some illnesses, the venom that infected George induced a powerful positive reaction. He coped with his repressed depression by developing his natural warmth into radiant charm. Like a suicidal clown, he captivated those about him, even as he deprecated himself to hide his own pain."

His eyes were closed, he seemed lost in thought.

"So here's the bottom line: your psychic contract required you to enter the political arena, but you created a winning weapon—a personal charm as real as it was heartfelt—and you took that slingshot into the lion's den, along with every other unmet need and every other aspect of your personality."

After opening his eyes, he reached out and snagged his jacket. Tossing it across his shoulder, he nodded for me to follow him out of the study and into the Oval office. We stepped inside as he slipped his jacket back on.

"*This* is the bottom line, Doc," he declared, with a wave of his arm, "*this* is where I've landed." He wandered to the credenza and gazed at the painting of horseman charging upward. "*This* is where God wants me, fighting his fight, so don't tell me to stop believing. No matter what anyone says, I'm gonna go on believing in God's call to deliver freedom to every living soul. And I'll tell you one thing more"—he jabbed an index finger into my chest—"with God on my side, that war *will* be won."

But what if he was wrong about that? What if there is no God? What if he was simply deluding himself? Should I toss these missiles? Would they burst the his rigid defenses?

"I need you to listen to me now, George." If he recoiled I didn't notice. "You're a spiritual man so let me ask a spiritual question. How does God send his messages?" I didn't let him respond. "We both know the answer. God doesn't engage in asinine sorcery. He doesn't float down from heaven on shining clouds or shout from hilltops in a booming voice. He doesn't cast spells or wave magic wands to change the composition of brain cells. No, when God wants to send a message he selects a *person* to be his envoy. But not just any person. He chooses the precise individual who somehow knows—or can figure out—what he needs us to hear. Now, most of the time

the messenger doesn't even realize he's on a divine mission—
he just knows he has a job to do. And, in your case, he probably
frets that you're the most difficult man to reach in the world.
But God makes a way where there is no way—he sees to it
that all necessary doors open. Then one day, against all odds,
or so it seems to some, the envoy finds his way into your
presence."

He eyed me respectfully and then responded softly, "And
you're that messenger?"

"All I know is that here we are, you and I. And mere
minutes ago you asked me what it is that you need to
understand. Now, I don't know whether that was your question
alone or whether God was prodding you. All I know, one man
to another, is that I'd be letting you down if I didn't do my
very best to help you address it."

"But you answered it already. You showed me how I came
to be in this place. What I *don't* need is for someone to tell me
how to do my job. I only need to know that I have a charge to
keep because I believe—and in my heart I know—that God is
guiding me."

"So why not assume that you're right? Why not assume,
if only for the next few moments, that God really is guiding
you—both of us, in fact?"

He broke into a smile. "Come sit on the couch, Doc," he
said. "So what's the word? What is it that God thinks I need
to hear?"

Now was the time.

"Maybe God would like you to know that the cloak of
divinity is the ultimate disguise of the Beautiful Lady. Maybe
He'd like you to see that she seduces with the promise of
immortality and deceives with the drug of certainty. Then,

once in her thrall, she compels her death-pale kings, princes, and warriors to kill in God's name."

"The drug of certainty?"

"She uses it to delude us into thinking that our beliefs make us free. It arrests the realization that our cherished beliefs are merely opinions. Notions that we picked up along life's journey—and this is important—from people we looked up to—parents, teachers, professors, priests, *people whose heads were higher than our own*. When the Beautiful Lady has us doped on the drug of certainty, we lose the will to examine our beliefs. We'd rather die for some crazy notion implanted into our skulls by some imperious higher head."

"The crazy notions of higher heads—what does that mean, exactly?

"Well, what about your belief that the war on terror is a war of good against evil. It *sounds* like a good idea, something that Billy Graham might preach from his pulpit, actually. In reality, however, it's merely a convenient and mind-numbing opinion. It blinds us to the evil in our own acts of cruelty. It justifies torture and sanctions killing. It frees us to use God's name to justify everything."

"But we're living in the new 9/11 world, Doc! Those radical Muslim extremists are total animals. The only sane choice is to fight fire with fire."

"And become brutes like them? We know better, so if we cede our higher moral ground we wind up worse than them."

"It's the *only* thing they respect—"

"Oh, please! Let's forget about the philosophy of war for a moment. Let's talk about the boy who got bitten by the snake. *You will not understand but will endure.* Well, he did endure, and to be sure, he never understood what happened. Somehow,

though, he transmuted one part of that snake venom into charm and became the leader of the free word. Inside, however, he remained wounded—wounded and enraged. So he became anaesthetized to his pain and oblivious to the pain he inflicted on others. Oh, Christ, George, don't you see? You're *still* responding to snakebite. You're trying to ease and excuse the pain of what turned out to be a series of lousy decisions that you point-blank refuse to reconsider."

"I got the best available intelligence and advice."

"Oh, George, you still don't get it! Can't you see that you seduced those advisors. Sure, they had their reasons, but so did you. You could have said no, but you didn't—"

"It was a matter of principle. I was doing what was right."

"Come on, George! Drop the pseudo certainty and connect the goddamned dots. You did what you did because you were under compulsion to make good on your psychic contract. Sure, you can use God's name to justify the mutilation and slaughter of the men and women you sent into battle, but the truth is that you were in such pain and were so numb that you didn't give two shits about the life or death of any such soldier. Don't you get it, George? You've been killing frogs, for Christ's sake."

He sat stock-still for several moments, then stepped slowly to the flag behind the presidential desk to stare out the window. The sun was down, the shadows long.

I followed him, but stopped in front of the oak desk. "And the reason those young warriors are dying for you, George"—should I tell him or not?—"is that they've been trained to accept the perceived wisdom of the higher head they call their Commander-in-Chief."

He slipped into his chair and lowered both hands to the desk. "I've been ... killing ... frogs" He leaned back, looked

up, and raised both palms. "Are you saying I was *never* my own man?"

"What I'm saying is that you failed to escape your father's domination because you never had a chance to figure out what had happened. You never realized that you were the victim of a poisoned contract. To win you had to lose."

"A victim… He loved me… It was unconditional. He never abused me. Never."

"He never *hit* you, George. But absence can be a form of abuse. Especially if a kid is left in the charge of a sadistic caretaker. Frankly, I look at your father's frosty frau and wonder what comfort he might have been finding on the road."

"Yeah, well, *that* all came out. The Democrats got onto it." He paused. "The mistress—that's what you're talking about, right?"

I didn't answer.

"Yeah, well, *I* got the job of sweeping the story of that particular Beautiful Lady under the rug." Tears welled in his eyes. "*I* was the one selected to deny it. *I* was the one who stood and lied to save his skin."

His shoulders were shaking.

My heart went out to him.

Suddenly he smiled. "See, I cry. I cry a lot." He straightened himself. "But I get over it, too."

"'*Thou should please me better wouldst thou weep*'—it's a line from Shakespeare. Says that sometimes the only way to deal with tragedy is to shed some heartfelt tears."

"I don't know why I cried," he said, "here with you right now, I mean."

He was asking a question, surely. Should I answer?

"Perhaps for a very good reason."

I spoke to the silver back of his neatly groomed head as he stepped slowly to the sofa.

"Perhaps you wept because you were forced to consider your loyalty to your father. You should never have been forced to tell that lie. She was his Beautiful Lady, never yours. But maybe your tears were symptomatic of a deeper issue. What everyone is telling you, George—and what you know in your heart but chase out of your mind—is that it is too late to ever truly *win* this war. Somewhere along the line it will begin to wind down, as all wars do—and let's pray that happens. But so much damage has already been done that victory will be meaningless. Our national reputation is in tatters. Hundreds of thousands of Iraqi lives have been lost and millions of others have been displaced, their homes and infrastructure destroyed, and their museums pillaged."

"Soldiers have given their lives—I can't let them die in vain."

"They already have, George. You know that. The only issue is how many more of them you're prepared to sacrifice. Stay the course and come what may you'll be consigned to history's scrapheap." I had his attention now. "But you know what, George? I have a hunch that that's precisely the legacy you want."

He was taken aback. "Why would I ever want that?"

"Perhaps for the same reason you broke down when you thought about your father's demand that you publicly deny his very real infidelity. But the real tragedy is that you are still trapped in his dominating web. You're a good guy, George, and like any decent son you want to win the approval of your imagined giant of a father. But what if the giant wants to hold you to that poisoned contract? And what if you're letting him do it? You'd be sacrificing the meaning and purpose of your

life—your very heart and soul—out of blind, misguided, and manipulated loyalty. It just might be enough to make a wise man weep."

He stared at me blankly. Had it been too much information for him to process? Probably. But he had listened.

"So dumb," he said to the bronze bust of his father. "I can't believe I've been so dumb."

"No, George, you merely did what you had to."

"Yeah, but now I see it. *Mission fucking accomplished*—can you believe that stunt I cooked up? Here I was, the fifty-six year old President of the United States, pulling on a flight suit, just like my dad. Getting into a fighter plane, just like my dad. Dropping from the sky onto the USS Abraham Lincoln, and then standing before the troops and declaring that the mission in Iraq had been accomplished. In that moment, I became a hero on a battleship, just like my dad—or so I imagined, right Doc?" He grabbed the glowing bronze head and continued, "Okay, Dad, I confess. I never earned that right. I never earned that flight suit. I didn't even fly that plane—I was just a passenger. Oh, sure, I believed in what I was doing. I really did think—I truly wanted to believe—that the fight was over and the good guys had won." He set the bronze back on the credenza. "And you know what, Doc? That lame ceremony on the deck of that battleship truly was the culminating event of my life. I was a winner! But only in that moment—and then it all went sour. I became a joke, a stooge, a butt for late night comics. I became a total loser—right?"

It was a rhetorical question but it needed an answer.

"The game's not over, Mister President. The battle's raging. You can still win it."

"I can? How is that possible?"

"By shifting the paradigm."

"I've had the best brains in the world thinking outside the box. There's no magic bullet, Doc. No last-minute strategy that's going to win this war."

"So let's win an altogether different victory, the battle for hearts and minds."

He smiled. "Rumstud says, 'when you've got 'em by the balls, their hearts and minds will follow.'"

"They'll follow for sure, but with hate in their hearts. But if you win the space between their ears, we'll have all hands free to pick up the pieces and create something worthwhile."

"And how, exactly, would you propose to win that territory, Doc?"

"I'd bring a secret weapon into play, Mister President—*you*. You're a great speaker, perfectly equipped to say the words that would win the day."

"You think so?"

"Yes, but you've got to be the real you, not the one-dimensional tough-talking commander in chief. Strut and certainty may work with marines, but it's a turnoff for the audience you need."

"Which is?"

"Arab leaders and the Arab world."

"There's no way I'm ever gonna turn them around."

"They're the same as everyone else."

"It's not gonna happen. Even if I could get them all together in one space I'd need to say something to make them want to listen."

"Something new and special—"

"Yeah, but they'd never get the message."

"You could make them listen, you could make them hear. It's a challenge that you could handle."

He ran his fingers through his hair. "Maybe I could." He dropped his voice. "But even if they'd listened to the message, do you think they'd believe me?"

"That would depend on what you said and how you said it. We both know that you can deliver a great speech—all you need is the right forum and a powerful message." I reached into my right breast pocket, withdrew Cathy's red envelope, and held it aloft. "This might just be the blueprint you've been looking for, Mister President." I paused before passing it into his outstretched hand. "My hunch, George, is that when you deliver this message the world will sit up and take notice. The cynics and naysayers will be disarmed. You'll show everybody that you're more than just a great leader. They'll see that you're your own man, too."

He held the envelope gingerly between thumb and forefinger, "A *red* wrapper,"—he grinned—"does it contain anything hazardous, or just more ideas?"

"Any idea that is not dangerous is unworthy of being called an idea," I replied. I was aching to release the Grinning Man, but was this the moment?

Just as I was dithering with that decision a knock sounded on the door, which then cracked open delivering Iago, in all his feisty splendor, into the Oval.

"I heard talking. And you're not usually here so late, Mister President." His attention was turned on me then. "Ah, the guru with big ideas."

The president smiled. "We were just about through, Dick. And, yeah, Doc Alter really does have some intriguing ideas." He held up the crimson envelope and Iago eyed it closely. "Bedside reading. We're gonna talk in the morning." He paused,

set his right arm on my shoulder, and walked me to the door. "Thanks," he said.

As I stepped out of the office, I could feel the vice president's riled eyes burning into my back.

POTUS REVERSAL PLAN

CATHY AND I TRAVELED IN SILENCE until the limo cleared Pennsylvania Avenue.

"How was it?"—she whispered the question, but her curiosity was palpable—"and did you …"

I took a deep breath. "We extracted full value from Tuesday, Cathy. I think we might truly be getting somewhere. And, yes, I delivered the red wrapper into his warm and willing hand."

"So he knows about The POTUS Reversal Plan?"

"Not yet. But if he's as good as his word, he'll open that envelope and read all about it tonight—what's left of it—and we'll discuss it tomorrow morning, God willing."

"And the vice-president? You saw him, too, right?"

"News travels fast. I saw him twice, actually—both coming and going."

"And going?"

"He barged in, right at the last moment."

She was momentarily lost in thought. "He's up to something."

"We're doing nothing wrong. Confidential, sure, but not underhanded."

"He doesn't like other people to have secrets. He has an agenda all of his own."

"What kind of agenda?"

"People are turning up the heat, and he's desperate to pass the buck. First, of course, for the failure to find Weapons of Mass Destruction. He swore they existed—and might even have gulled himself into so believing—and *that* was the rationale for war. But they didn't, of course, and what a fiasco that WMD hunt turned out to be. He's also on the griller for setting up secret prisons and ratcheting up the interrogation techniques."

"The solution is in his own hands."

"He's a weak and sadistic bully. You said so yourself. Time and again he plays the 'ticking time bomb' argument to justify his cruelty. So tell me, what kind of a solution do you think would appeal to such a person?"

She was implying something—but what? Oh, God! *The Duplicitous Firefighter Syndrome*—the insecure firefighter who becomes a hero by being first on the scene to extinguish the roaring blaze he secretly set.

"You think *he'd* set off a dirty bomb?"

"All I know for sure is that he'd look like a hero if it happened. I'm sure he's figured that out. He's already done a lot of weird things. Well, they would be weird if they weren't so clearly self serving. He's corrupt, of course. Everybody knows he rakes a treasure trove from his Halliburton connection. He's never denied it, actually."

"So if that dirty bomb goes off?"

"They'll all run amok and expand the war from here to kingdom come. So tomorrow's meeting couldn't be more vital." Overhead lights flickered rhythmically in her earnest face as the limo glided to the Jefferson. "Andy says it's all systems go. We just need you to persuade the chief to fall in with the

plan." The limo drew to a halt. "I'll see you in the morning, downstairs at five forty-five."

So, now I had time to thoroughly examine my copy of the missive in the ominous red wrapper that I had slipped between the pink presidential thumb and forefinger. The Jefferson desk lamp cast a tranquilizing yellow light over the pages:

POTUS REVERSAL PLAN

Executive Summary

• On Thursday, 3 May, an Arab conference will gather in Egypt to examine what might be done to stabilize Iraq. This is an important meeting:

• Heads of State and important dignitaries will attend.

• The entire Arab world will be paying attention.

• Al Jazeera Television will be providing in-depth coverage.

• The Secretary of State is currently scheduled to brief the conference and speak on behalf of the United States. If we move quickly, however, President Bush could attend in her place, and if that happens:

 • All major world television networks will cover it.

 • The entire world will pay attention.

 • This a could be a pivotal moment to:

 • Open Arab minds,

 • Repair damage to United States credibility and reputation,

 • Change the course of the war.

The message the president might deliver to achieve those goals is set out hereunder.

DRAFT PRESIDENTIAL ADDRESS

(808 Words)

I want to take this opportunity to speak to the Arab and
Muslim nations gathered here today and to the world at
large. I begin with a simple message...

A simple message? I glanced over the full text. Yes, it
was simple—but bold and audacious, too. But would the
Commander-in-Chief be able to summon up the courage to
go along with it? To be fair, he had woken to the realization of
the unconscious forces that had so driven his apparently
mindless refusal to reconsider failing policies. I folded the
papers carefully. Guard them with your life, she'd said. The
president already had a copy, so I wouldn't need this one
tomorrow. After a moment's thought, I slipped the file into
the tiny bedroom vault.

And what about the Grinning Man? I extracted him from
my pocket and studied the monogrammed envelope. All going
well, I would deliver that shroud to the president at the close
of our next meeting. I set the white envelope back into my
breast pocket.

It had been a long and tiring day, but again, however,
distressing dreams disturbed my sleep.

> *I entered the door of a drug clinic to lead a therapy
> session, but the door opened into the Oval Office. A
> coffin, the lid of which was made of mirror, had been
> laid atop the presidential desk. I watched transfixed
> as the lid slid slowly open to reveal Ethan. He was
> wearing a blue suit jacket with an American flag pin
> in the lapel. His eyes were open and he was breathing
> but I could tell from the film of sweat on his face that
> he was still using drugs. I tried to speak to him, but no*

words came, just a horrible croaking. He clasped the
mirrored lid and pushed it forward so I could study my
image. I had been transformed into a ghastly, bloated
bullfrog. Then I became aware of the scent of burning
cordite and discovered that it was coming from the short
fuse to a giant firecracker that had been inserted into
my rectum.

The nightmare was shattered by the ringing of the bedside phone. I glanced at the luminous sentinels that guarded the blinking colon within the bedside clock. Who could possibly be calling at 3:04 A.M.? I grabbed the handset.

"Hey, Doc, glad I got you—it's me, George."

I hadn't pulled the curtains. Light from a full moon was streaming into the room.

"Something important must be happening for you to be calling, Mister President."

Big ideas delivered just before bedtime often set a leader's mind to racing, so in fact I was not entirely surprised to get this wee-hours phone call.

"Yeah, there is. Listen, I opened the red envelope and looked over the plan—the reversal strategy. Let me tell you, it truly is a big idea. I couldn't sleep for thinking about it. I like the speech, too. It's brilliant, really—but the presentation will be crucial, so I might need to George it up a little, if you know what I mean."

"So you want to proceed with the plan?"

"You bet—yeah, we're gonna do it. That's why I'm calling. This really is the way to go. Listen, I thought about the rest of our huddles, too. What I see, and I see it clearly, is that this speech is gonna be a whole new beginning, a whole new culminating event, a whole new, uh, psychic contract. Right, Doc?"

"I think so, yes. It's a daring plan, and with just a little luck it really could mark the beginning of a new chapter in your life."

"Right, and everyone'll see it." He dropped his voice to a whisper. "Listen, there's no time to lose—we both know that. We got to start getting the train out of the station now."

"I agree, the timing is critical."

"Yeah. But we've got to keep it all secret. But you and I got to talk. I just sent you a limo—"

"You need me at the White House right now?"

"Yes, come quickly, Doc. The car's probably downstairs waiting for you already."

He abruptly hung up and I stared at the phone. Were the heavens truly aligning for me to meet the Wednesday night deadline—now less than twenty-one hours distant? Would there really be a limo downstairs? Was this whole incident just an extension of my weird dream? Maybe, because the muted opening bars to Beethoven's Ode to Joy suddenly sounded. They were coming from my satchel. I reached inside to extract my cell phone. It could only be Cathy.

But, no, it was not.

WED., 05/02/07—EARLY A.M. SESSIONS

"DOCTOR MARK ALTER, RIGHT?"

"Who are you?"

"We're here to escort you."

"Who gave you my number?"

"We're downstairs now."

The gray-suited security officer holding the limo door recognized me. He nodded for me to enter, then slid in beside me and the limo pulled off into the night.

We never passed through the White House guard station, in fact, I do not recall even seeing the White House. Instead we entered what was like a garage, but which turned out to be the opening to a narrow and winding one-way tunnel. We finally stopped at the gunmetal gray door of an elevator, guarded by another gray-suited security officer, from whose frameless lenses the limo lights bounced. After we exited the limo, my escort slipped a plastic card into a slot beside the door. It glided open to reveal a brightly lit steel elevator. We entered and the door slid shut behind us. The cabin moved slowly upward, then abruptly halted. The door opened and a hand reached for mine.

"Doctor Alter?" The voice was as sweet as the face. "I'm Laura."

She was so poised that my initial astonishment gave way to relief.

"George is resting," she said. "Perhaps you and I could talk in the library." After she moved forward a couple of steps, she glanced back over her shoulder to say, "Let me lead the way."

The gilded wood chandelier cast a soft light up onto the gray pastel ceiling and onto the rosewood paneling.

"It's a lovely, relaxing room, don't you think?" she asked.

The finicky furnishings were from the late Federal period, and the carpet was a fussy Tabriz. A large, clumsy Duncan Phyfe drum table bearing a vase of sweetly scented pink roses stood immediately under the chandelier. Though intended to be casual, the antique, pink upholstered chairs were too flimsy and upright to be comfortable. The effect was neutral enough, but somehow, for me anyway, the whole prissiness conjured an air of mustiness.

"Yes, a lovely room," I lied.

Settling on a couch between the two north windows, their slatted timber Venetian blinds tightly closed, she sat facing the door and indicated for me to take the chair to her left. I was to face the white neoclassical fireplace mantel.

"George had a busy day." Her voice was firm but she made no visual contact with me as she said it. "I realize you're here to help, but just the same I can't begin to tell you how extraordinary it is for him to have called you so late at night." She clasped her hands. "It is more than a little weird, really."

"You might—or might not—be surprised how often I get calls in the wee hours from insomniac leaders struggling with big issues. So I've learned to do as they ask—and show up where they tell me."

My response seemed to reassure her.

"I've been away for a couple of nights, but George called me today. He was excited, very much so, as he told me a little about the work you do. I understand you help leaders sort out their lives . . . and all of that. I gather you've made some progress." She took a deep breath. "Well, actually *I* called *him*. We've been together for a long time, and I'm very sensitive to his, uh, needs." Her smile was somewhat defensive. "I guess all old married couples get wise to each others vibes, don't you think?"

"I always suspected my wife was clairvoyant."

"*Was*?"

"She died ten years ago." Should I tell her or not? "She was killed in a botched robbery, actually."

"I'm so terribly sorry."

"Life happens."

"I know." Sometimes the eyes confess the secrets of the heart. "I was responsible for a man's death once. I was just

seventeen. I drove through a stop sign; I never saw it." She exhaled deeply. "I don't know why I'm telling you this…."

"Traumas never fade until we share them."

"He was my beau." Tears welled in her eyes. "I never got over it."

"Never?"

She dabbed her eyes with a handkerchief she retrieved from her pocket.

"Not until George came along. I was thirty-one by then. People said we were opposites, but the truth of the matter is we were both a little wild. But I'm sure you know that. We married three months later."

"And the rumor is that you straightened him out?"

"We helped each other. Isn't that what love and marriage are about?"

"It seems to me that love is an ideal and marriage a reality."

"We all need a little help to close the gap."

"I think so."

"Then great marriage isn't about two perfect people finding each other?"

She wasn't so much asking as testing me.

"Well, that's the myth. The reality more likely has to do with two imperfect people learning to enjoy their differences."

"And helping each other to grow?"

"Yes—and not run away from life."

She smiled, then reflected a moment. "George used to joke that marriage is based on the theory that when a man discovers a brand of beer exactly to his taste he should throw over his job and go work in the brewery."

Jokes can be incredibly revealing. But was she saying more than she realized or was she intentionally nudging our

conversation to the issue of addiction? For the moment, I decided to play it straight.

"Well, we can never see into someone else's marriage. But, again, it seems to me that successful marriage might just require falling in love with the same person many times. Let's be honest, happiness in marriage is largely a matter of chance."

Smiling again, she said, "Like putting your hand into a bag of snakes in the hopes of drawing out an eel?"

An astonishing sexual metaphor from a woman so seemingly prim. Had she suffered from bad prior relationships? Perhaps she'd deliberately killed that former childhood sweetheart. Goody-goody persona often masks underlying rage. Or maybe she'd merely gotten stuck with a flaccid eel and was seeking reassurance.

"Nearly all marriages, even happy ones, are mistakes. In a more perfect world, both partners might find an ideal mate. The real soul-mate, however, is the one you are married to."

"George and I love each other, we're best friends, too."

Was she saying that their relationship had become platonic?

"That's great. Friends don't always have to agree on everything or always go everywhere together. Sometimes they even have other similarly intimate friendships. Friendship is more about ideal things. That's why it's typically less subject to stress than marriage."

"Stress is the killer for us." Revealing rather more than she'd intended, Laura dropped her hands to her lap, her eyes following them. "He's fine. Most of the time he's just fine."

"Most of the time?"

"This job … this job … well, you must see it for yourself. The pressure is incredible … and … and things haven't been

going well. And nobody's perfect, Doctor Alter. Once or twice—he might have been drinking again."

"Tonight?"

"From what I gather his sessions with you were both enlightening and disturbing. He said that you and he had come up with a big idea, a paradigm shift, he called it. He was very excited, perhaps too excited.

"Big ideas are innately exciting."

"Dangerous, too, I fear. I called him because I was worried, and after speaking to him I knew I had to come back. It's no secret that he has an addiction issue, he's discussed it openly. That's why, when I heard that blend of excitement and agitation in his voice, I knew I had to come straight back. He needed me here, and I was right. I found him passed out on the floor in his private study. Maybe he didn't use anything. I couldn't see anything or find anything, so maybe he just fell asleep, but I don't think so." She paused. "He woke up and said that you were coming and that he needed to freshen up. After he went upstairs, I looked in on him and found him passed out on the bed."

"Did he mention the chance of an urgent trip to Egypt?"

Her eyes darted to the door; she'd heard him coming. Dropping her voice to a whisper, she said, "He needs help, Doctor Alter. The kind that only someone like you can give. Please."

The door burst open and he strode into the room. I stood but she did not. The silence was awkward. The president's shirt was white and crisp, the top button open and his red tie loose. He was carrying his blue suit jacket over an arm. "Just needed to freshen up, Doc," he said, breaking the silence and grinning self-consciously. "Well, at least you got to meet my better half," he added as he strolled toward her. "Thanks for

attending to Doc Alter, darling." He pecked her on the cheek, and she snatched her head away as she rose to her feet.

"Doctor Alter is a good man, George"—she stepped through the open door—"so you listen to him." She punctuated her words by firmly closing the door behind her. A brief silence followed.

"Getting to Egypt in time is impossible, Doc," he said with a poker face before breaking into a wide smile. "But *nothin's* hopeless for this United States President. So we're gonna find another way to get this football into play. In fact, I've already put things into motion. Here's the plan. We're gonna go downstairs to the communication center, bet you didn't know about that. Well, you might've, but you'd never guess the scope of the thing. Come on"—he strode toward the door —"I'll show you."

The downward journey took longer than the ride up. This time, the elevator opened into a charcoal-carpeted, spacious, brightly lit space. One gray suited security officer sprang to attention, but George instantly put the fellow at ease with a cheery nod. Three large, flatscreen television monitors were mounted beside one another on one wall, and beneath them was a row of eight clocks showing the time around the world. Facing them were a long black desk and a row of red-upholstered chrome swivel chairs. On the wall to the left, a large window framed a view into an elaborate recording studio.

"See, Doc, no need to hop a plane. We can deliver a closed circuit message to just about any major world city. But we got to get the right message. So here's the plan. We'll work from the draft and start taping a broadcast for those, Arabs, those, uh, leaders of the Arab world, right now. Then we'll polish it till I get it perfect. Now let me introduce you to the team." He

strode to the studio door, pressed it open, and we stepped inside.

A chorus of "Good Evening, Mister President"s greeted us, from what turned out to be a television camera operator, a sound engineer, and a communications director.

"This is Doc Alter," said the president. "As you know, Doc and I will be working on big speech, so we're gonna need all the help you guys can give us. So where've you got to on this project?"

"The speech is on the TelePrompter, Mister President," said the communications director. "What do you think of the setup?"

We checked out the television screens. A replica of the Oval Office desk and chair was standing in front of a voluminous bookcase.

"I like the desk but let's make the whole thing the Oval."

The director nodded and the bookcase image was suddenly gone, replaced by the Oval Office windows, replete with rows of standing flags.

"And can you get me a glass of ice water?"

"It's in the studio already, Mister President, just like you asked. I'm assuming you don't want to show it on camera."

"No, just within reach. We're recording, right? So you can fix whatever we go with later." He turned to me. "I'm not a natural actor. Didn't used to be much good at these kinds of pitches, actually. Takes practice. But I've gotten better. Learned to relax, loosen up—that's the key." He turned and led the camera and sound technicians into the studio. The director indicated for me follow him outside and take a chair next to him in front of the television screens. The clear window gave us a partial view of the studio, enough to see the desk and the technicians.

"There's a makeup room in there, too," said the director, "so it'll be a minute or so before we see the president onscreen. Meantime, I'll need you to wear these headphones, just as I will. That way we can hear what's happening in the studio, and we can also make ourselves heard." He slipped the thick headphones on and smiled. They made him look like a big bug; I followed his lead.

My eyes focused on the microphone hanging over the empty presidential desk repeated three times on those impressive television monitors. I remember cynically thinking that most people's heads are filled with other people's ideas, their lives are a mimicry, their passions a quotation—and, since speech falls midway between thought and action, it often substitutes for both.

So, I wondered, might the fate of the Middle East truly be determined by the ability of this well-meaning but incurious and insecure leader to deliver a message? Had he truly given up on the fallacy that it's because he understands complex issues better than anyone else that he mouths belligerent words? Might it even be possible that he had come to the realization that peace, no less than war, requires idealism, self-sacrifice, and a righteous and dynamic faith? The trouble with weak leaders is that they'd rather seem tough than intelligent. So would this particularly fragile mortal be able to seize the big idea that sometimes the fastest way to win a war is to surrender the notion of victory?

He was now framed on the three monitors. The window into the studio gave a wider view that included that of the TelePrompter, camera and microphone, and the men operating these. After taking a gulp of ice water, he set the glass down behind the desk, then sat and clasped his hands on top of the desk.

"I'm ready," he said. "Gonna nail this, you watch."

"You're looking good too, Mister President," said the director, raising his left forefinger to his lips in a respectful call for silence. Then, maintaining eye contact he slowly pointed his right forefinger towards the president and nodded to begin. The president straightened his back and gazed straight ahead. Then his brow furrowed, and his words came out unevenly:

> I want to take this opportunity to speak to the Arab and Muslim nations gathered here today and to the world at large. I begin with a simple message: I'm sorry.

He halted and addressed me through the glass window. "Does that sound right, Doc? I mean I know I said I liked it earlier, but does it *sound* okay?" He reached beside him for his tumbler. "I mean does it sound, uh, presidential?"

"It sounds fine, Mister President," said the communications director.

"Yeah, but what does Doc think?"

"I think you're striking the right note, sincere but not contrite." He wasn't reassured. "But you might not be tapping the full potential of your poise and power."

"Poise and power?" He gulped the water again, and set the tumbler back. "Okay, let me take another shot."

"From the top, Mister President," said the communications director.

This time he was infinitely more fluent:

> I want to take this opportunity to speak to the Arab and Muslim nations gathered here today and to the world at large. I begin with a simple message: I'm sorry. I'm sorry that I rushed into the invasion of Iraq. I honestly believed that Saddam had weapons of mass destruction. I was wrong. I now realize that in unilaterally launching the war

the way I did, you were left to feel that I had breached a bond of trust between America and the world. Not only did that alienate you from us, it made us less effective in Iraq. We had too few allies and too little legitimacy. I apologize—sincerely. I'm most sorry, though, that my bungling of the war has prompted all of us to take our eye off the ball. I messed up the treatment so badly that …

He winced and halted. *"Bungling? Messed up?* Do I really need to use those words, Doc?" He reflexively took another sip from the tumbler.

"They're nice clean simple words and it's the kind of straight talk people expect from you, Mister President, so it'll soften up the audience for the real kick later."

"Yeah, soften 'em up early"—he raised and shook both fists gleefully—"then kick 'em hard later. I like it."

"Let's take it from the beginning of that last sentence," said the director.

The president pointed both index fingers at the communications director and grinned. "Will do," he said, inserting his fingers into his ears, *"Big-Ears!"*

The director smiled politely and the president refocused himself:

I messed up the treatment so badly that people have forgotten the patient really does have a disease. Now that I've apologized, I hope you will stop fixating on me and look closely at what is happening in your backyard: the forces and pathologies that brought us 9/11 are still there and multiplying.

"Oh Christ, do we really want to say *messed up?* Or *apologized?* And what about *pathologies?* What the hell does that mean? I mean, I know I approved it, but how does it *sound?*"

"The message itself is deceptively bold, Mister President, as you well know, of course. And your delivery is heartfelt and

sincere, pitch-perfect, in fact. Seems to me that you'll disarm them now, then catch them off guard later."

"Yeah, disarm 'em first,"—he took a quick sip of water—"then catch 'em later"—he nodded—"I remember."

"Go on to the next line—from 'Friends we are,'" said the director.

> Friends, we are losing in Iraq. But to whom are we losing? Is it to the Iraqi "Vietcong" – the authentic carriers of Iraqi nationalism? No, it is not. We are being defeated by nihilistic Islamist suicide bombers, who are proliferating across the Muslim world. We are losing to people who blow up mosques, markets, hospital emergency wards, and girls' schools. They don't even tell us their names, let alone propose a peaceful future.

"This is good stuff, Doc!"

"Yes, it's working, Mister President. Very commanding."

"Yeah, I've got it all working, Doc."

"No need to go back, Mister President," said the director. "Just keep on trucking."

"Right, keep on truckin'."

> Look at the past two weeks: On Thursday, at least nine Iraqi soldiers were found dead after a suicide car bomber rammed a checkpoint. Two suicide car bombers crashed into a Kurdistan Democratic Party office in Zamar. A day earlier, a suicide bomber killed four policemen in Balad Ruz. Two days earlier, nine U.S. soldiers were killed by a pair of suicide attackers driving garbage trucks packed with explosives. A few days earlier, five bomb attacks killed nearly two hundred people in Baghdad. On Monday this week, a suicide bomber blew up a funeral in Khalis, killing at least thirty.

"Wow! Are these figures right, Doc?"

"I gather so."

"Those bastards!" He took another gulp from the tumbler, then set it back, refocused, and raised his eyes to the camera.

That's twelve suicide bombers in a little over a week. And it's been like that every month. These suicide jihadists are so hard to defeat because they have no desire to build anything. Their only goal is to make sure that America fails in its effort to bring decent, pluralistic, progressive politics to Iraq. They will kill any number of Muslims to ensure that we fail.

Do not delude yourselves that this is only about Iraq. In March, a suicide bomber blew up an Internet cafe in Morocco, and on April 10, four more suicide bombers struck there. On April 11, a pair of suicide bombers, claimed by Al Qaeda, killed twenty-four people or more in separate attacks in Algiers. In February, a suicide bomber in Quetta, Pakistan, blew up a courtroom, killing the judge and at least fourteen other people—the sixth suicide bombing in that country in a month. Last Friday, Saudi police arrested one hundred and seventy-two who they said were jihadists planning to carry out missions like flying planes into oil fields. On Saturday, a suicide bomber in Pakistan killed at least twenty-eight people while trying to blow up the interior minister. You may think that I'm more dangerous than Bin Laden and that a strong America is more dangerous than Al Qaeda—

"Oh, Christ! Why would they ever think that, Doc? I've put my presidency on the line for those fuckers, those, uh, Arabs, those Arab leaders. America has given blood and treasure to bring them democracy and freedom, for Chrissakes."

"You're merely setting up a straw man, Mister President. And now you're going to knock him down."

"Yeah, right, I remember. Prop him up, knock him down."

"Continue on from, 'You may think that I'm more,' Mister President."

You may think that I'm more dangerous than Bin Laden and that a strong America is more dangerous than Al Qaeda. You're wrong. If we are defeated in Iraq, they'll come after you. They already have. And if we're defeated in Iraq, you'll no longer have to contend with a world with too much American power. You'll have to contend with a world with too little American power. And you will not like it.

Don't let your anger with me blind you to your own interests. You are holding your breath until I turn blue. But I'm not going to turn blue. You are. I want to get out of Iraq as soon as possible, but I need you, the Arab leaders, to get off the fence. I know that you fear democracy in Iraq, but the alternative is worse. If the jihadists win, the Arab world will have no future. I need your help in forging a settlement in Iraq and in denouncing this suicide madness from every mosque and minaret every hour of every day—with no qualifications.

"Way to go! Tell it to the fuckers straight."

And to Europe, China and Russia, I also say: Get off the fence—I can't stabilize Iraq without your help. I don't have the resources. I know I was a jerk in stiff-arming you. Believe me, I'm over it. I'm here to listen to what you want me to do. But unless we—the world of order—all pull together now, the forces of disorder are going to have their way, and there is no wall that will protect us.

His on-camera delivery was pitch-perfect and the windup was masterful. I'd not seen anything so impressive since his speech to Congress after the 9/11 attacks. It was a polished performance that could inspire the respect of even his most scathing critics.

He bounced out of the studio euphoric and smiling broadly. "How long till it's ready, Big-Ears?"

"All the takes were clean, so it should be a very simple process, Mister President," replied the director. "Give me five minutes and I'll have a disc for you," he added as he strode from the room.

"So what'd *you* think, Doc?"

"I thought your performance was poised, assured, fluent and utterly professional, Mister President. You struck exactly the right chords. It is a speech that will go into the history books and make you infinitely more than a hero here at home. They'll sing your praises throughout the Middle East, too."

"And the whole world, too—right Doc? They'll be rememberin' me." He gazed off into space for a moment. "And *quoting* me?" he asked. "*Me*—right, Mister Alternator?"

He seemed dizzy and off-center and his mood was escalating from exhilaration to ebullience.

"Yes, they'll quote you, Mister President."

"They won't be thinking—and no one else will be claiming—that someone else wrote this stuff—right?"

"Never. It has your imprint all over it."

"My imprint?" Miffed, he asked, "What does *that* mean?"

"It means that everything about that speech showcased your special personal style."

"Are you saying that someone showcased me?"

"Not at all. You showcased yourself."

"With my"—he pursed his lips—"special personal style?"

"Your unique ability to distill complex issues into solid common sense and deliver a message from the heart with simple, plain words."

"Simple? Plain?" Clearly annoyed, he stepped into my space. "Look, I mightn't be *Doctor* George Bush, but I'm no simpleton, either."

"No one would ever—"

"So don't you or anyone else try to grab the credit for my words"—his eyes were blazing—"my ideas, my— uh, bigtime drift."

"Of course not, you'll be getting all the credit for the paradigm shift."

I instantly realized that I should never have said that.

Glaring at me as he turned beet red, he repeated, "Paradigm? Bigtime? Shift? Drift? They're all the *same*." For emphasis, he poked me in the chest seven times to beat out the rhythm of, "Who gives a shit, anyway?"

After a few minutes of uncomfortable silence the director strode back into the room holding up a thin plastic box. "Here's your disk, Mister President," he said gingerly, apparently aware of the change in mood. "It's pretty well perfect."

The president snatched the disc and studied it closely.

"Pretty well? What does that mean, Big-Ears?"

The director took me in as he tried to focus on the president.

"I think the director is saying that we have a first-class pressing of your outstanding performance, Mister President."

I should not have spoken up.

"I wasn't talkin' to you, Alternator." He swung his chin to the director. "And why're you looking at him when you're talkin' to me?"

The director stared at the floor for several seconds before responding. "Perhaps you'd like to view the disc, Mister President."

"When I'm good and ready, Big Ears." Angry, he swung his attention between the director and me. "Anyway, I'm gonna show it to myself—upstairs." Clutching the DVD tightly, he swung around and stumbled against a chair. He lost his balance and crashed to the floor, taking a nasty bump to the head on his way down. His eyes rolled upward and he stared blankly into our stunned faces before turning to vomit the contents of his stomach on the carpet. Then he lay dead still.

The technicians were in the studio so I couldn't tell whether they'd noticed the incident. I do remember that none of them appeared as the director dropped his voice to a barely audible whisper. "It's the vodka," he said. "The bottle's empty."

"Vodka? He drank a *bottle* of vodka?" I asked.

"I can't be sure. What I do know is that it was half full when we began."

All that imbibing of ice water suddenly made sense.

What to do? I dropped to my knees. A bruise was forming above his eye where there was a slight laceration. But I could see that he was breathing. I also caught a peek at a silver hip flask inside his breast pocket. The DVD had fallen from his hands, so I picked it up and noticed that the plastic case was cracked.

"I made two copies, so you can hold on to that one," said the director.

I reflexively slipped it into my jacket pocket. Then the door behind me burst open, and I heard an anguished voice.

"Whatever is happening?"

REPERCUSSIONS

DON'T ASK ME HOW, BUT A WOMAN INEVITABLY knows when her man is in trouble. Laura fell to her knees. "Oh George, George," she murmured, wrapping her arms around him. Her eyes met mine, but there was no need for an explanation; we both knew what had happened. "We've got to get him upstairs," she said.

A rush of clomping feet fell fast behind her words.

"What the fuck is happening?"

The vice-president was wearing gray slacks, a blazer, and Gucci loafers, but was open-necked and sockless. He was glaring so angrily at me that he failed to notice the First Lady ministering to the president on the floor. But then he did and waved to the coterie of grim-faced security officers who had followed him into the room.

"Help her get the president upstairs immediately," he barked.

I was intrigued by the speed of his response. Two of the gray suits, one to a shoulder, picked him up. Then, led by the First Lady, they dragged him semi-stumbling from the room.

The vice-president glowered at me. "I demand to know what has been happening," he said.

I glanced over his shoulder to see Andy standing in the doorway. The gentle shake of his head indicated his need to feign ignorance, and for me to say little or nothing.

"The president called me a couple of hours ago—"

"*He* called *you*—at three in the morning?!"

"Late calls from top leaders are not uncommon in my line of work."

"*Really?*"

"He said he wanted my advice on a speech he was thinking of giving and wanted to rehearse," I said, ignoring his sarcasm. "I came as soon as I could. We went through it once and then, as you saw, he became ill and threw up."

"*Became ill.*" He mulled the words then turned to the director. "So where's the speech?"

"In the computer," replied the director, omitting to mention that he had already turned the data into a broadcastable DVD.

"In the computer? Well freeze that. Where's the hard copy?"

"I'm not sure, but I can get you a printout from the TelePrompter."

"Get it for me *now.* Amateurs," he spat at me. "*You* seem to have no idea of what you're doing, either, Doctor Alter." He eyed the mound of vomit on the carpet. "And now we have to clean up after your so-called help. Any professional suggestions as to how we might handle this? "

"Food poisoning is not uncommon, Mister Vice-President."

"*Food poisoning*—what sort of leadership counseling is that?" His lip curled into a sneer. "The President of the United States of America does *not* succumb to *stomach bugs.*" To Andy he added, "How will we ever explain this idiot to the press?"

"Nothing's on the record," Andy replied.

The vice-president eyed me coldly. "So get him out of here and out of town—*now.*"

"I'll handle it, Mister Vice President."

The vice-president stepped so close I could feel the heat from his flabby belly. "The stakes are high, Doctor Alter"—he waved his stubby forefinger in my face—"for you as well

as us, so not a word of this to anyone." His breath was tinged with menace—or cordite, maybe.

Andy escorted me in silence to his commodious, golden-carpeted northwest corner office, then closed the heavy black door behind us. Cathy was seated at the mahogany conference table; Andy took the head, and I sat opposite Cathy. The first signs of dawn were glowing in the floor to ceiling window.

"It didn't go well?" she whispered. Yellow light from the chandelier shone on her face and the moody seascape on the wall behind her.

"Yes and no," I answered. "The outcome was not ideal, but despite his illness—or perhaps even because of it—our Commander-in-Chief did a first-class job of presenting the message."

"Yes, he can do that," said Andy. "He's a superb communicator when he's prepared and relaxed. And as you say his illness helps him to relax—but only for a while."

"But in this case, he held it together right till the end."

"Sure, but the Veep won't let that message see the light of day."

"He'll kill the file," said Cathy.

I was in a quandary. Should I tell them about the DVD in my pocket? That might not be necessary—not right now, anyway.

"The director edited what he told me was a perfect disc," I said. "The vice-president didn't know so he didn't ask and the director never mentioned it."

Andy and Cathy exchanged glances.

"The director is a good guy," said Andy. "He knew what he was saying—and not saying." He paused. "He kept us in the loop throughout. I did get a late call when he spotted the vodka bottle, so I had a hunch it might all go off the rails."

"Things are moving quickly. Do you think we still might be in control?" asked Cathy.

"I wouldn't be so bold as to say that, but we might not have lost all influence, either. The fact is that the communications director does have the DVD, so there's a chance—very slim, I admit—that when the president recovers he might just authorize the broadcast." He became lost for a minute in watching the dawn outside his window. "In which case, it will doubtless ring out across the world, and you'll know that your mission was accomplished, Doctor Alter." Smiling ruefully he added, "But one thing for sure is that he won't be keeping this morning's meeting with you, so, all things considered, my feeling is that Agent Vale should escort you back to your hotel so you can pick up your things to go home."

It was just after half past six—and today was Wednesday.

"So near and yet so far. I'd set him up with a great reading so I'll be sorry to miss this session."

"You saw his problem first hand, Doctor," said Andy. "You don't really think you could have turned him around, do you?"

"It was Mark who fired him up and got him into the broadcast booth."

"Yes, and that was a great achievement, a miracle really."

"I'm not Svengali, but I did manage to breach the emperor's supposedly impenetrable state of denial. After that, however, *he* processed the ideas and *he* decided to change course."

"You were lucky, I think, to catch him stone cold sober."

"Maybe so, but if someone could only persuade him to read the final discussion paper—and if I could only catch him sober again—I might just be able to reach him again."

"And that someone, that friendly persuader, might still show up," said Cathy. "I mean, if it's meant to happen it will, right?"

"From your lips to God's ears," said Andy.

"Be careful," I wisecracked, "when the gods want to destroy us, they answer our prayers."

I didn't realize it then, but the joke was on me.

05/02/07 A.M. —DISCUSSION / RELATIONSHIP

WE SPED TOWARD THE JEFFERSON. SHOULD I GRAB my stuff and hightail it home? Or should I hang around and hope that someone—God only knows who—might draw me back into the president's orbit—or he into mine? If so, it would need to happen quickly. I decided to watch briefly and wait. I studied the oncoming centerline in the road, and then contemplated the orange early morning sunlight that danced in Cathy's distracted face.

"You came real close to making it happen, Mark."

"Not close enough. I played the power game and lost."

"The power game?"

"It's like chess. A group of courtiers forms around the king. On his own, he's pretty weak, so he needs the other pieces to survive. And they need to protect him, or they're out of the game."

"But people have ideas and feelings."

"Right, and that's the problem. Imagine a game of chess where all your chessmen had passions, intellects, and dollops of cunning. You'd be uncertain of your opponent's pieces and your own, too. What if your knight could shuffle himself on to a new square on the sly?"

Her smile in reply was sly. "And what if your bishop, in disgust at your castling, could wheedle your pawns out of their places?"

"Right! And what if your pawns, hating you because they are pawns, could sneak away from the protective positions you'd assigned them purely for the pleasure of seeing you checkmated."

"You might be smartest person in the world, yet still be beaten by your own pawns."

"Correct—and you would be most likely to be beaten if you arrogantly depended on mathematical imagination, and regarded your passionate pieces with contempt."

"So the message is?"

"To be a master player, you must also be a master psychologist. Understanding hidden motives is the key to acquiring and holding onto power."

"Sounds incredibly Machiavellian."

"Machiavelli was a realist. He told the impolite truth. He pointed out that we all want power but that we have to pursue it subtly, seeming disinterested and nonchalant, fair and decent."

"Congenial and cunning?"

"Exactly. The perfect courtier got his way through seduction, charm, deception, and subtle strategy, always planning several moves ahead. Life in the court was a never-ending game that required watchfulness and strategy. It was cultured war. It's the same today. Everything has to appear decent and democratic, but if the players adhere too rigidly to the rules they get hammered by those who don't."

"But isn't that the argument for torture? Do unto others before they do unto you."

"It's the dilemma of any decent person. Each of us has to find a way to negotiate through it."

"I guess we can opt out of the power game."

"Maybe, but the people who say they have are often the most adept players in the game. They project apparent weakness as a virtue. But any truly disinterested person wouldn't bother to win sympathy or respect with a proclamation of impotence. In the game of power, a display of weakness can actually be a powerful, subtle, and highly destructive maneuver. The same is true of professions of integrity or wide-eyed innocence. Assertions of piety are power plays intended to gull us into believing in a player's noble character. These players toss sand in our eyes by flaunting their piety and their exquisite sense of justice, when in fact they're tricking us with persuasion or coercion, even."

"So what should we do if we can't opt out?"

"Choose words carefully and excel at the game. Language exerts hidden power, like the moon on the tides. It's the quick way to become a better friend, lover, and provider. To become a perfect courtier is to become a source of pleasure. You make others feel good about themselves, so they'll always want to be around you."

"Sounds incredibly manipulative. I mean, don't you just make them codependent?"

"Maybe, but if the power game is unavoidable, then it's better to be deft than dopey. Nothing about power is natural. It's not moral or immoral, and it's not good or evil, either. It's a godlike force. We can use it to do good or evil, but it's a mistake to think in those terms. It's a game. So judge your adversary by his actions not his intentions. If a player's actions put you out of the game, who cares if he had your best interests

at heart or was a friend or foe? You are your own opponent. Stay calm and play to win."

"Here endeth the lesson?"

I laughed. "Not quite. Remember this, value depends upon cost. There's no point in attaining a worthy goal at a ruinous price. A sure way to lose is to get dragged into a losing situation."

"Thanks." I don't think I'd noticed just how beautiful she was. Maybe the challenge we'd shared had closed a certain emotional distance, too. She really was a striking creature. "I guess your career doesn't permit much of a social life," I said.

She smiled. "I don't need a social life."

"So, you're a loner?"

"I've just never met the right person, if that's what you're asking."

"I guess I was a little intrigued."

"And what about you, Mark? Are you a loner?"

"A widower actually."

"*Widower*, such a melancholy word"—she smiled empathetically—"but you're not thinking of entering a monastery, I hope."

The limo drew to a halt at the door of the Jefferson. Einstein was right; time really does accelerate in the company of a beautiful woman.

"My instruction is to keep you in sight at all times," she said. She followed me out of the limo, then leaned back into the driver's window: "I'll call when I need you," she said.

I'll confess it plain. Yes, my heart skipped a beat when she followed me into the hotel suite.

I took my computer from the tiny vault beside the cocktail cabinet, then stepped into the bedroom and strode to the *en suite* bathroom to pack my shaving gear and toiletries.

"You've got time to shower," she called to me.

"Well, yes, I would feel infinitely better for that."

I caught a glimpse of my reflection in the mirror. At least I had a full head of hair. Okay, most of it is silver, but might that be a turn-on for young women with Elektra issues? Maybe so, maybe not. But at least my frame was still strong. Chalk that up to regular workouts and the influence of Manhattan, a city crammed with existentialists seeking to recreate themselves to live forever.

I closed my eyes and the tranquilizing water drenched my skin. Okay, maybe I was guilty of wishful thinking. Slice it any way, but youth was gone and the wisdom that allegedly replaces it seemed meager compensation.

Yet one can be surprised.

"Sometimes it's best not to think, Mark"— she raised a finger to my lips— "or to talk, either."

What can I say? The overriding obligation of a truly mature individual is to steer youth away from folly. But one also has to consider the situation—this time and this place— this man, this woman?

Jefferson's portrait was floating above an altar, and I was lying in a coffin contemplating his blazing gaze. To my surprise, the eyes began to twinkle and he spoke, "Life, liberty and the pursuit of happiness compel us to acknowledge that we are mortal," he intoned. Then his face slowly morphed into a portrait of Grace. She was smiling enigmatically and her eyes were closed. "Grace, Grace," I said softly. She seemed to hear my voice, and tossed me the bouquet. I caught it, and noticed a tiny florist's envelope attached. The card inside bore a message; "Eyes without speaking confess the secrets of the heart."

"Time to wake up, Mark," she whispered sweetly. I opened my eyes and found myself looking into an effervescent television screen inside the open cabinet opposite the bed. By the top right corner of the FOX news panel, I saw that the time was 9:59 A.M. Cathy was wearing my pajama top. She dropped the remote between the pillows. "You really should get your head shaved," she said with an impish grin. "I mean, silver hair can be altogether too tempting."

I didn't know how to reply.

"No talking," she said. "Let's catch the news."

"FOX is your favorite channel?"

"Right now, yes. FOX is a key player in the war." She propped the pillow behind her head. "I have a fantasy where Rupert Murdoch is elected president but refuses to take the office because he won't give up power."

The American flag rolled across the top of the screen, and a picture of the White House dissolved to a vacuous newsreader with a long mane of platinum blond hair and clownish red lips that mouthed a solemn message:

"The Director of Homeland Security today announced a heightened security alert to Code Orange. The announcement follows a special intelligence briefing just yesterday. In the wake of the announcement, President Bush has cancelled all scheduled meetings and will be flying to his Crawford ranch for three days of confidential discussions with top advisors, including, according to FOX News sources, at least one general. 'Nothing is more important to the president than the security of the American people,' said Secretary of State Condoleezza Rice, 'and we will be seriously considering all of our options.'"

Cathy grabbed the remote and hit the mute button.

"So, there it is, Mark." She tossed the remote back onto the bed. "He's gone into hiding for three days to clear his head and heal his bruises."

A beep announced the arrival of an email. She grabbed the I-Phone and studied the incoming message.

"Oh, shit! The veep got to the director before we did. They deleted everything out of the computer and destroyed the DVD, too."

"Is that all?"

"It's more than enough, Mark. What'll we do?"

The phone burst to life. We both studied it intently, uncertain of how to proceed. It could only be for me. I picked it up. The sweet southern accent was unmistakable.

"It's me, Laura, I was hoping you'd still be there, Doctor Alter."

"And I am—and honored I am that you called."

I cupped the mouthpiece with my hand and whispered to Cathy that it was Laura. She flashed two thumbs up.

"I really enjoyed our conversation."

"The pleasure was mine."

"I'm just sorry things turned out the way they did, but…"

"What happens happens."

"You just might be doing the Lord's work…."

"Well, thanks."

"And you might still be able to help. I mean you originally intended to have at least one more session with George."

It was both a statement and a question. I felt a burst of adrenaline.

"I did, yes. And if it were still possible to help, I'd be delighted."

"I'm wondering if you could possibly meet with me and then have an early lunch with George—or possibly even join us for the weekend at the Crawford ranch?"

"I can fit in with whatever you can make happen."

"I'll do what I can, after that it'll be up to God. But come what may, let's get you back here immediately. I'll have a driver pick you up within the hour." She clicked off and I became aware of Cathy staring at me, expectantly.

"The First Lady wants me back in the picture—now, for lunch, then maybe to Crawford for the weekend. She's sending a car."

"Sounds weird—are you sure it was her?"

"Absolutely. I recognized her voice and she also mentioned last night's conversation."

"This could be a huge break, Mark!" she said excitedly. "There's a communications center at Crawford from which they can put out a television broadcast anywhere in the world."

"Could they transmit a DVD?"

"But we don't still have one, do we?"

She shot me a hard look but I decided it might be best if she didn't know, and failed to reply.

"Listen, Mark—if you do still have a copy"—she paused, waiting for me to give her a nod, but I didn't—"then broadcasting it would be a piece of cake—so long as the president authorizes it, of course. Did the First Lady say what she wanted?"

"Not exactly, but I'm sure it has to be the alcohol issue. She probably wants to get in on the act and help rescue her husband."

"And if you solve that problem you might also persuade him to authorize the broadcast! You have the opening to help them both, Mark—how will you handle it?"

"I'll confuse them."

"They're confused already."

"Yes, but not enough. Not yet. I need to introduce her to 'The Game'."

"The *game*?"

"It's a reading. It'll be the perfect conversation starter. With luck, she'll become part of the presidential solution."

"How will you get it to her?"

"I have it on a file in my computer. Ideally, I'd like her to have it before I meet with her. I'll print it out now. Can you get it to her ahead of time?"

"If it's a small file, just email it to Andy." She passed me a card that was blank except for a nondescript email address. "He'll print it out and deliver it to her."

I set my feet on the floor. "Give me a minute, I'll send him the file now."

I strode from the bedroom to the private lounge, but could not help glancing back as Cathy slipped her supple frame from the bed to the bathroom. Women are such a mystery. Men think they're the seducers, but that's rarely the case, especially, apparently, with this new generation of independent young professionals. But then she glanced back, too. Was it my imagination, or did I detect fondness for me in those indigo eyes?

I'd left my computer on standby, so the screen came up quickly. That was just as well, because I had one of those strange, out-of-nowhere apprehensions that my life might depend on my next several moves.

By the time I returned to the bedroom, Cathy was fully dressed and standing at the door. "Best if I get out of here, now," she said. Then she paused and tossed me a kiss. Was she gently mocking me? I couldn't quite tell. "Enjoy the gift of life," she said. "Tomorrow may be too late."

And then she was gone.

The limo would be downstairs by noon. Time might still be on my side.

I pulled myself together, packed my bag, carefully slipping my computer into the cushioned side pocket, and rode the elevator to the lobby. The driver, who was waiting, must have had a description of me. "This way, Doctor Alter," he said, firmly relieving me of my bag.

He led me to a long black vehicle. I was about to step inside when my cell phone vibrated. It was Cathy. "The veep knows the only remaining copy of that speech is the one the director gave you."

I'd never mentioned the extra copy to anybody, so how did Cathy know?

"The director told you about that?"

"He told Andy."

"Anyone else?"

"I don't know. It'll be safest to assume that everyone knows." She clicked off.

I ducked into the backseat of the limo, and reflexively recoiled from an unexpected sluglike presence.

MID-A.M GROUND TRANSPORTATION

"I'M KARL," HE SAID, EXTENDING A FLACCID PALM. "The First Lady asked me to escort you."

It was Turd-Blossom in the flesh. His hand was moist, and the eyes behind his rimless spectacles were polar.

"I gather you have some big ideas that might have caught the president's attention so it's especially nice to meet you, finally."

"Thanks—and call me Mark, please. This is certainly an unexpected honor."

As the limo pulled away, he settled back into the gray velvet, folded his lily white hands across his paunch, and smiled enigmatically. "Seems you have an odd take on the Iraq War."

"I might be on the side of those who say that we can no more win a war than an earthquake."

"That's a popular position right now, of course." The smile hadn't left his face. "But the people who say it are mostly theorists who deal only in words, whereas a president deals with reality—and the reality in this case is that the outcome of a war depends upon actions."

"To be honest, I have a moral problem with your selling of the war. I mean Iraq *never* had weapons of mass destruction—right?"

"Nobody knows for sure." Still smiling, he lifted a manicured index finger to his pudgy nose and scratched at it. "But it doesn't matter because in times of war, survival is more important than truth. At worst we told a noble lie."

"But we weren't *at* war."

"Of course we were. It just hadn't been declared."

"That's how you justify our preemptive strike?"

"You really should stop with your questions now. I've been grilled by experts," he said condescendingly, ready to dismiss me. But then his manners must have kicked in for he continued, "But, I will answer this question. That is *exactly* how we justify the war. We had to formalize the situation."

"And we didn't care about world opinion? It's okay for the U.S.A. to become the bully of the free world?"

"World opinion and the hypocrisy of other world leaders doesn't bother us. We all know that absolute truth is the first casualty in war—a lie is just another way of presenting the truth."

"The problem is that one lie costs a whole lot more than one truth because it costs the entire truth."

"The public would rather win the war than agonize over truth,"—he was warming to our debate against his better judgment—"that's why they elect leaders to tell them noble lies. It's also why it's more important for a leader's proposition to go to war to be more compelling than truthful."

"Correct me if I'm wrong, but as I see it, Saddam was just a coward who erected a Beware of the Dog sign, but didn't have the dog. More to the point, we were attacked on 9/11 by fifteen Saudi Arabians and four Egyptians armed with box-cutters and the idea that God was on their side. We can bomb Iraq back into the Stone Age, but how will this protect us from another dozen or so Saudi or Egyptian zealots armed with box-cutters?"

"We'll be shielded by our boldness. Ah, Doctor Alter, there's no point in having power unless you use it. If we fudged on the WMD issue, we now have Iraq strategically placed to influence the entire Arab world, so we, uh, the president made a hardnosed real-world decision to shift the entire region toward democracy and freedom."

"We're not there for the oil?"

"America has never been an empire. All we want is to help the Iraqis provide a secure supply of oil to the world—all of which is totally in their best interests."

"But have we been demonstrating power or incompetence?"

"Has everything gone right?" he answered, staring out the window. "No. But the creation of a new system is difficult. We're the enemies of everyone who would profit by the preservation of their old, corrupt institutions."

"And as far as I can tell, getting only tepid defense from those who would gain by the new ones. All of which proves, don't you think, that power corrupts?"

He must have had his answer ready for he turned his full attention on me. "Maybe. But the more interesting question is does powerlessness make anyone pure?" He grinned, pleased with himself, and pressed on. "I don't think so, Doctor Alter. In the real world, even well-meaning people are corrupted by powerlessness. Those who have no power will do anything to get it. But nobody gives you power, you have to take it"—he smiled boyishly—"and absolute power is kind of neat, really."

"I understand that the essence of leadership is the enjoyment of power and the responsibility that comes with it. Unfortunately, the mere love of power is the disease of narcissists. I think you might be confusing power with wisdom and greatness. You seem to believe that because you have power, you also have wisdom. But wealth and power stem mostly from luck. Greatness, however, is the result of goodness, daring, and discipline. Therefore, the only power worth aspiring to is power over oneself. Leaders who possess this power know that the love of liberty is the love and concern for others, and that the only advantage of power is the capacity it ensures to create a better world for everyone."

He adjusted his spectacles. "Well, that *is* idealistic. In the real world, how do we create such paragons?"

"By exposing them to good ideas. That's what alters the power balance. It's also why the best ideas are resisted. They come with heavy burdens. The gods of power frown on the frivolous, punish those merely looking for good times, and ultimately give satisfaction only to those who study and reflect."

I sensed his smirk. "We should take care not to make the intellect our god," he said. "It has powerful muscles, but no personality."

Personality! Precisely what got W elected. But of course his apparent affability sprang from serious underlying maladjustment.

"Knowledge builds authentic confidence, which is infinitely more crucial to leadership than personality. Better to know the lessons of the past and understand when *not* to use all your power. A leader is more effective when he has power in reserve."

"In my book, power never takes a backward step." The limo slowed, then reaccelerated as we entered a subterranean tunnel. Rove seemed not to notice, and continued to press his point. "Power is about passion, not intellect. It's the capacity to command respect"—I could not see his eyes but his white teeth flashed a *schadenfreudean* smile—"by holding someone else's fear in your hand and showing it to them!"

So there, the bully had gleefully admitted the cruelty in his modus operandi even though he failed to realize the extent of the cowardice that inspired it.

"Well, it seems to me you might be both right and wrong. Fear does rob the mind of the power to reason and act. And, yes, people do defer to a man with a gun, but the respect is for the gun, not the man. Remove the gun and respect gives way to contempt—and then reprisal."

He paused. "What do you *want*, Doctor Alter?" The question from the shadows caught me by surprise. I didn't answer before he continued, "Look, everything has a price, " he said, "and at this level, whatever you want I can almost certainly get."

"What do I want? Well, nothing you have or can get. I mean, you can't resurrect my wife or son. Separate evils took each of them to early graves. I was sorely tempted to give up on life, but then I made a choice. I decided, as naïve as it might sound, merely to be a force for good."

"I'm listening, Doctor Alter, and I'm almost persuaded."

"Almost persuaded?"

"Unfortunately, a lifetime in politics has taught me that idealism such as yours is merely a cloak to hide an underlying drive for power. And that, surely, is why you've gravitated to leadership consulting—which, as a psychologist, I imagine you clearly understand."

"Well, you're right, of course. My role is to influence those in power. So the more influence I have, the greater my power. Where we might differ is that I use my power for one reason only."

"And what might that be?"

"Well, not to sound priggish, but in my zeitgeist, the only legitimate use for power is to exercise it for the good of all humankind."

"Again, a very noble sentiment, Doctor Alter. Let us hope that you are never tested in having to weigh your own best interests against the good of all humankind."

The vehicle had come to a halt, and peering out, I recognized the gunmetal elevator door. Again, I was in the bowels of the White House.

I stepped out of the limo, but Turd Blossom remained seated. "You'll be in good hands," he said. The words were harmless enough, but something in his tone triggered alarms in my brain and stomach.

I was about to take my bag from the limo driver when the elevator doors slid open and the vice-president strode out,

two gray-suited security officers in tow. They all eyed me coldly, then the vice-president pointed at the bag. "Anything coming up into the White House must be inspected." He grabbed the bag—almost greedily, I thought—and clenched it firmly. Then, noting that I was observing him closely, he half smiled. "These are dangerous times," he said. "One cannot be too careful."

The vice-president and his two body guards ushered me into the elevator. I anticipated a surge beneath my feet as the elevator would propel us up into the White House. Instead we sunk, and that earlier apprehension of imminent danger now welled within me.

SECURITY CLEARANCE

THE ELEVATOR OPENED INTO A VESTIBULE. The walls, floor, and ceiling were gray, the lighting fluorescent. A steel door, with folding chairs flanking it, was set into the back right corner of the room. The two security men hung back behind the vice-president as he set my overnight bag onto a Formica-covered table and spoke to me. "It's just routine, Doctor Alter, but we'll need you to empty your pockets and show us the contents of the bag."

"Not a problem." I nonchalantly tossed the envelope containing the Grinning Man onto the table, then dropped my wallet and cell phone onto the wrapper. "Other than those, I've only a change of clothes and my computer."

He stepped forward, grabbed the envelope and opened it. "What's all this about?" he asked.

"It's a case study I'm presenting to a convention," I replied.

I held my breath as he cast his eye over the paper. To my relief, he failed to awaken to the Grinning Man (or perhaps I should say that the Grinning Man failed to awaken to him).

"You ivory-tower types love this arcane stuff," he said as he stuffed the paper back into the envelope, dropped it onto the table, and turned his attention to my bag.

"You have a computer in there?"

"I take it everywhere. I'm working on a book, so I need to get my thoughts down in spare moments. I also have discussion readings that I draw upon for counseling sessions."

"I've heard." He peered into the bag, removed the computer, and set it on the table. "I guess you know that terrorists have been known to hide explosives inside cell phones and computers."

"I have read that, yes."

"Well, we trust you, of course, Doctor Alter," he said, "but since you've been staying in a hotel, a terrorist may have found a way to tamper with this stuff, so we'll need an expert to conduct a thorough inspection." Without my being aware of how he was summoned, a nerdy male assistant entered the vestibule and retrieved everything from the table. Then he and the vice-president strode through the open door.

As the door was about to close behind them, one of the security officers called out to the vice-president. "We also need to search him for weapons—right?"

The vice-president's head reappeared around the door. "Yes." To me he said, "I understand you might be flying with the president so we can take no chances, as I'm sure you understand. And depending on what the inspection of the computer and cell phone reveal, the search may need to be rigorous." His head disappeared as he reached out and closed the door.

"Seems we need to check you for hidden weapons." I raised my arms as instructed and they proceeded, one in front

of me and one behind, to run their hands all over my body, rather robustly, I thought.

"So I guess this is what you call rigorous," I said.

"Not really," said the senior man, "rigorous calls for a much, uh, closer inspection."

"*Closer*? You'd want me to *strip*?"

"A rigorous search needs to be—probing."

Probing. A cavity search! *That's* what he was saying. If the vice didn't like what was on my computer they'd force me to strip and bend over. My intellect told me that the vice-president would shy away from presenting me to such ignominy. But my intuition suggested otherwise. Vice was a bully, and would draw comfort from my humiliation.

Think of the devil ... Strutting back into the room and holding up a DVD disc between his fingers as if it were a communion wafer, the vice-president had an expression on his face that told me he knew exactly what it contained. "*This* just popped out of your computer," he said, eyeing me coldly. "How did it get there?"

Coming up with an answer didn't take a lot of thought.

"It was given to me last night by an authorized official."

"*Authorized*? By whom?"

"By the president. It is an approved recording of a presentation he made. He knows of the existence of the DVD, and he was also there, in person, when it was given to me."

I saw no reason to add that the president was also dead drunk at the time.

"Did he give you permission to make a copy of it?"

"Not specifically. But it was a potentially irreplaceable recording and discs can be unreliable, so I backed it up to my hard drive."

"You did indeed!" Smirking triumphantly, he said, "And in so doing you have broken the law."

"That was never my intention, and in the absence of intent, no crime has been committed—especially since, as a trusted advisor to the president, it was my duty to protect the file he had authorized me to safeguard."

Smoldering beneath his gaze, the vice-president spoke in a deliberate monotone. "Listen, Doctor Alter, you're playing with fire. We're at war and you're trafficking in secrets."

"Any secrets I have are with the president. He has sought my advice to explore all his options calmly and rationally. You're clearly a brilliant man, Mister Vice President, so I'm sure you'll be the first to agree that any war that requires the suspension of reason as a necessity for support is a bad war."

"Let's be truthful, Doctor Alter. You're a peacenik."

"I'm a pragmatist actually."

"Really? Well, let me tell you something you should be able to get your head around. Yes, war kills men and men deplore the loss. But war also crushes bad principles and tyrants. And in so doing, saves societies. And *that's* the noble cause we're embarked upon."

"Noble? It doesn't bother you that Iraq had no weapons of mass destruction and nothing to do with 9/11? How noble can such a war be?"

"Beware lest in your anxiety to avoid war you obtain a master. Saddam was a cruel tyrant with evil intentions. Nobody has disputed the fact that he turned weapons of mass destruction on his own people, the Kurds. So the world is better off without him."

"Two wrongs make a right?"

"War is ugly but other things are uglier. The moral morons who bleat that nothing is worse than war are in fact worse.

They deem nothing worthy of a fight and sacrifice patriotism on the altar of pacifism. Nothing is more compelling to them than their own personal safety. They freeload upon the backs of people better than themselves."

"So, you'll be among those brave souls who gather arms and enter the fray?"

"A man can be a patriot without risking his life. I've risked my name and reputation for my country. Anyway, there are plenty of lives less valuable. The civilized world will look back and say that we were right to prefer war on our terms to peace on the terms of Islamic extremists."

"There's a third way, surely."

"Really—such as?"

"We could win the war by stealth and diplomacy. The highest form of generalship is to conquer an enemy by strategy."

"Sun Tzu said that. Right now, we're dealing with the realities of the present, Doctor Alter. We're waging war so we can live in peace, and there's simply no substitute for victory. So if we're reduced to trading quotes, then I prefer the perspective of Prince von Bulow, 'To the meaningless French idealisms, Liberty, Equality, Fraternity, I prefer the German realities of Infantry, Cavalry, and Artillery.'"

"And you don't care that world opinion condemns preemptive war—"

"This was one of those situations in which war could not be avoided. It could only be postponed to the enemy's advantage."

"It doesn't matter to you either, I suppose, that people say it was illegal and call you a war criminal."

His face reddened as his face swelled like that of a bull frog. His tongue appeared like a lash as he spoke. "It's the winners who decide what the war crimes were."

He was still glaring at me when the IT nerd slipped back into the room and set my computer and cell phone on the table. "The computer is harmless—and just to be sure I reformatted the hard drive."

I was galled by the high-handedness of this invasion.

"You wiped everything from my computer!"

He ignored me, and continued talking to the veep.

"The cell phone rang a couple of times so we know that it's not a bomb, either."

"Did you answer the calls?" asked the vice-president.

"Uh, no. But I copied the internal files so we'll be able to see who was calling and who he's been calling. I also made a backup of his computer, so we can have our people examine the contents at our leisure."

"A *backup*," said the vice-president. "Is it possible that *he* might have *another* backup."

The IT expert eyed me warily. "He's away from his office, so he wouldn't have been able to back up his entire computer. I suppose he *might* have been able to copy the DVD to an external flash drive."

"A flash drive—what's that?" asked the vice-president.

"A miniature, portable hard drive."

"Miniature? How miniature?"

"As small as two fingers." To make his point he held up his two forefingers side by side.

"Two fingers!" To the senior security officer, the veep asked, "Did you search him for a flash drive?"

"Not *rigorously*."

Dismissing the IT man, the vice-president said, "Thanks for your help, you can go now." After waiting for the door to close, the vice-president spoke to the security officer in charge, "This is a national security issue so there's no choice." Oh, Christ! It was clear from his expression that he meant for them to run a cavity search. "I can't be present, "he tossed off as he strutted to the elevator. "You both know the *stakes* and you both know your *duty*." In what almost resembled a Strangelovian salute, he extended his arm sideways and punched a button with his forefinger. The doors whished shut and he was gone.

I heard a sharp snap behind me and turned. The junior security officer was tugging milky white latex gloves onto his upturned fingers.

"We're going to need you to strip," said the senior officer.

It was straight out of those notorious Milgram experiments. A powerful authority figure had formally instructed innately compliant human beings to inflict punishment, pain, and humiliation upon an innocent victim and then cleverly removed himself from the scene. If need be, he could deny ever having given such an instruction and assert that nothing of the sort had ever happened. The nameless underlings would simply disappear. So, should I fight and refuse, first verbally then if need be physically? I contemplated the various arguments I might use to stop these grim guardians. Given the frozen expression on their faces, I seriously doubted my powers of persuasion would sway or deter them. And, physically, it was a fight I could never win. Indeed, I might inflame them, and ultimately wind up in worse shape than if I had meekly acquiesced. So perhaps I should buckle under and attempt to anesthetize my apprehension by mentally framing the intrusion as nothing more than a routine

prostate exam. None of these choices seemed tolerable, though. To be honest, I felt afraid.

And then that sweet Ode to Joy wafted into the sterile air. I didn't ask permission and I didn't wait even one moment before striding to the table and grabbing my phone. The music abruptly stopped and, though it seemed to be coming from a far off place, one of the sweetest voices I ever heard whispered into my ear.

"It's Laura"—oh, what a sweet, sweet voice—"you missed lunch. I'm calling from the plane. We're on our way to Crawford. I called you earlier but you didn't answer. When it seemed you weren't coming, we couldn't wait." Sounding stressed, she added, "But we'll still need you to join us. Where *are* you, for goodness sake?"

I weighed whether to disclose the indignities that had befallen me, but decided she would think I was exaggerating. She might even conclude that I was some kind of nut and accidently play into the vice-president's hands. He would deny everything, and at best I would wind up looking like a wimp.

"I don't know for sure. The limo picked me up as you said it would, but then"—both security officers were eyeing me suspiciously—"I got held up in the security system. As far as I can tell, I'm still under the White House."

"Oh, that's so *silly*! Are you alone?"

"Not at all. Two very professional security officers are taking care of me."

"So let me talk to whoever's in charge."

I passed the phone to the senior officer. "It's the First Lady, she'd like to talk to you." Eyeing me suspiciously, he reluctantly took the phone.

"Yes." His tone, abrupt at first, immediately softened. "Yes, ma'am …" He sounded chagrined. "It's just routine security, ma'am… Yes, ma'am… Right away, ma'am."

After passing the phone back to me, he said, "Seems there's a helicopter and a minder waiting for you on the South Lawn."

My escort and I ascended slowly and in silence. His eyes were downcast the entire time, as well they should be. Mine had been a harrowing experience, but on the bright side, I now knew something I had only previously suspected. The vice-president truly was a duplicitous devil. Did the president know? Probably. Weak leaders are often paired with outwardly tough but inwardly cowardly sidekicks. They both condone and turn a blind eye to the sidekick's machinations. Think Goebbels. No, Goebbels would be Rove, not Cheney. Think Goering. Yes, Goering. The ghost of Goering was alive and well and haunting the White House.

Maybe the notion of reincarnation is not so farfetched.

FLIGHT FROM THE WHITE HOUSE

IT WAS 1:21 P.M. AND THE BLADES ATOP THE JADE green Sikorsky Sea King helicopter were already spinning. The ceremonial marine stood guard beside the prominent Old Glory emblazoned above the hatch. I ducked beneath the four whirling blades, strode up the five aluminum steps, and bundled into the cabin. To my surprise—and, if I'm being honest, to my delight—Cathy Vale grabbed and stowed my overnight bag, then motioned me to take a seat next to her and behind and to the left of the pilot.

"We're still in good time, Doctor Alter," she said, very professionally. "This will be a very short ride to Andrews

Airbase. We'll pick up a Gulfstream and head for the Crawford airport, a couple of miles from the president's ranch."

The plush, black leather seat gripped me as the South Lawn receded and we ascended into the Washington sky. I wondered how Cathy might feel about me now, given our recent—how shall I say it?—our, uh, close encounter. I suffer from the political incorrectness of old-school males that allows me to view her as a vulnerable girl, not always a professional woman. I also wondered if, for her, I might merely be an interesting diversion, an intriguing experience, a widower to console with a simple act of kindness. I studied her face, but her professional mask remained in place. And yet, and yet . . .

Waving a hand, she steered my eyes to the view of the anachronistic, gloriously misplaced Greek and Roman architecture elements so loathed by Frank Lloyd Wright. The White House, the Capitol, the eye-catching Rotunda, the Washington Monument, the Supreme Court, the Treasury, the National History Museum—on and on it went. This particular perspective would surely captivate the heart of every giddy politician who ever rode the presidential helicopter. *Oh, to be holding the reins of power on this Monopoly Board,* those levitating aspirants must have thought. But it is for a shot at eternal glory, surely, that power-hungry players so willingly demean themselves. To be anointed leader of the free world can be a ticket to immortality. Ah yes—the definition of that that cynical lexicographer Ambrose Bierce penned sprang to mind:

> **Immortality***;* noun:
> *A toy which people cry for,*
> *And on their knees apply for,*
> *Dispute, contend and lie for,*
> *And if allowed*
> *Would be right proud*
> *Eternally to die for.*

The Gulfstream turbos purred like testosteroned tomcats as we became airborne and rose above the clouds. The scent of high octane lingered in my nostrils, but the soft and supple leather seats smelled of money, as did the artfully designed beige interior. It was set up to carry eight passengers, but Cathy and I were the only upfront cargo. In the rear were a couple of white-shirted, stone-faced security guards, one of whom was spread-eagled on the luxurious couch.

Our seats were wide and set beside each other in the middle of the narrow cabin behind the pilot. A wall panel beside each seat contained stationery embossed with the name of the plane, *Conquest*. We each had a Plexiglas portal, mine to the right of me, hers to the left. Strobes of sunlight broke through the bright cumulus clouds that floated past her Plexiglas portal, and flickered on her face.

"I gather you were delayed," she said.

The remark was cautious, coded, and indicated that she had an inkling of what I had been through. And of what might be coming. Given the presence of those security officers, it seemed unwise to share the darker elements of the morning's drama, so my response was equally cautious.

"Just routine security. The vice-president was kind enough to be on hand to usher me through it himself."

"Yes, I heard he has tremendous respect for the work you're doing." Such irony! Not that anyone else would notice. "But, of course, the security of the president is paramount, so I guess the vice-president made sure that you passed a rigorous inspection."

"That was his understandable concern. I guess you security people get used to expert's inspecting cell phones and computers, ejecting DVD's, backing things up, and reformatting hard drives."

Her eyes widened. "Reformatting hard drives?"

"Yes, that can be a problem"—I offered up the faintest of smiles—"unless one has taken proper precautions, of course."

"Proper precautions?"

"'To foresee is to rule'—that's a quote from Pascal." Was this the time to tell her more? Again I decided no—why put her at risk? What she did not know, she could not tell, even under duress. "I might have been delayed even longer, but the First Lady called, personally, perhaps from Air Force One for all I know, to expedite things. So the inspection never got too, uh, probing."

"Nothing overturned your equilibrium?"

"I still have time to complete my project, and all's well that ends well. So, do you make this kind of trip often?" I asked. "I mean how does all that work?"

"Well, I've only been to Crawford once, and I'm never quite sure who sends me on these assignments. But if a person is important enough, as I guess you must be, the order typically emanates from the chief of staff. He who ultimately knows everything."

So, there it was. Vice had secretly tried to terminate my discussions with the president. But Andy must have subsequently heard about that abuse of power, presumably from the First Lady. Then he put Cathy back on the project, but, I wondered, does Vice know? "I guess at that level everyone knows pretty much everything."

"One has to assume so," she replied.

She was right of course. Vice was certain to know that I was on my way to Crawford. But what else did he know?

"So I guess people keep close track of you, too?"

"Sometimes they like me to fly under the radar."

So Vice knew about me, but not about Cathy.

"Is that truly possible?"

"It's typically a crucial element of my job, Doctor Alter. Right now, you're the man with the message, and my mission is to make sure that it gets delivered, and I'm going to do just that." Sliding a solid fabric blind across her window, she was cast in shadow. "We'll be there in an hour. " She leaned back in her seat and closed her eyes.

To foresee is indeed to rule. I plucked a pen from my pocket, a piece of stationery from the side panel, and swung out the floating table from the arm of my chair. Perhaps a poem would suffice. I watched as the black ink flowed from my pen onto the soft blue paper:

> *There's a chapel in the mind*
> *And when we kneel there can find*
> *The shining wisdom to rewind*
> *All trespasses*
> *Yes, there's an altar in that place*
> *So upon a fall from grace*
> *We should carefully retrace*
> *All our sins*

I folded my literary effort and set it to the side of my table. Beneath us, the lizard-like shadow of the plane slid across the sunburned prairie. How had it all come to this? Where was I going? What was my mission? The answer came up out my unconscious like an atoll coming up out of the sea: *I had a charge to keep*—I truly and inescapably was a man with a message that must be delivered. I pondered how best to honor my duty and eventually settled upon a three-pronged strategy. I would introduce the First Lady to the Game and the president to the Grinning Man. Then, since one precious DVD remained, I would summon all my powers to persuade the president to

authorize the broadcast of his speech. I closed my eyes, settled back into my pulsing seat, and chased thoughts that floated like sweet but ungraspable butterflies within my brain.

An otherworldly voice came over the address system, "We are losing altitude." But horizontal cumulus clouds were floating past the window, so we were not falling. The voice continued, "All our journeys are futile." Cathy was not by my side. Where could she be? I glanced backwards. The security officers were nowhere to be seen, either. Was I alone on the plane? I attempted to stand but my seat belt was fastened. I tried to release it but the catch was locked. Was I strapped into a doomed plane? The handle on the door to the pilot's cabin began to turn. Then the door burst open and a captain in a shabby uniform stepped out. His eyes were dull and his complexion was strange and wan. Tears welled in my eyes as I recognized the face. It was Ethan. "Here's the problem, Dad," he said, "success has many parents, but failure is always an orphan." He smiled as if we both knew exactly what he was saying. I reached out to him but he stepped back, and began to sing:

*Tempt a son to ride the sky
and he will slip you, flying high,
or nip you for the blatant lie.
—for sure, he'll trip you bye and bye*

Then he strode to the emergency exit and yanked the release handle, and the plane careened as the door flew open. He snapped a salute in my direction then, as the plane plunged downwards, leapt out into the sky.

"Hey, Doctor Alter—we just dropped into an air pocket." Cathy grasped my elbow. "And you were dreaming, too, right?"

"Yes, I guess so."

She smiled and raised the shade on her window.

"If you look out, you'll have nice view of the presidential ranch." A winding stream glistened in the distance. "That's the Brazos River. Next to it, cotton fields. A local pilot recently wound up in handcuffs for dusting the boll weevils with insecticide there. He didn't know the president was in residence and he had violated the twenty-mile no-fly-zone—if he's not in residence, it's only six."

"So they take security seriously—almost James Bondish?

"More than you realize. Some officials believe it is possible for a small plane to be used in an attack, so a whole airborne armada constantly hovers over the ranch. Pilots have wound up facing helicopter gunships and F-16 fighter jets. The FAA has taken action against dozens of pilots."

"So it's under control?"

"You'd think so, but the number of wayward pilots is actually increasing. Over the summer, despite ample news coverage of his month-long working vacation there, a dozen or so pilots flew too close to the ranch. They don't know where the restricted space begins and ends. The six-mile circle around the ranch is clearly marked as prohibited on aviation charts. But whenever he's in residence, the circle can expand to whatever his security detail sees fit. When Russian President Vladimir Putin visited, the circle grew to thirty miles. The Air Defense Command initially requested an eighty-mile circle to give fighter jets more time to respond to a potential threat. But that got nixed by the FAA. Such a large area would have affected the approach paths into Dallas/Fort Worth International Airport, so you almost have to be the president's

social secretary to know where it's safe to fly." My stomach turned as the plane banked. "And the problem is compounded by the topography."

The countryside was marked by gently rolling limestone hills and cedar trees that appeared to be quite tiny. The buildings were all located in an area only slightly larger than a cornfield.

"But we won't be challenged, I hope?"

"No, they know we're coming. They're sure to have had someone tracking us from the moment we left Andrews."

After thinking about that for a moment, I passed her the poem. "Here are a couple of verses you might find enlightening," I said.

"Verses?"—she smiled—"I'll look them over, later," she said, slipping the blue notepaper it into her purse.

Someone tracking us.... I may have experienced a premonition, or I may simply have fallen into another bad dream, for the double reflection of a face appeared in the Plexiglas. Perhaps I was becoming paranoid. *Someone.* Those images were refracting from a pair of spectacles. *Someone.* The spectacles were perched upon the nose of the VEEP. The mouth beneath it was fixed in an evil grin. Then, as suddenly as it appeared, the images disappeared, the turbos growled, and the wheels of the plane bumped us to a steady landing.

CRAWFORD RANCH: P.M.

A FLOOD OF MID-AFTERNOON SUN HIT OUR FACES as we exited the plane, and I reflexively cupped my hand to my forehead and panned the scene. A shimmering mist of fuel vapors rose into the sky. As it wafted away, I caught the heavier scent of cedar trees. I stepped onto the steaming blacktop and was momentarily comforted by something solid beneath my feet.

"Well, howdy—and welcome back, Miss Vale." She said she'd only been here once so I was a touch surprised as the limo driver greeted Cathy like an old friend. Perhaps all aging men warm to attractive young women. "This time, we'll bypass Crawford and take the back roads."

The security guards watched as the driver closed our door, then disappeared into the appropriately bullet-shaped, silver security trailer just inside the gate. The driver tucked himself in behind the wheel and turned, his profile to us. "Protesters heading for the Bush ranch are routinely harassed by a local posse," he said with a chuckle, "and the local sheriff has been known to detour protestors down dead-end roads." He hit the gas and we began to glide out of the airport. "Regular sightseers mostly have no problem," he continued, one eye on the road, and the other on us. "Unless, of course, they disobey the orange signs against stopping, standing, or parking near the ranch. That can rouse the Secret Service to action."

With his introduction out of the way, he slid the Plexiglas partition slowly upward. Cathy and I were alone.

She reached into her purse, produced my poem, and unfolded the blue notepaper. "What's this?" she asked with an amused smile. It really is hard to impress a modern young woman, apparently. She scanned the page, mouthing the words. "Are you writing me love poems?"

"My son was the poet, I'm just a dabbler. But you've got a literary bent so you'll figure it all out when the need arises—just don't lose it in the meantime."

"Oh, Mark, you're so coy—or should we both say cryptic?"

Cryptic? Perhaps she was telling me to guard my words. If the limo was bugged, the driver didn't seem to know.

Refolding the blue paper and tucking it back into her purse, she said softly, "And when you passed through security, you're sure you lost nothing you can't replace?"

"Anything lost can always be found, so long as we follow the heart's poetry."

"Poetry reveals our deepest secrets?"

"Of course. If he were alive, Shakespeare himself would tell you that a subtle poem always a code that clues our intuitions and discloses our innermost secrets."

"She smiled, reached into her attaché case and produced a one-page, neatly typed document, which she then she slipped onto my lap, pointing to the headline: EXECUTIVE ORDER TO BROADCAST. It was an official authorization to let the president's speech out into the world. I followed her forefinger to bottom of the page. My mission could not have been made clearer. I must persuade the president to sign on the dotted line—and then present both the document and the DVD to Cathy. She folded the heavy bond paper and slipped it into another one of those special red envelopes, and placed it in my hand.

"And that's how our mission in life gets to be completed, Doctor Alter? And all in good time, right? Isn't that what the Zen masters teach?"

I tucked the envelope into my breast pocket. "Time is less of an issue in the Zen world than in this one."

"I guess so"—she nodded solemnly—"Cinderella's coach always turns into a pumpkin at midnight in this world."

Midnight! It was half past three now. Egypt was eight hours ahead of us. To reach them at ten in the morning, their time, the broadcast would have go out at two A.M. our time. So she was giving me till midnight to complete my part of the mission.

"So time is always running out?"

"Cinderella has to deal with wicked sisters full of vice, too. They'd kill her if they could."

Wicked sisters full of vice. The veep and his cronies! This was turning into more of a nightmare than a fairy tale.

"Well, I'm not in Cinderella's shoes—and thankfully I'm about to enter what is surely one of the world's safest havens."

"Stay in touch. Maybe I'll have something to share later."

We rode along an asphalt road with dirt shoulders that abutted an eight-foot high fence, whose painted cedar poles and crossbars encased sturdy wire mesh.

The partition slowly lowered. "Just about there," said the driver. I saw a wide ranch gate a couple hundred yards ahead of us. "Yeah, this is the dude ranch where the president becomes the Marlboro Man," said the driver with a chuckle. "But those Dixie Chicks needn't be ashamed that the president is from Texas. Real Texans know he's the son of a carpetbagger whose ancestral mansion is in Maine. Mostly they turn a blind eye. Mind you, some neighbors preferred the smell when it was a hog farm. Excepting, maybe, for the former owner. He sold out and became reduced to a kind of sharecropper. Now he runs two hundred head of his own cattle on the ranch. Guess it provides the president with mad-cow-free, free-range-fed beef, so he can say he still eats it."

The driver's volubility worried Cathy. "Thanks for injecting some local color for Doctor Alter," she said, her tone closing him down.

"Well, here we are then," he said.

In no way did the entrance embody what some have called the president's imperial style. Three old wagon wheels were mounted on top of a crossbar, which was supported by two

fifteen-foot cedar posts. In the distance, a row of cedars rose from the dusty earth.

We cleared security and headed north until the blacktop turned to dirt, and a galvanized tin roof appeared atop a long, low limestone structure, stark and simple as a motel. The contrast between this backwoods dwelling and the ancestral home in Maine—a two-story New England shingle-style, oceanfront home, as I recall—was dramatic indeed. Perhaps the Crawford home represented a continuation of the wish to deny his roots and diss his father.

"The house was designed by what they call an environmental architect," said the driver, "and then it got built by a local religious commune. They hauled in that yellowish native limestone—all being discarded by a local quarry, by the way, so they got it cheap—supposedly so as not to mar the natural landscape." We came to rest beside clusters of bluebonnets. "It all looks pretty peaceful," I said.

"Sure, safe and sound, too," said Cathy. "You can't see them, but a dozen tiny guard huts for Secret Service sharpshooters are scattered over the property. SS also patrols the perimeter of neighboring properties, too." She paused. "We're going to drop you here, Doctor Alter. I'm heading back to the security trailer that was just inside the gate." After the driver opened my door and I stepped out, I leaned back in when Cathy said, "You can call me if you, uh, need anything."

Anything. I stood in the bright sunlight, inhaling the sweet scent of cedar. What I needed was more time. Persuasion is a process, not a single event. I could not risk pushing too hard— or seem to be doing so. The conversations that lay ahead would need to appear leisurely. For me to succeed, the president would have to believe that any breakthrough was his and his alone. To succeed I would have to take risks, and I would also have

to be prepared to fail. *Anything.* If only she'd said *Mark*—as in 'call me if you need me, Mark.' I was becoming altogether too attached to this modern young woman. But she, I guessed, merely took what she needed, and the odds of my remaining on her shopping list seemed slim. But then again, maybe not.

As the driver handed me my bag, the front door to the house opened and the First Lady appeared clad in slacks, a blouse, and matching moccasin's, all white. She held out her right hand, "Welcome to Crawford," she said. "So glad you could come." She seemed genuinely happy to see me. "We've no other visitors, so rather than put you in separate quarters, you can use our guest room. But let me give you the one-dollar tour before I show you to your room." Her sweet drawl was comforting, yet I sensed that her warmth masked trepidation.

"You just missed George. He's riding his bike through the ranch's canyons to clear his head. He'll be back in an hour, so that'll give you and me time for a quiet visit." Raising a hand, she indicated the rolling hills behind the house. "We fell in love with the landscape and decided to build a real home"— she settled a fond gaze on the structure itself—"something unpretentious to enjoy, not just look at, something to catch the views and the sun and nestle into the landscape."

The hills rose behind the house in the north and to the front of it in the south. The low profile of the house itself ran from west to east. To the west, a grove of oak trees would doubtless shelter out the late-afternoon sun. To the east was a sparkling lake of maybe ten acres.

"Seems you succeeded," I said.

"We wanted something manageable, nothing huge."

The house was long but narrow, no more than 4000 square feet overall, small indeed by Texas standards. A roof

overhang that jutted out ten feet provided shelter from the sun and extended all the way around the house.

"We wanted our parents to feel comfortable here, so there are no stairs or thresholds," she said. Then she smiled. "We also want to grow old and become grandparents here ourselves." She pointed out a cluster of bushes and shrubs. "I planted those honeysuckles myself. By the time we retire, they'll be shielding us from the sun."

"A swimming pool, too, I see."

"Oh that, the twins wanted that. George calls it the whining pool because they whined until they got it."

Inside, a series of floor to ceiling glass doors and windows ran throughout the house. In the main room, they provided north and south and east aspects.

A limestone fireplace surround was set into the east wall. To the left of it, two sets of double doors opened onto the patio and overlooked a cedar grove. To the right, one such exit commanded the same view. In front of the fireplace, a conversation area was set up around a glass and wrought iron coffee table, on which a vase of bluebonnets and couple colorful Texan-style art books were placed.

Two generously sized tub chairs sat on either side of the fireplace, facing into the room. On the north and south sides of the room, two cushy camel-colored, linen sofas faced each other across the coffee table. Finally, opposite the fireplace, two commodious lounge chairs, lightly patterned in blue, also faced inwards.

"This is the dining-living-family room, all in one."

The west wall was filled with bookcases. In front and alongside them stood a long, rectangular, honey-oak dining table, encompassed by eight dining chairs.

A vase of freshly cut bluebonnets sat on the dining table. "Locals say you're not really a Texan unless you've had your baby picture taken in bluebonnets. Bluebonnet seed can lay dormant in the soil for up to twenty-five years and still germinate and flower." Warming to her subject she continued, "Legend has it that bluebonnets first appeared as a sign of a drought's end. An orphaned Comanche girl sacrificed a doll, her most valued possession, to end a drought and bluebonnets appeared the very next morning."

For sure, her husband had never had his baby picture taken in bluebonnets. Was she fessing up that he wasn't a true Texan? Was she was hoping for the germination of a powerful idea within his dormant mind, and sharing a prayer for renewal? Probably not. That was my hope, not hers.

"It's a home where George can kick off his cowboy boots and watch baseball on TV," Laura finished.

Why bother to become president if you'd rather watch baseball? Did this signal an underlying disinterest in addressing weightier issues? Was his fascination with baseball further evidence of obsession with his father, the sometime Yale baseball star? Or perhaps, the errant son was hoping to substitute television for alcohol as a means to distract himself from his own failing presidency? I suspended judgment. Better to think about all that after I had introduced him to the Grinning Man.

"We already owned most of the furniture."

Why did she want me to know? Was she attempting to convey an impression of frugality?

"The sofas are new but the desk belonged to George's grandfather. There's also a desk in George's study that used to belong to his dad."

The Freudians would have a field day! They'd see an emotionally fragile owner playing out his Oedipal struggles on television, then, for penance, toiling away at his father's old desk.

"We didn't want anything grand. I spent a lot of campaign downtime flipping through home décor magazines looking for good ideas and bargains. I don't want people coming in here and going, 'Ohmigod, they've spent every last penny.'"

Why confess to a stranger the concern that people would judge her profligate? Did she, too, suffer the same sense of inferiority as her husband?

Leading me out through the wide north door, she said, "The house is mostly one room wide. We figured that was a good way to catch the breeze. It's kind of quirky, but the porch is the usual route from one room to another. We sit out on this patio a lot of the time, especially when it rains. We watch the water pour down off the roof without getting wet. Water's scarce in this part of Texas, so we built a gravel border all around the house to channel it into a huge tank for irrigation," she added, delighted to showcase the environmentally friendly features. "Then, when the weather gets hot, the water in the tank cools this very patio. It's all kind of neat, don't you think?"

"Very clever indeed."

"And here," she said, leading me farther along the covered walkway, "is the guest bedroom." After pushing open the door open, she lowered her voice and said, "Andy gave me that quirky little piece of yours on the Game. He said you wanted to discuss it with me. Well, I read it, of course, but it was a little confusing, so I'll need to read it again. Why don't you drop your things and freshen up, then join me for coffee in the living room."

The guest room was small but comfortable. Twin beds dressed in white linen were set against the south limestone wall. A bright oil of the sunburned local hills hung on the west wall above a narrow pine desk, which in turn abutted a built in wardrobe. I dropped my bag inside the wardrobe and stepped into the bathroom where I splashed my face with water. As I reached for a towel to dry my face, I gazed out the window above the sink at a leafy oak. The acorn may never fall far from the tree, but does the shade of a towering oak stunt the growth of a sapling? The immediate challenge, of course, would be to clue the First Lady into her role in the Game. As I lowered my eyes, the blurry face of grinning man appeared within the bark of the oak. On closer inspection, I realized that the visage was merely a trick of my imagination. But it triggered a thought—two heads are better than one. Yes, Laura and the president should *both* meet the Grinning Man. My mind raced ahead. As to the precise paths of their intellectual and emotional journeys, I would have to see how the sessions played out, and then follow my intuitions. But would I be up to that? I would know the answer in mere moments.

THE GAME

I KNEW THE GAME WOULD CATCH HER attention, so I was not surprised to find her sitting in a tub chair in front of the fireplace, reading about it so intently that she failed to notice me enter the room. On the table in front of her were two china mugs, a silver pot of coffee, a matching jug of cream, and a sugar bowl. Sensing my presence, she raised her eyes. "Oh, Doctor Alter—pardon my inattention."

"Not at all. In fact, you are paying very close attention to all of my needs." I settled myself into the matching tub chair. The faintest whiff of creosote emanated from the fireplace and mingled with the scent from the vase of bluebonnets and the aroma from the coffee pot. An image of Grace raced to mind. Flowers and ashes, contentment and companionship. I glanced to the view showcased by the southern windows. Having moved westward, the late-afternoon sun was no longer visible, but the last rays bathed the undulating auburn hills in a soft and soothing light. Then a stray cloud cast a shadow over the scene.

"George is in an odd mood," she said, pouring the steaming coffee.

I imagined that would be true. It would be embarrassing for him to meet me so soon after his relapse in the recording studio.

"Moods are intrinsic to the human condition," I replied with a smile.

The coffee was a fine brew.

"So you know how to handle temperamental people," she said, obviously worried that this next meeting would blow up in my face.

But did I share her concern? Yes and no. On the bright side, he'd have had time to process our earlier discussions and readings. Then again, our most crucial discussions had taken place in the evening, and 'agreements reached in the hue of night are overturned by the morning light.' So daylight forces might obliterate all memory of the events that culminated in his egregious collapse.

Laura set her cup down and retrieved the paper from the coffee table. "So what should I make of this funny game you—oh, George, there you are." She rose slowly.

And there he was indeed, thick-necked, barrel-chested, and lightly perspiring. His cycling outfit was professional: rubber-lipped, yellow-lensed athletic sunglasses, tight white shirt, black riding shorts, and shoes. Holding his helmet in his left hand, he reached out with the right. "Welcome to Texas, Mister Alternator." It might have been my imagination, but the handshake and drawl were stronger, his expression stonier.

I attempted to meet his gaze, but caught only my own image in his golden lenses. "Well, thanks for asking me. I'm honored—and especially privileged to be in your home, of course."

Awkwardly, he removed the glasses and waved his hand over the room. "Just a homely place for simple Texas folks," he said. Then he stepped forward and swung an arm around the First Lady. Now I understood his discomfort. His right eye was badly blackened, and a nasty, stitched, iodine-laden lesion stuck to his brow like a cornered cockroach. His grin was somewhat sheepish. "Laura's the one with the vision, you know!" From the way he delivered the line, I gathered he was making the intentional pun and gently mocking his own appearance. "Ignore the wounds," he said, "this mountain biking can be a dangerous business." Maintaining his smile, he asked the First Lady, "No news, while I was away? No crises, no tragedies, no disasters?"

"Nothing remotely earth-shattering," she replied.

He focused on the piece of paper in her hand and stepped back, clearly miffed. "I didn't mean to intrude."

"*Intrude*? Don't be silly, George. Doctor Alter and I were just talking about a couple of ideas he has so kindly shared."

He plucked the paper from her hand, studied it, then cast me a cocky grin. "The Game," he said, "the *Game*." He

paused. "Yeah, I read this. We're gonna discuss it later, right, Doc?"

"You shared it with me, George, so I thought it might help if I got Mark's insights, too."

"*Mark's insights*," he repeated coldly before grinning at me. "Well, you really do have a way with people."

"Oh, George, *please*!" Her irritation mollified him but only somewhat.

"Look, I got nothin' to do right now." His remark dripped with sarcasm. "So maybe the good doctor would care to clue me in so I can participate in this discussion, too. Whatdaya say, Alternator?" He clearly intended his disdain to end the discussion.

"Well, I'm not a family therapist," I said, playing it straight but keeping my options open.

She jumped right in. "I think it's a *great* idea. George and I already shared your other readings."

"You did?"

"Yes, and I particularly liked the idea of a psychic contract." She knew very well that he was miffed, but nonetheless chose to take his sarcasm at face value. "George's dad would have been a tough act for anyone to follow."

Clearly savvy, she had a thoroughly pragmatic perspective. He wanted a one-on-one discussion in which he'd have more control, and in many ways, I favored that, too. But he and I had covered a lot of ground, and the leadership readings were out of the way. Now we'd be discussing the issue that most crucially affected her. That would make it difficult for him to lie or dissemble in her presence. If I could get a real discussion going, her insights might be very helpful. Sure, he might clam up, but I could cross that bridge then—maybe. My newfound charm hadn't worked too well on that latex-gloved security

officer. But then again fate had intervened before he got to the point of entry. Fate! Was fate playing a hand here in Crawford, Texas? I'm not superstitious, but I remember thinking it might be wise for me to accept this concerned and empathetic woman's entreaty as a precious gift from the gods.

"Well, Mister President, another perspective might be helpful. You want to start right here and now?" I was pretty sure he'd want to shower and change first.

"It's just a couple of minutes of light reading"—he tossed the paper on the coffee table—"so why don't you step up to the plate." He strode past me and plonked himself down in the tub chair I'd been sitting in. This was amusing. First he'd suggested something he didn't really want, but now his macho side had taken over and he couldn't back out. Fortunately, he hadn't sweated too profusely.

She took the other tub chair, and I decided to remain standing. "Here's a suggestion, folks. The president is right, the Game is pretty straightforward, so let's get that out of the way first, then break for an hour or so and meet again."

"To talk about what?"

"That'll depend on how this first discussion goes."

"You don't wanna say?"

"Oh, George! Doctor Alter knows what he's doing. Have a little faith."

He set his sunglasses back on his nose and the cockroach went back into hiding. Then he leaned back in his chair and folded his arms across his chest. "Sure, *Doc*"—he flashed a thin but ebullient grin—"so let's get into the game." The surly teenage tone and closed off body language was intentional. I knew, as I turned the contents of that pithy paper over in my mind, that I would need all the diplomatic skills I could muster

"Well, the basic concept is simple, as you say, but deceptively so. It first appeared in the book *Games People Play*. The book became a best-seller, then someone turned the idea into song and it soared to the top of the charts."

"So it really is pop psychology, right?"

Pop psychology. On the bright side, he was listening, so a serious reply might catch his attention.

"In fact, the author was a psychiatrist, and the book began as a technical text for his colleagues. Fortunately, in addition to being a pioneering practitioner, he was also a fine writer with a knack for making complex ideas accessible." The First Lady had been paying very close attention. "You've read the piece, so perhaps you'd like to summarize the key concept."

Happy to showcase her understanding, she began, "Well, the basic idea, 'transactional analysis,' seems to be that unless we get a handle on what we're doing, we poor humans are akin to puppets condemned to play the same silly charades over and over."

"Right!—thank you."

The president jumped right in.

"What you transactional analysis I call shallow psychobabble."

Shallow psychobabble. Should I have tried to tell him that the greatest ideas confound and confuse precisely because they seem so simple? No, best take the other tack.

"And you may be *right*! But just so we're all swinging at the same ball"—I reached down, picked the paper up and passed it to the First Lady—"can I ask you to refresh my mind, and maybe yours, too, by reading the opening passage aloud?"

Her voice, though sometimes tremulous, was clear and sweet:

THE GAME OF ALCOHOLIC
From *Games People Play*, by Eric Berne

> In full flower Alcoholic is a five-handed game, although the roles may be condensed so that it starts off and terminates as two-handed.
>
> • The central role is that of the *Alcoholic*—the one who is 'it'—played by White.
>
> • The chief supporting role is that of *Persecutor*, typically played by a member of the opposite sex, usually the spouse.
>
> • The third role is that of *Rescuer*, usually played by someone of the same sex, often the good family doctor who is interested in the patient and also in drinking problems.

The president squirmed uncomfortably in his chair, but Laura pretended not to notice and continued:

> In the classical situation, the doctor successfully rescues the alcoholic from his habit. After White has not taken a drink for six months they congratulate each other. The following day White is found in the gutter—

"So much for that dopey doctor!"

"You may be right, again, Mister President. Maybe the doctor was naïve to imagine that a once-and-for-all cure was possible. Maybe he should have known better. Do you have an opinion on that?" I asked her.

"I think … I think …"

"She's not sure what *she* thinks—and *you're* the expert, so why don't you tell us what *you* think?"

This was not going smoothly. "Well, cases differ, so nobody knows for sure." I needed to reframe the discussion. "But is it possible, Mister President, that this story might be somewhat akin to a parable?"

"A *parable*?" The question piqued his born-again sensibilities and he uncrossed his arms and sat forward.

"Perhaps Doctor Alter is suggesting that the story is setting us up to draw our own conclusions."

"Well, yeah! But a parable has a *message*. And I don't see one here. So what's the moral, Doc?" He was still combative but his mood had shifted slightly. He was engaged, albeit reluctantly.

"Well, as you know, parables can sometimes be obtuse."

He removed his sunglasses and jutted his jaw. "Yeah, but only till you figure them out!"

"Right, the aim of a parable is to lead us to the truth."

"The *real* truth."

"Exactly"—I shot him a grin—"not just the kind of superficial insight you immediately spotted coming from the self-congratulatory doctor in this particular parable."

He perked up at the compliment, and Laura spoke up, asking, "So what can be extracted from the story, Doctor Alter?"

I drew a deep breath. "Look, we're all adults. So let's not pussyfoot around. One expert, Eric Berne, is offering us his ideas of the childish rules that govern what he calls the "game" of alcoholism."

"But he is only *one* so-called expert, right, Mark?"

Hey, he called me Mark! And he also set his glasses on the coffee table.

"Yes! And he came up with his theory fifty plus years ago, so *he might well be wrong*. In fact, many psychologists believe that he *is* wrong!"

"They *do*? So why the hell are we bothering with this idea at all?"

"Because Mark's leading us somewhere," Laura answered disarmingly. "Right?"

"We're discussing the idea because this guy's ideas might be better than other experts realize—*or* he might be wrong in some cases but right in others. So, we should suspend our judgment and at least *think* about what he's saying long enough to reach a reasonable conclusion." I noticed that the president's hands were steepled. "I mean, don't you agree, Mister President?" He acted surprised to find me seeking his approval. "I mean I'll bet you have to go through this kind of process in every cabinet meeting?"

Grinning broadly, he said, "You got *that* right, Doc."

I decided to go for broke.

"So, for the purpose of this discussion, let's make another assumption, Mister President. Let's assume that the three of us—you, me, and the First Lady—might just be engaged in what Eric Berne calls the Game of Alcoholic."

Laura stepped into a longish pause and said, "If that were so, then might what happened last night, make"—she peeked at her husband—"uh, according to the rules of this game—"

"Yeah, yeah, yeah. According to this guy's rules, I'm the hopeless alcoholic who wound up in the gutter"—he offered up a winsome, conspiratorial grin—"right, Doc?"

"Well, yes, that's probably how he'd characterize things."

"That would make you the Rescuer and me the Persecutor?" said the First Lady, clasping her hands defensively across her lap. "But you don't really think I persecute George, do you?"

"You might be the better judge of that!" I replied, addressing my answer to the president. He grinned again, awkwardly at first, but then rather more broadly. I refocused on the First Lady. "But I think the answer is going to be 'maybe

so and maybe not.' Let's press on with the reading and you'll see what I mean."

This time her voice was more confident.

> In the initial stages of Alcoholic, the wife may play all three supporting roles: at midnight the *Patsy*, undressing him, making him coffee and letting him beat up on her; in the morning the *Persecutor*, berating him for the evil of his ways; and in the evening the *Rescuer*, pleading with him to change them.

She paused awkwardly and I jumped into the silence. "I'm sure you'd never intentionally persecute anyone, but what I think is less important than what you think. Other than not seeing yourself as a persecutor, is there a role in the game you think you might have played?"

"I might have played Rescuer."

"Did you play that role last night?"

"That wasn't a game," she said, warily. "I just came down when I thought George might've been in trouble."

"Well"—the president formed his fingers into revolvers, and pointed them at the ceiling, revealing the clunky, black watch on his left wrist to be a sophisticated heart-rate monitor—"according to these rules we all played the game last night."

"Has it happened before?"

They shared an awkward silence.

"Did you ever try to prevent the president from . . ."

"Going off the rails? Yes. I was at him all the time."

"So you, Mister President, might have viewed the First Lady as …"

"My Persecutor?" He thought about that for a long time. "Well, maybe somebody had to show me the error of my ways."

"Somebody had to *punish* you?"

Standing, Laura let her gaze go to the glass door that overlooked the cedar grove. "*Me*. Yes, that was me. I played Persecutor and Rescuer both." She shook her head slightly and refocused on us. "Your mother got on your case, too, George."

"And my dad …"

"But nothing worked until …"

"Until Billy Graham showed me the light—so I guess, according to this set of rules, he was my Rescuer."

"Oh, George! There were other Billy Grahams, too. "George was okay for long stretches; he was great when he was governor of Texas."

"But then he got to be president and things went awry?"

"No, not immediately," the president replied. "I relapsed—that's the word, right?" he finished quietly.

"It happened sometime after the Mission Accomplished speech," Laura added, looking steadily into my eyes. "He believed what he said, you know. They all did. But then the whole war got out of hand. Our soldiers kept dying, and George didn't know what to do. Then you came along … Do you hope to become his rescuer, too?"

"No! That is *exactly* what I have absolutely no intention of becoming"—they both looked at me blankly—"because according to game theory if I fell into that role I'd merely compound the problem." I paused. "Let's consider the final paragraph."

And so she continued:

> The *payoff* in 'Alcoholic' comes not from the drinking itself but from the hangover, and most especially the psychological torment. In therapy, these drinkers favor a hard round of psychological 'Morning After'—that is to say, a protracted discussion of the suffering that followed

their binge. *The transactional object* of the drinking is to set up a situation where the inner Child can be severely scolded not only by the internal Parent but by any parental figures in the environment interested enough to oblige. Hence the therapy of this game should be concentrated not on the drinking but on a subroutine within the Game called morning after, the self-indulgence in self-castigation.

"Kind of getting back to that psychobabble stuff again, Doc?" he said good-naturedly. "I mean, what's the moral, exactly?"

I nodded to the First Lady, "Any suggestions?"

"Is it saying that the alcoholic *enjoys* being scolded?"

"Is she on the right track, Mister President?"

"I sure as hell don't enjoy being yelled at, so why would anyone else?"

"Well, there might be method in the apparent madness." I took another deep breath. "If we accept this theory, the alcoholic achieves three goals: first, he draws attention to his plight; second, his unconscious mind finds a way—albeit a self-destructive way—for him to escape his current predicament; third, he also eases his guilt by punishing himself for his apparent failure—thereby redeeming himself again, or so he hopes."

"Oh, Doctor Alter! It all seems so bizarre."

"It can seem incredible, I know. What I personally find remarkable is the logic that drives the syndrome."

"Look, Doc, I've gone almost as far as I can along this weird road. But I'll stay with you one more step"—he pointed a forefinger directly at my heart—"so long as you can riddle me one last question." He showed a burst of pride in cutting to the core and said, "*What's the cure?*"

I remained silent.

"George is right, we're continually arguing about this game without getting anywhere. So, does this fellow know how to solve the problem—"

"Yeah—or is he just another ivory-tower theoretician?"

So, there it was. They'd both reached the point of wanting to extract clarity from confusion. Should I answer or not? I pondered the absence of the Grinning Man. Should I launch him now? No, I decided, not just yet.

"Well, according to this theory, the cure lies in persuading the alcoholic to give up the game."

"How does that work exactly, Doctor Alter?"

"The other players have to refuse to indulge him by getting drawn into the game. Instead of playing any role, we have to take what is called an adult contractual position."

"But we *are* all adults, Doc."

"Not according to this theory, George." A light had gone on for Laura. "Sometimes we play childish games—like Alcoholic and Rescuer—and sometimes"—she smiled sheepishly—"we become scolding Parents and Persecutors."

"Yes! The cure has two parts. First, everyone has to understand the game and learn all the rules. Then, after we figure out what's been going on we can—and must—*refuse ever to play any part in the game ever again!*"

"Sounds doable, Doc."

"It does, but there are problems. First, it can be unbearably difficult for an Alcoholic to find anything as absorbing as the game."

"*Why?*" Laura asked, almost plaintively.

"Well, the problem is that most alcoholics are afraid of intimacy. What that means is that instead of giving up the game of Alcoholic altogether, they may have to play some other game."

"Yet *another* game? And what might that be, Doc?"

"Well, according to this theory you might have played King of the Hill very successfully in Texas." He blanched at my reference to our earlier conversation on mountains and fathers, then he grinned sheepishly and began to process that apparently off-putting thought.

"You said there were *two* problems in getting an Alcoholic to give up the game, Doctor Alter."

"I did, yes, but I might be getting ahead of myself. Can we take a break, and then see how our next meeting pans out."

"That would suit me fine," said the President. He grabbed his sunglasses, jumped to his feet, and said, "I'm expecting a call. I also need to shower and change." He studied me, affably, I thought. "So how do you want to handle this Doc?"

"Can we get back together in an hour or so?"

"Sure, come meet me in my office at eighteen-fifteen."

18:15—that kind of obsessive focus is not uncommon among alcoholics and dry drunks.

"Will it be okay for me to sit in on that discussion?"

"Doc's the one running the show. Whatdaya think, Mark?"

Mark. His mood was infinitely more open—she'd been a big help. Just the same, our next conversation might be infinitely trickier. It was better, clearly, to have the president resurrect the Grinning Man before bringing the First Lady into the discussion. By the time that happened, they'd both be pretty confused, and if the wisdom of my dream held true and clarity really did spring from confusion, all would be well.

"How about the First Lady joining us after, say, uh, fifty minutes?"

"I've arranged dinner for eight, so that should work well."

He seemed relieved.

"Meantime, I have one last piece of homework, Mister President." I produced the white shroud from my pocket extracted one copy of the reading, and delivered it into the presidential palm.

He unfolded and glanced over the pages. "You want me to read this *now*?"

"No, just look it over before our next discussion. It's a quick read. You'll enjoy it."

He cocked his head, held the document up between thumb and forefinger. "Hey, a grinning man—just what the doctor ordered," he said, casting a smile at the First Lady and disappearing out the door.

"Come out on the patio," Laura said, leading me outside. "It's lovely this time of day."

She was right—the air was warm but dry, the patio surprisingly cool, and the late-afternoon sun bathed the cedars in soft light. Laura stretched her arms above her head and breathed in deeply. "Don't you love the smell of wildflowers," she said rhetorically. "See, the yellow in the foreground there"—my eyes followed her pinky finger—"that's the Texas Star. Just beyond it the Lemon Horse-Mint, and that far-off blue-green ring of plants is Texas Prickly-Pear Cactus."

"I like your pond," I said.

"George and I built that. He stocked it with bass and I loaded in the water lilies. Sometimes he launches his little dingy and goes fishing. It's so peaceful, nothing to hear but the birds singing. Listen!" We stood in silence for maybe thirty seconds. "Swallows, kingbirds, and cardinals. I just wish I could see one of those yellow-footed snowy egrets, but not today." She held my gaze. "So how far did we get, Doctor Alter?"

"We might have laid a framework, don't you think?"

"A framework? Yes, but is that enough?"

"It's a start. It's a piece of the puzzle."

"And that reading you handed him, was that a piece of the puzzle, too?"

"Maybe"—I reached into my pocket and withdrew the envelope—"here's a copy, see what you think."

She accepted it cautiously as well she might. "You want *me* to read this, too?"

"I'd like you to study it carefully. Your help and insight could be vital. Just give me fifty minutes alone with the president first."

Holding the envelope by a corner, she said, "There must be something important in here."

"Not some *thing*—some *one*. Now, not to seem ungracious, but if you'll be so kind as to excuse me, I'd like to snatch a moment alone in my room."

"Oh, I understand, of course. I guess you feel like a brain surgeon about to enter an operating theater."

In fact, I felt like a detective investigating the scene of a murder while understanding that the killer might just be watching my every move. I lay with my head on the fresh feather pillow and contemplated the fading light on the undulating Texan tan and olive hills. Perhaps that flock of camouflaged sharpshooters was staring back at me. Surely not. I closed my eyes and sought a tranquilizing Zen moment, but my mind would not be stilled. It was raising the specter of the Grinning Man, and my heart skipped a beat at the prospect of conjuring him in the flesh—and then stripping him naked. I reached for my satchel, extracted the scoundrel, and scanned his story:

The Grinning Man
By Alfred Adler

A man from an upstanding, socially conscious, well connected family dropped out of school … The bleakness of his situation, worsened by the reproaches of … To ease his anxiety he … On one occasion, the jeering made him … This new stance and behavior proclaimed … his efforts were directed towards maintaining the conviction that … The desperate search for a consoling …

Yes! Yes! Yes! A plan of attack became apparent.
Or so I imagined.

EVENING PRAYER SESSION

"AN HISTORIC PIECE OF FURNITURE?" I ASKED.

He removed his steel-rimmed reading glasses and dropped them along with the discussion paper on his six-by-three, brass-handled, dark mahogany partners desk.

"Historic?" He grinned. "My old man would agree with that. It used to be his"—he was leaning back in his high-backed leather chair with his tan boots on the desk—"and so did this chair."

Both items of furniture seemed out of place. The clumsy, overly large desk seemed glued to the floor, and, in this setting anyway, the high back of the dark-tan chair was intimidating. I got the feeling that whenever this current leader of the free world slipped into this regressive setting he became an emotional toddler in a high chair. Two sturdy, cherry hardwood chairs—the kind favored by university professors—stood in front of the desk, presumably so the president could sit beside his guest. Both chairs faced away from the desk, perhaps to

catch the view through the wide screen doors to the swimming pool and the chocolate box hills beyond.

He dropped his heels to the cool, polished concrete floor, adjusted the Texas buckle on his neat blue jeans, strode to the front of the desk and shook my hand. "Grab a seat," he said. We slipped into the two hickory chairs. "Well, I did my homework, Doc. Gotta confess I have absolutely no idea what to make of it. And there was no way I could relate it back to that weird game theory idea."

"But you did like *that* concept?"

"I always like games. So I can get my mind around the idea that social behaviors and such fall into patterns without us realizing what's happening." He paused. "Trouble is, now that I've had time to think about it, I'm not so sure there's any such game as Alcoholic."

"You're not?"

"Not as it affects me, anyway."

"You sure?"

"As sure as I can be."

He was looking for direction.

"And you might just be right!"

"I'm *right*?"

"I didn't say you *were* right. I said you *might* be right."

"Now you really are playing games, Doc. Word games. I mean. Why the fuck tell me I'm playing a game—then come back half an hour later and tell me I'm not?"

"Maybe because I want *you* to come up with the right answers."

"Me? You're the expert."

"That's not possible. You know infinitely more about you. I'm just a catalyst. My job is to help you discover what you already know."

"Even though you don't know what I know?"

"Right."

"I thought we already did that."

So! He did recall—at least in part—our earlier conversations. But he was confused, too. I needed to get him back on track.

"So let's get back to the big question: why do you think you fell off the wagon?"

"Okay, then. All right. Here's what I think." He gazed up and to the left before closing his eyes. Then, opening his eyes and blinking, he said, "I think I simply gave in to the urge to have a drink."

"But why?"

"Whatdaya mean, *Why?*"

"What I mean is, you're a highly insightful leader, and you vowed to Billy Graham that you were going to stop drinking, so something must've caused you to forget all about that."

"Something did."

"*Something?*"

He said nothing for maybe thirty seconds.

"Look, I'll tell you the truth"—he knitted his eyebrows together, his expression solemn—"I succumbed to, uh, *sin.*"

Oh, Christ, no, not sin. I did not want to revisit that subject.

"The devil made you do it?"

"He might've"—his voice remained deadly serious—"the devil's real you know. I believe that, I really do."

The devil. This was disappointing, and we might be going nowhere.

"So how, short of exorcism, can we get rid of the devil?"

"Sayin,' 'Get thee behind me Satan' for starters."

Oh, puh-lese! Was he joking? I couldn't tell.

"I guess it is a start, as you know it doesn't always work."

"The devil's cunning. Charming, too. He catches people unaware."

"He caught *you* unaware?"

"He surely did."

This was not going to be easy. There may well be gods and devils, but the way otherwise intelligent people misuse these otherworldly agents to explain away their personal failings inevitably catches me by surprise. It was something I'd noted often in my work with prison inmates. Ask them how they came to be in jail, and four out of five ascribe their incarceration to God. Not the devil, by the way, but *God*. But was I being a hypocrite? Ever since Ethan's funeral my own talents seemed to have taken on an otherworldly dimension. But now, unfortunately, these faculties were becoming erratic and deserting me. What was I doing wrong?

But then I rebounded. Ju-jitsu—I had a need for ju-jitsu.

"You're probably right!" I said. "I don't quite know why, but I'm having the strongest hunch that some evil spirit really did lay a trap for you."

"You really think so?" He pressed his hands to his thighs, leaned back, and drew a deep breath.

"I do, indeed. We know for a *fact* that people really do devilish things." I lowered my voice. "Personal experience has also shown me the power of prayer." He broke into a blissful smile—thrilled, I think, to discover that I might be a kindred spirit.

Jolting forward, he asked, "So there simply *must* be a god, right?"

I nodded yes, and he raised his palm to high-five me. I momentarily studied his stubby fingers and thick, hairy forearm

before our palms smacked together and he growled with pleasure, "Right!"

I strolled to the screen door and turned back to share a Christian smile.

"You know I believe that the Lord *asked* me to deliver his message to you, George. So let me make another confession. I also believe in destiny. I believe that we each have a fate. *But*—and it's a big but—God has given us free will, too."

"He has? Of course, he has. He has!"

Now I was connecting.

"So the challenge of life is for us to render unto Caesar the behaviors that are Caesar's—"

He added softly, "And unto God the things that are God's."

"Right! And we need to make that distinction *now*. We need to figure out exactly how to distinguish between the behaviors that God has ordained us to perform, and the behaviors that our faulty free will and the machinations of the devil have brought to our lives. And never forget, *the sins of the father are visited onto the son*—"

"I know, I know."

"Which is precisely why modern psychology with its focus on family can sometimes lead us to truth."

"Psychology is based on the *Bible*?"

"Of course! Cain and Abel, the Parable of the Prodigal, the woman at the well, they're *all* about human psychology. Atheists hate to admit it, but in fact the Bible is the very *foundation* of modern psychology."

"That's incredibly interesting." He paused thoughtfully. "But, you know, I'm not surprised. Not so surprised as some would imagine, anyway."

"And *I'm* not surprised that *you're* not surprised! It's one of those core items of intelligence that great leaders know without knowing that they know, if you 'know' what I mean."

He laughed and continued. "I know, yes, I know. I know what you mean. And you're right, I know I know, and I always knew."

To get us back on track, I said, "So let me share something that I'm feeling, that I'm feeling right now." His eyes widened. "I'm getting the strongest possible feeling that you and I should call on God to guide us in our discussion of our reading." I strode back and grabbed the reading from the desk. I sat back down in my chair and drew his gaze. "I believe, as you know, that God put this text into my hands before commanding me to come here."

I fell to my knees and closed my eyes.

He knelt beside me.

"In the name of your only begotten son Jesus," I prayed, "I appeal to you, God, to guide George W. Bush, the humble servant whom you have anointed leader of the free world, as he explores the distinction between the manifestation of your divine guidance and the evil urgings of the devil. Lead George to fully tap into the awesome power of the astonishing intellect and deep intuition with which you gifted him, so that he may discover the elements of prior sin that may have caused him to make unhappy choices in the application of your divine gift of free will. Show him where the intermittent abuse of alcohol, a cross which he has borne with grace and courage, might be caused by forces of which he is not fully aware. And, God, I pray anew for you to anoint me your servant, as I share this sacred spiritual journey with George. *Amen.*"

"Amen."

Rising from the kneeling position beside a born-again was a new experience for me, and I have to confess I felt more than a little awkward. Not so, George, however, as he regarded me in an infinitely more favorable light. To be honest, I'd have to confess to having betrayed my own principles by engaging in out-and-out manipulation. I tried to comfort myself with the thought that I was stooping to this behavior for an infinitely greater cause. There was no escaping it. But I realized that my argument was merely a variant of the "ticking time bomb" argument favored by proponents of torture.

But then another thought struck me. What if I really was in the grip of some benign supernatural power? What if *my* persuasiveness sprang from *that* power? If that were so, then my words and behavior were inspired and my heart was pure. And judging by the expression of peace on George's face, I had succeeded in uttering an incantation that had unlocked a door to his heart—and with luck, his intellect, too. So, now, this was the moment to usher him through that portal and lead him through the Byzantine passages of his mind and bring him face to face with the Grinning Man.

THE GRINNING MAN

"CAN I SHARE SOMETHING STRAIGHT FROM THE shoulder, George?"

"Well, uh, sure."

"What I see when I look at you"—the cockroach was motionless, he was listening closely—"is a leader who thrives on a challenge."

"Damn right, you do."

"So I'm delighted to confirm that we have a challenge in front of us right now."

"Here, now?"

"In the form of this next reading."

"It looked a little nutty, actually."

"Nutty?"

"Nutty, quirky—whatever. But no more so than everything else you've given me"—he grinned—"all of which I've enjoyed, by the way."

"You've grappled with it masterfully, if you don't mind my saying so."

I watched as his shoulders flexed in his red-checkered western shirt.

"Yeah, well, in my job I've gotten pretty good at cutting to the chase."

"I see that. You've honed a natural gift."

"So what's the big challenge with this piece, then?"

"To confront the Grinning Man—"

"Nobody frightens me, nothing and nobody," he said, swelling pridefully.

"—and then pin that ghoul into the big picture."

"Wazzatt mean?"

"It'll become clear soon enough. Right now, just to be sure we really are on the same page"—I passed him his glasses and the reading—"would you do me a favor and read this out loud?"

He set the glasses gingerly on his nose, taking care not to disturb the cockroach, and took a deep breath. His voice was confident:

> A man from an upstanding, socially conscious, well connected family dropped out of school and became a lowly clerk. Having fallen so far short of familial expectations he gave up hope of ever rising in the world. The bleakness of his situation, worsened by the reproaches of his friends,

weighed heavily upon him. To ease his anxiety he became a heavy drinker, and his overt alcoholism supplied an excuse for failure. After some time, however, he was hospitalized with a bad case of Delirium Tremens.

"Delerium tremens?"

"The DTs."

"Yeah, I know. But what are they exactly, Doc?

"Literally, *delerium tremens* means trembling madness; colloquially, they are the shakes and the accompanying horrors. They're related to hallucinations, but not exactly the same. DTs happen to people who abuse alcohol, especially binge drinkers. They get confused and see insects, snakes, rats, pink elephants—weird apparitions connected to their jobs or surroundings; gardens that look like jungles full of menacing, malevolent monsters, wallpaper infested with malicious spiders." I studied him closely and decided that he'd had no personal experience with the DT's. "Care to press on?"

He did:

> He was examined by doctors strongly opposed to alcohol abuse. They prescribed an exacting course of treatment that completely cured his alcoholism. Upon discharge from hospital, he abstained from alcohol for three years. Then, however, he returned to the hospital with a new ailment; now he constantly saw a leering, grinning man who watched him at the job of casual day-laborer that he had fallen into. On one occasion, the jeering made him so angry that he decided to discover whether the grinning man truly existed or was merely an illusion: he swung his pick and flung it at the taunting phantom. The apparition dodged the missile, but returned the attack, pounding the man severely with very real fists.

"The grinning man was *real*?"

"Yes. Our supposedly reconstructed alcoholic often hallucinated, but this time he'd heaved his pick at a flesh-and-blood person. So here's the sixty-four dollar question that we're going to have to address: *why did he do it?*"

"He wasn't playing that game of alcoholic."

"Right, he didn't fit that model at all. It had to be something else, something deeper. Let's consider the next paragraph."

He continued:

> Analysis revealed that the apparently "cured" and abstemious sufferer had suffered a "double conflict." Not only had he failed to progress in life, he had also fallen into worse circumstances and greater despair. He had lost his job, been evicted from his home, and forced to earn his living as a ditch-digger, a role which both he and his family and friends considered utterly demeaning. Both his outer and inner stresses were worse than before. In being freed from alcohol, he lost a vital source of solace. Being perceived as an alcoholic actually enabled him to perform his prior clerical role. If reproached by his family for being an underachiever, he could offer a plausible rationalization; clerking, however humble, was as good as any role one could reasonably expect an alcoholic such as himself to handle. In his mind, this excuse was infinitely less shameful than his inability to handle a higher-status occupation.

"This is interesting, Doc, but totally irrelevant."

"Why so?"

"Cuz it's got absolutely nothing to do with me. I was never an underachiever. Sure, like I said, when I was young and foolish, I was young and foolish. But I always wanted to be *somebody*. So I gave up the booze and I got to be rich. And then I got to be Governor of Texas. And, now I'm the

President of the United States of America. I'm the leader of the free world, for Chrissakes!"

Should I ask him a touchy question?

"How, exactly, did you get rich?"

He stiffened briefly.

"Okay, okay. We discussed that already. A bunch of Texas investors put me in the way of some money—but that's business. They organized things so that everybody got rich—including me. But they *needed* me. They couldn't have done anything without me. So it was a fair deal—for everyone."

"Why did they need you so badly?"

"I have a great heart, you said so yourself. They wanted my people skills." He paused, expecting me to continue, but I remained silent. "Okay, okay, I was well-connected, too."

"They wanted your connections, your influence, your family name—all of that?"

"Yeah, yeah—we went through all that before. But it really is a bum rap. It was *me* they wanted."

"So the family name—your father's name—had nothing to do with anything?"

For one moment, while the blood rushed to his face turning it beet red, I thought he might hit me.

"Okay, okay! Look, I'm not a dope, Doc. So, okay, maybe they did need my family name more than they needed me, but what the hell, you gotta do what you gotta do to make your pile—just so long as it's all legal, of course."

"And it *was* all legal?"

"Oh, Christ! So some shit-faced media creep said my career was a series of bribes. *Bribes*—can you believe that?" He paused. "Okay, so everything mightn't always have been, uh, pure—or not pure enough for those nitpickers—but it sure as hell was legal. And nobody's ever proved that it wasn't."

"How did you feel when those deals were all done?"

This time when his voice came it was soft and slow. "If you really wanna know, Doc, I felt like shit!" His fists were clenched, and he stood stock-still for maybe ten seconds, before loosening his fingers and dropping his arms to his sides. "But not right then…."

"So when?"

"Well"—he smiled disarmingly—"just the day before yesterday, if you really want to know."

"Why so recently?"

"Oh, come on, Doc. Don't sell me short. I've been *listening*. The psychic contract, the looming mountain, the dominating old man—and then the game-playing and all." As he slipped back into his chair, he said, "That fucker, my own dad, was pulling strings—including mine—behind the scenes."

"You felt, uh, manipulated?"

"Yeah, I *felt* it. I just didn't *know* it—not until now. And, okay, I'll admit it before you say it. Maybe you're right and all those rotten feelings were why I got onto the booze and all that. But you know what? I saw the light and got myself clean. And then *I* went on and *I* became Governor of Texas and then *I* became President of the United States. And that's something *nobody* can deny."

Should I push him further?

"Would you mind if I asked you a question to which I don't want an answer—not yet, anyway?"

"You got some funny ways, Doc, but if you don't want me to answer, what do you want?"

"I want you to hold the question in the back of your mind."

"So, shoot, what's the question?"

"How many times have you fallen off the wagon since you became leader of the free world—and why?"

He paused then blinked. "That's *two* questions. Well—"

"Don't answer—"

He pressed on with the reading:

> Unfortunately, following his "cure" he was turned out into the world to face the same old unpalatable realities—and worse. Now if he failed there would be no consoling and acceptable excuse; nothing upon which to lay blame for his failure, not even alcohol.

He raised his head and stared vacantly through the screen before settling his eyes on mine. "You're not trying to tell me, are you, that without alcohol *I'd* have no one to blame?"

"What you think is more important than what I think. Let's push ahead then you can tell me what you think."

He dropped his gaze to the reading:

> And so his unconscious mind created a novel way to resolve the situation: the hallucinations simply reappeared. He regressed, aligned himself mentally with his prior situation, and viewed the world as if he were still an hallucinating drunkard.

"*I'm* not having hallucinations, for Chrissake, Doc"—he grinned—"unless you're one."

"Press on. Let's see how one of the world's great psychologists makes sense of this curious case."

> The new illness was a means to escape his demeaning ditch digger role. It also spared him the need for him to make a conscious decision. This new stance and behavior proclaimed to family and friends, "Alcohol has laid waste to my life, my situation is irretrievably hopeless and there is nothing that I or anyone can do about it now." This latest hallucination lasted for a long time. Again, he was admitted

to hospital. This time, he comforted himself with the excuse that he might have fulfilled familial expectations if only alcoholism had not ruined his life.

"Listen, Doc—alcohol did *not* ruin my life—and I *did* fulfill absolutely all of my family's expectations!"

"I guess—so why have you fallen off the wagon?" As he was about to respond, I set a forefinger to my lips, "Don't answer."

With a smile he continued:

This strategy enabled him to maintain his sense of self-worth. It was more important for him not to lose his self-esteem than it was for him to work. All his efforts were directed toward maintaining the conviction that he might have accomplished great things if he hadn't fallen victim to misfortune. This was the state of affairs that enabled him to feel he was as good as anyone else, but that an insurmountable obstacle lay in his way. The desperate search for a consoling excuse produced the hallucination of the leering man; this apparition was the savior of his self-esteem.

"The grinning man saved him? How the fuck does *that* work?"

"Well—"

"I don't hallucinate! There's no goddammed apparition in my life."

"Everything's okay?"

"Yeah! I'm doing okay. Listen, I might have fallen off the wagon, but that was just pressure. Look, I've got more pressure in my job than anyone in the world."

"You have?"

"Yeah—*the whole damned world*."

"What kind of pressure?"

"What *kind* of pressure?"

"Sure, tell me about it."

"Listen, I'm a wartime leader! What the fuck else do you need to know?"

"Leading in a time of war is a high pressure job?"

"Is it high pressure? Is leading in a *time of war* a high pressure job? Do bears shit in the forest? Read my lips, Doc. Yes! Yes, fucking yes! It really *is* high stakes stuff. And you can bet your life that it's nothing that anyone ever chooses."

"Nothing you'd ever choose?"

"Right! No sane leader ever *wants* to go to war."

"So why did you make that choice?"

"Look, I *know* where you're going with this, Doc."

"Well I mean, it *was* your choice, right? You figured you had to make a preemptive strike. Shock and awe and all that."

"Look, we already had this discussion. And I *heard* what you said. You said I was hell bent on fulfilling my psychic contract"—he paused and eyed me warily—"and that I was just killing frogs." He clenched his fists. "But I've had time to think about all that, and my gut told me that I was doing something else."

"And what exactly did your intuition say?"

"My gut says that I was honoring my sacred oath to protect the American people."

"You went to war to save the people?"

"Damn right I did! We were being threatened by a madman—a *madman*! I had no choice. I was the *decider*—and the *leader*—so I *had* to act."

"And if you hadn't acted what would have happened?"

"Hindsight! Oh, Christ, *hindsight*! As it all turned out I got it wrong. Is that where you're going?"

"Wrong about what?"

"Look, we *might* have been wrong about the WMD—I'm still not sure we were—but Saddam was a madman and he was mocking the world."

"He was mocking the world?"

"Right, and scheming. He was a threat—WMD or no WMD—he was a cruel, contemptuous sonofabitch."

"Contemptuous?"

"Yeah, we went to the U.N. and we gave him an ultimatum, and he tried to stare us down, tried to stare down the whole world actually."

"And…."

"And everybody caved in—"

"Everybody?"

"Everybody except *me*."

"He couldn't stare you down."

"No, he could *not*."

"So you delivered that dose of shock and awe—tossed everything you had—in the direction of …"

"Saddam Hussein."

"Yes, of course, Saddam Hussein—the contemptuous tyrant, right?"

"Right! That's *exactly* what he was."

"He was a leering, grinning, contemptuous sonofabitch?"

"A what?"

"A leering, grinning tyrant—right?"

"A leering … grinning …"

"He was a bad guy—right?"

"A leering … grinning … " He stood slowly and stared vacantly. "A leering, grinning man …" He shuffled to the screen door and stood facing out.

I sensed Laura's coming into the room. She was standing in the doorway contemplating her dazed and confused

husband. She might have been there for some time, but I hadn't noticed her and neither had he. When she glanced in my direction, I placed a finger across my lips and gently shook my head. Anxious and afraid—daring, as far as I could tell, not even to breath—she remained motionless.

ILLUMINATION

"WELL"—HER PRESENCE HAD CAUGHT HIM by surprise—"Laura."

His greeting was a touch ambivalent. I stood and smiled in her direction. As she moved into the room, he added a chair to our set of two and placed it beside his own.

"You've had time to think about the grinning man?" I directed the question to her as we slipped into our intimate triangle.

"Well, yes," she replied. "I read it closely, and I have to confess to overhearing some of your conversation, too."

I broke the contrite silence. "I'm sure we're not saying anything we'd not be happy to share because I think we might finally have gotten a handle on that reading. What do you think, Mr. President?"

He was slow to reply, but when it came it was directed more to her than to me. His voice was soft, his demeanor reflective—the cowboy was gone.

"Doc has shown me something. He's brilliant, he's a brilliant guy—you really are, Doc. I don't say it lightly—and he's gotten me to see deep into my heart, deeper than I'd imagined possible. He's shown me, uh, helped me… helped me to see…"

He was dazed.

"Just to recap, we were discussing two things. First, we were reconsidering the forces that might have been at work to cause the president's recent relapse. And I think we got to the point of saying that maybe it was not directly related to the game of Alcoholic—that's where we got to, right, Mister President?" He nodded. "Yes, we said, the game *might* be in play—but even that would not explain what triggered the recent relapse. That's where we got to on that point, right, Mister President?"

Again he nodded.

"I can certainly follow that," she said.

"So then we moved on to the question of the Grinning Man. Who he might be and where he might fit into the big picture—"

"And how he might have been responsible for the relapse?"

"Yes, that's where our discussion was headed, wouldn't you agree, Mister President?"

"What I see"—he was staring in the direction of the floor—"what I see is that"—again he hesitated—"what I see is that, is that I, is that I threw, is that I threw a pickaxe"—he raised his head—"is that I threw a pickaxe at a leering…." His vulnerability affected me a great deal. "I mean, *that's* where we got to, right, Doc?"

I couldn't look away from him, even though I could feel her moving uncomfortably next to me. I understood that she might be afraid of what was coming next. At that time it was a concern I did not share. Experience had taught me that the world changes for the better when the Grinning Man is stripped naked.

"Do you feel like clarifying that for Laura?"

Would he go backward or forward? Rumor has it that an idea expands the brain forever, that the mind can never shrink to its former size. In my experience, however, the demons of resistance and regression can often be just as powerful as the forces of denial. And right then those contrarian agents seemed to be at work within him. Would he be capable, in this troubled state, of putting his insight into words?

Speaking directly to her, and surprisingly only for her, he said, "It was Saddam. *He* was the grinning man. I threw everything I had at him"—tears were welling in his eyes—"and . . ."

This was not the time for him to end that sentence; there was nothing to be gained, not right now anyway, by forcing him to admit that literally thousands of young men and women had been sacrificed on the altar of George W. Bush's ghastly, ghostly childhood memories.

"Time and again your husband's courage is inspiring," I added as I studied his face. Our discussion had obviously affected him. "Only the most outstanding leaders dare to confront their own mind's demons."

"Well, thanks, Doc." He rose woodenly to his feet, as if lifted by invisible threads. "And if you'll both excuse me for a couple of minutes, I have to make a phone call."

He slipped out of the room. He'd been through an emotional ringer, no doubt about it. It was 7:02 P.M., and time was running out—and I still needed to secure his approval for the broadcast.

"Unless you shared something with George that I didn't catch, then I'm still not quite sure," she said, a moment or so after he left, "of how the story of the Grinning Man has a message for our lives." How right of her to say *our*; she'd

enabled him, every step of the way. "Or of how the story answers the question of what triggered George's relapse."

"George's intuitions kind of beat me to the punch, actually."

"He figured it all out for himself?"

"The unconscious mind is incredibly perceptive."

"I am sorry, I don't quite get it."

Should I have taken the bait? It had been a long day, and I had been retained to enlighten one person, not two. But I wanted to help her, of course.

"There are many theories of human behavior, and they often overlap. So first, let's consider the psychic contract. Is it fair to say that your husband's culminating achievement was to become president?"

"Yes, of course—well don't *you* think so?"

"Maybe. But then the pressure of the job became intense."

"Sure, but not so intense that he couldn't handle it."

"Did it become even more intense after 9/11?"

"Of course—George was the one who had to figure out how to respond."

"Right. So might it be more accurate to say that the so-called Mission Accomplished speech following the decision to invade Iraq was his real culminating achievement?"

"Not really. I mean everything went sour after that."

"But that's the whole point—a culminating achievement becomes a defining moment, sometimes good but quite often bad."

"So in that moment George became what you call a loser?"

"As it all turned out, yes—but only according to the rules of the psychic contract—which any of us is free to consign to a mental scrapheap any time we choose—"

"So long as we're aware of those rules."

"Right! So long as we have insight into our inner lives. But what if we don't?"

"We just go on?"

"Maybe. Sure, mostly the loser just goes on, anaesthetizing his shrunken self-esteem by whining—"

"That the grapes of success would have been too sour to enjoy."

"Yes, Aesop definitely got that right. But, there's also another way the ever-clever unconscious seeks to save face."

"There is?"

"Sure, the mind may simply create a Grinning Man."

"I'm still not with you."

"Let's assume that George fulfilled his psychic contract on the day he became president."

"Yes."

"But that the pressure of the job turned out to be more than he could handle."

"I'm not sure that's true."

"Did he suffer a relapse before 9/11?" The expression on her face was a dead giveaway. "So he *seemed* like a Winner but in fact was locked into a debilitating struggle, a struggle he feared—perhaps even knew—he'd never be able to handle. And so coped as best he could. First by passing the buck to his vice-president. Then by retreating to Crawford, and then, by falling off the wagon." She said no, but her head nodded yes. "Then something truly dreadful happened; terrorists attacked the World Trade Center. And the pressure became unbearable, and he simply had to find a way out."

"He got the best possible advice at every turn."

"Sure, because he tried, again, to shift responsibility to others. Yet, curiously, as Commander-in-Chief, he gave the order to stop pursuing Osama bin Laden in Afghanistan. Instead, if we accept the theory of Alfred Adler—which your husband now seems to have done—in one last ingenious hope of rescuing his self-esteem and becoming a Winner in terms of the psychic contract, he tossed his pickaxe at the apparition of an altogether different leering man—Saddam Hussein. In fact, Freud would probably argue that our inner demons often have overlapping identities and that by authorizing a preemptive war against Iraq—which clearly had absolutely nothing to do with the destruction of the World Trade Center—George unconsciously hoped to kill both Saddam and his father."

Sitting there in silence with the First Lady, I became aware of the scent of chlorine and honeysuckle. It's odd what pushes into our consciousness. The sun had disappeared and the hills were a palette of fudge and charcoal. The swimming pool glowed with the reflection of a tawny rising moon.

She rose and held out a hand as fragile as that of a porcelain doll's. "You've been very helpful, Doctor Alter." She glanced over my shoulder and I reflexively turned to see what she might be looking at. But there was nothing, just the open door. "If you'll excuse me, I'll just go and check on George." She dropped her hand from mine, then led me out onto the patio and eastward to the guest room. "You must have had a busy day, why not rest for an hour or so."

"Sounds great. I also need to check my office phone for messages. Is that possible?"

"Of course. There's a phone next to your bed. And cell phones work, too."

I kicked off my shoes, lay on the bed, and gazed out at the moon-soaked oak. Grace's face appeared in the shadows. So, my love, I asked, how did I do? She didn't answer but I sensed that she was happy with my work, so I pressed on. We were right, my sweet, the acorn never falls far from the Grinning Man, and the unveiling of that visage is seldom a happy experience. But no matter, the stakes are infinitely greater things than a brittle president's psyche. His inner journey was merely a first step—and time really is running out.

We must now persuade him to unleash that potentially world-changing speech. And, yes, you're right, about that, too. How lucky we were to have captured it on digital disc before he got that hideous yellow cockroach appended to his brow. The world could never guess that such a polished delivery had dropped from the lips of a falling-down drunk. How lucky, also, that a perfect copy of that disc still survives. But was it really luck? Maybe the Lord really has worked in the mysterious ways his devotees claim. But if there's a God, then there's a Devil, too. So, which of these forces will prevail? But again, how right you are, my love. The force that wins is the force that we create. So, now that the Grinning Man has been dispatched to the nether world, how can I seize the moment and persuade the president to release his speech?

Was Grace really a heavenly spirit or merely a pattern of neurons within my brain? God only knows. My sullen gray matter said one thing, my pulsing heart another. My pulsing heart. I tapped it. Yes, the executive order was there in its blood red wrapper. It was then that I sensed the presence of a grinning man.

EVENING MEETING WITH POTUS

"HEY, MARK."

A shadow filled my screen door, and I sprang to my feet. It was the president. I slipped on my loafers as he slid the door open. Grabbing my hand, he said, "We need to talk."

Indeed we did—*this* was the time to seize the moment.

After we strolled to the eastern patio, he lowered himself into a grayed teak patio recliner and indicated for me to do the same. The stars glittered as brightly as the eyes of a lover and the air was redolent with the scent of honeysuckle. He broke the silence, saying, "If we sit here long enough, we'll see the sun rise again. Life's like that, don't you think?" Staring straight ahead, he continued, "I mean, what I now know is that the sun has already set on a big part of my life. And I can never get that back. But you know what?" He glanced in my direction. "I'm not gonna waste one moment worrying about that Grinning Man. I'm puttin' all that behind me and thinking about tomorrow."

A zephyr breeze cooled my cheek. The opening was right here and right now—I just had to choose the right words.

"You're wondering how you—the real you—might rise up like a bright new sun to awaken the world in the morning?"

"The old man always wanted a bright new son."

Sun? Son? Had this pun fallen from a shooting star?

"A bright new son? Yes! Act well your part and a bright new sun is what you will surely become. The new son—the new you, the *real* you—will bring new light."

"You think so?" He gazed back into the night. "Act well my part? What does that mean, exactly, Doc?"

"Well, George"—I decided to go for the kill—"we both know that God has chosen you to play an especially challenging role on this stage we call the earth. We've also acknowledged

his insistence that you and I meet, first within your inner Washington sanctum, and now all the way out here in your sacred refuge, beneath this starry sky. He is commanding that we tap your inner strength and wisdom so that you may fulfill your divine mission."

"My mission?"

"Your *divine* mission."

"But what is it?"

"You know it, George."

"I do?"

"And you know that you know—for you know in your heart how close you already came to completing it. You know that the Grinning Man tricked you at the last moment."

"He did?"

"You know that, just as surely as you know that you have unfinished business with God."

"Unfinished business?"

"Precisely. And that's why we're here right now. It's also why God preserved a pristine copy of that powerful speech that you recorded."

"He kept a copy?"

"He kept a copy and he placed it in safekeeping. He knew the devil would come to tempt you in your own personal Garden of Gethsemane. God arranged for you to be delivered from that grinning fiend. And, now that you're in full possession of his precious gift of free will, God is relying on you to complete the divine contract you've embarked upon."

"The divine contract?"

"All it will take will be for you to say the word."

"The word?"

"It's as clear as the Northern Star up there, George. God is begging you to authorize the broadcast of the DVD that he preserved."

"He has it on DVD?"

"It *exists*! And I know that you know—better than any man alive—that it exists precisely because God *wants* it to exist—"

"I can see that."

"—because it's vital to his plan—and your mission."

"I *will* complete my mission, Doc." He grasped my forearm. "What do I have to do? I mean, what's the next step, exactly?"

I produced the envelope from my pocket."

He eyed it suspiciously. "Yet *another* red wrapper?"

"It's nothing special, a mere formality."

He plucked the envelope from my hand, stuffed his thick right thumb into the flap, tore it open, and studied the thick, white bond paper.

"It's an executive order," he barked, peeved: "Who authorized it?"

"It's nothing till you sign it, George."

He read it in silence, mouthing the words.

If I didn't say something the moment might vanish.

"When the Lord wants us to remake the world, things happen in the twinkling of an eye."

"You're a sharp guy, Doc."

"I'm a mere intermediary—we both know that."

"We do?"

"Sure. We sense the spirit that's guiding us. We know that the paper in your hand has been placed there by divine providence." I produced a gold pen from my pocket. "You only need to sign it." I pushed the pen into his hand. "One copy is for your files, the other is for the Crawford Communication Center. We should move quickly—there's a tide in the affairs of men, which, taken at the flood leads on to fortune."

"A tide?"

"It's a line from Shakespeare, actually."

"Shakespeare?"

"He was making the point that some moments are more vital than others—"

"Vital?—"

"—and that our place in history can turn upon a single decision—one self-assured stroke of a pen, as it were."

He dropped both the envelope and the paper to a patio table, then penned his signature to both copies. "I did it, see?"

I was saddened that the leader of the free world should exhibit such an overt need for the approval of a father surrogate. On the bright side, I was in control of the situation and this was no time to relax.

"Your handwriting is intriguing, Mister President."

"You think so?"

I felt a burst of Mission Accomplished exultation as I gathered up both copies and took in his thick signature. I now only needed to deliver the document to Cathy, and direct her to the disc.

"Your neat but bold signature reveals an unusual capacity for intuitive thinking and audacious action." He beamed, and I smiled right back, tucking the documents back into the envelope as I did so. "So I know you'll be commanding me to waste no time in getting this to the communications center." Still flattered, he grinned again. Too much was at stake for me to wait for any further response. I dropped the envelope into my pocket and retrieved my cell phone. "So be it, then. The agent who brought me here can make the delivery." I hit the redial button, jammed the phone to my ear, stepped a couple of paces away from him, and gazed over the lake.

"Agent? Which agent?" His voice was wobbly. Was he having second thoughts? Was he miffed that I'd taken charge? When I peeked back at him, he seemed distracted.

"Agent Vale as I recall," I said with a smile, then stared up into the dark night sky willing the radiating cell phone signals to connect with and complete the return journey from its destined starry satellite.

"Agent Vale." Her voice was cool and professional.

"This is Doctor Alter. The Commander-in-Chief wants you to come straight over to pick up a document"—I glanced back at the president, who seemed disoriented—"and then arrange a broadcast."

"Certainly, Doctor Alter." Her words resonated with excitement. "Right away, sir."

I snapped the phone shut and dropped it back into my pocket.

"Get Laura—quickly!" He was clutching at his heart as he lowered himself into his chair and closed his eyes.

Before I could move, I heard her footsteps—she seemed to be running—feminine intuition again, for sure. After racing up to him, she threw her arms around his shoulders.

Something was wrong.

"Should we call a doctor?" I asked.

"No. We always have a doctor close by. For the moment he just needs to rest. It's all been a terrible strain as I'm sure you understand."

I caught sight of headlights moving toward the house. I could also hear a purring engine—it had to be Cathy.

His eyes were still closed.

"Is there nothing I can do?" I asked.

"All things considered, the wisest course might be for you to slip quietly away," she said softly.

APPREHENSION AND RENDITION

I STOOD BATHED IN THE LIGHT FROM HALOGENS and tasted a mist of Texas clay as the limousine drew to a dusty halt.

The passenger door burst open and Cathy jumped out.

"You have everything we need?" she asked, not quite masking her sense of urgency. "I mean, everything, right?"

First I nodded, then I silently shook my head, no more questions please—let's get the show on the road before he changes his mind.

We bundled into the limousine. A uniformed driver was in the front seat and the partition separating us was in place. Clay and gravel crackled beneath us as we pulled away. Looking out the back window, I saw that the house was fully lit, but no one was to be seen.

"Where's the president?" Cathy asked.

"He had a weird chest pain and didn't look at all well. But Laura said it was nothing, he just needed to rest."

"She might be right. If he really does suffer from an iffy heartbeat, she doubtless has what he needs on hand."

"Like what?"

"A couple of pills or a defibrillator—"

"Like the funny box on his back in the presidential debate?"

"Exactly. But atrial fibrillation can cause strokes, so it's not funny at all."

"Is there any actual evidence of brain damage?"

"Some experts say they see telltale signs of droopiness in his face. He's had tests but never released the metrics—just the bald assertion that he's in superb condition." She was both elated and unsure. "You did get him to sign off, right?"

I removed the red wrapper from my pocket and handed it to her. "It's a done deal, his signature is right there."

She opened the envelope and studied the presidential signature. "Hey, Mark, you did it—you really did!" She pushed the document back into the envelope and dropped it into her attaché case. "We've got time to make that broadcast."

The limousine stopped and she peered out the window.

"He's waiting for direction, Mark. We can turn right, take a thirty-second ride up the hill to the security center, then make the broadcast from there. Or we can head out the gate, take the Gulfstream back to Washington—or just about anywhere, actually—and send it from there." Her eyes settled upon mine. "So where's the DVD?"

"You couldn't figure that out, Cathy?" I cocked my head. "You didn't decipher the code?"

"The code?"

"The poem I gave you—*There's chapel in the mind / And when we kneel there can find / The shining wisdom to rewind/ All trespasses.*"

She'd be impressed when I made sense of it for her.

But she was not.

"Oh, come on, Mark, this is no time for word games."

She was right, I was thinking like a teenager. Such is the power beautiful young women exert over silver-headed men.

I was about to respond when I was blindsided by clusters of dazzling lights coming from several directions. They set the cabin interior ablaze and washed over our bewildered faces.

I felt a rush of warm air as the doors to the limousine were flung open.

"Out, out," barked a surly voice. "Get out of the car—now!"

Cathy spoke up. "He's okay," she cried, "he's with me."

I remember very little of what happened next. I glimpsed a large vehicle, a Hummer, I think, and several gray-suited men. Two of them were carrying revolvers. Someone snapped some kind of hood over my eyes and everything went black. Beyond that, I remember only the sickly, sweet smell of chloroform—then, much later, a frightening dream:

> *I was an opera tenor whose arms and legs were chained with heavy irons. I was gazing lovingly across a tiny altar into the deep blue eyes of a young and beautiful masked soprano—Cathy, perhaps, I could not tell. Above the altar, soft beams of light seeped through a stained window, within which Thomas Jefferson was floating above the Washington Monument. I broke into song:*

> > *There's chapel in the mind*
> > *And when we kneel there can find*
> > *The shining wisdom to rewind,*
> > *all trespasses*

> *The soprano fell to her knees in front of the altar, and we sang a duet:*

> > *Yes, there's an altar in that place*
> > *So upon a fall from grace*
> > *We should carefully retrace*
> > *All our sins*

> *She stretched out on her back beneath the altar, then reached up and extracted a gleaming silver disc, and a bronze key to unlock the chains. Both had been hidden on the underside of the altar. The soprano rose, set the key on the altar, then held the disc aloft in both hands. I looked on lovingly and we completed the duet:*

> > *The shining wisdom to rewind*
> > *all trespasses*

A resounding boom thundered. The church doors burst open and a portly, sneering commander wearing rimless spectacles strutted with a phalanx of uniformed soldiers down the aisle. They halted at the altar and the commander raised an arm. Two soldiers stepped forward and blindfolded the soprano. The others surrounded her, produced pistols, formed a firing line, and took aim. The commander dropped his right arm, the muskets fired, and the soprano fell to the floor. The commander grabbed the bronze key from the altar, then stooped and plucked the disc from the dying soprano's hands. He pocketed the key, tossed the wafer to the floor, and crushed it with his heel before leading the troops back down the aisle and out the door, which swung tightly closed behind them. In that moment, a bolt of lightning pierced the cathedral window, striking my racing heart, and setting the entire scene ablaze.

SPECIAL OPERATIONS UNIT

CASE OF MARK ALTER

Confidential to Walter Reed Medical Center, Psychiatric Unit.

We processed, as a matter of urgency, your inquiry following our delivery of Mark Alter for observation. We confirm that the son, Ethan Alter, died of a drug overdose in a basement apartment in Brooklyn, N.Y. on 03/13/07, one day short of his 24th birthday, leaving an envelope at the scene, which we traced to a sometime girlfriend, herself also an addict. She refused to relinquish the contents but did offer them for inspection. There was no suicide note, merely unpublished poems and rejection letters from various magazines. Our field agent did, however, report sighting an item of interest, being strongly anti-American sentiments written by the son on the day of the second inauguration of President George W. Bush. We have asked the agent to retrieve this document, and will forward it in due course. Meantime, we trust that you will calibrate the extent to which the father may have shared the son's antipathies and self-destructive tendences, and provide treatment as necessary.

WALTER REED MEDICAL CENTER

PATHOLOGY & TREATMENT OF

MARK ALTER

Confidential to Special Operations Unit

The patient was delivered in presentable condition and appeared to be in cogent command of his faculties. As is abundantly apparent from the transcript of his statement, however, Dr. Alter's outwardly equable manner masks a deep pathology, which, in the absence of serious treatment, is likely to prove impenetrable. Dr. Alter's hold on reality was doubtless rendered extremely fragile following the fatal shooting of his wife. The subsequent apparent suicide of his son—which left Dr. Alter alone in the world—apparently brought on a full psychosis. One might have anticipated greater resilience from a formerly successful psychoanalyst, but in fact mental healthcare professionals are notoriously prone to acute depression. Dr. Alter's increasingly distressing dreams—particularly those of falling from great heights and peering down the barrels of loaded guns—signal his unconscious apprehension that his sanity was under severe stress and would ultimately fail. We therefore view his entire tale as a psychotic attempt to treat his own troubled psyche: in a split of personality, he delusionally cast himself as therapist to the President of the United States—an unconscious surrogate, as many of the dreams make abundantly clear, for his drug addicted son—then fantasized the twin roles of Patient and Therapist in the hope of regaining his own sanity, perhaps even of resurrecting his son. As noted, Dr. Alter's state of denial and consequent mask of normality seem impenetrable, so we see no alternative to Electro Convulsive Therapy, and hereby recommend same.

NEWS CLIPPINGS

Politics

At this week's Rose Garden press conference, United States President George W. Bush confided that while riding his mountain bike through the dirt hills of his Crawford ranch this past weekend, he suffered a fall that resulted in a mild laceration above his left eye. "It's not the first time I've taken a tumble," he said, jokingly, "but as the public well knows, I always bounce back up, refreshed and raring to go." Striking a more serious note, he went on to state that he had sojourned to the ranch for a quiet meeting with top intelligence advisors and had been assured "in no uncertain terms" that generals in the field are reporting "very significant recent progress" in the Iraq war. "The bottom line," said the president, "is that we have turned the corner in this conflict, and I intend to press right on to victory."

Mental Health

The bizarre case of the Manhattan psychologist Doctor Mark Alter took a final turn today with his passing from heart failure. Readers of this column will recall that despite his success in treating high-profile corporate leaders, the tragic deaths of Dr. Alter's wife and son apparently resulted in deep traumas that caused him to fall into an "irrecoverable depression." Dr. Alter then suffered an abrupt, disorienting nervous breakdown that caused him to go missing. He was serendipitously discovered within the ranks of New York's mentally ill and homeless by government agents in the course of an unrelated investigation, and referred to Walter Reed Medical Center. Ultimately, however, Doctor Alter failed to respond to emergency treatments. He leaves no family and in keeping with his beliefs and wishes was cremated. No memorial service will be held.

The 2nd Coming of 43

From heaven we look down upon your tongue,
and ponder on past promises eclipsed,
as sycophantic aides you strut among,
who hail your empty words and arrant quips.
For flowers were never strewn at our feet,
and siren songs for us were never sung;
our mission met a deadlier drumbeat,
as vaunted claims of conquest came unstrung.
Yet still you swagger, surly as you bleat,
propped by opulent puppeteers galore,
and fawning, fulsome phrases of deceit,
come wafting from your acquiescent jaw.
Those words hang briefly in the air like chaff,
but your lies will rise as your epitaph.

Ethan Alter
20 Jan 2005

ACKNOWLEDGEMENTS

I am grateful to The New York Times
for permission to use *The Hail Mary Pass*, by
Thomas Friedman in his column of 2 May 2007;
to Penguin Press for permission to quote from
Games People Play by Eric Berne;
and to Little Brown for permission to include
Snakebite, the lovely poem from the novel
Snakebite Sonnet, by Max Phillips.
I should also like to acknowledge
an idea from *Kokology*,
by Tadahiko Nagao and Isamu Saito;
material culled from Wikipedia;
and the concept of the Grinning Man
from the work of Alfred Adler.

THANKS

My very special thanks to Margaret King,
mercurial principal of The Flatiron Literary
Agency; to my editor, Marjorie Hanlon; to Dean
Wareham and Heather McRay for their sensitive
suggestions; to cover designer David Di Nuccio
for his brilliance and dedication;
and to John Weber, the daring chief of
Welcome Rain Publishers, for his encouragement,
support, and sage advice.